BLACK IN BLUES

BLACK IN
BLUES

HOW A COLOR TELLS THE STORY OF MY PEOPLE

◇◇◇◇◇◇◇◇◇◇◇◇◇◇◇◇◇◇◇

IMANI PERRY

ecco

An Imprint of HarperCollinsPublishers

HarperCollins books may be purchased for educational, business, or sales promotional use. For information, please email the Special Markets Department at SPsales@harpercollins.com.

Ecco® and HarperCollins® are trademarks of HarperCollins Publishers.

FIRST EDITION

Designed by Alison Bloomer

Library of Congress Cataloging-in-Publication Data has been applied for.

ISBN 978-0-06-297739-7

24 25 26 27 28 LBC 5 4 3 2 1

*IN LOVING MEMORY OF
DWAYNE ROLAND MILLER AND
CORNELIUS DURREL PERRY,*

*AND FOR MY DEARS
WHO LOVE BLUE.*

I notice I am at the edge of a lake. The blue of it is more than the sky, more than any blue I know. More than Lina's beads or the heads of chicory. I am loving it so, I can't stop. I want to put my face deep there. I want to. What is making me hesitate, making me not get the beautiful blue of what I want?
—Florens in Toni Morrison's *A Mercy*

For most of your career, you have been a blue writer.
—Arthur to Thelonious Monk Ellison in *American Fiction*

Blue is one of the largest colors on the earth. You look at the sky it look blue, you look at the water it look blue. Blue is the protection, that color that God gets to you so you have to see it and it carries lots of meaning. Each person in they heart have something to say about blue. But my thing about blue is this: you can't see the end of blue.
—Joe Minter, artist and founder of the African Village in Birmingham, Alabama

CONTENTS

⬦⬦⬦⬦⬦⬦

BLACK IN BLUES

OUR BLUE INTERIOR

✕✕✕✕✕✕✕

"WHICH IS YOUR favorite color blue?" I asked Ian, my first cousin Jillian's youngest child. Even then, when very small, he knew an encyclopedia of shades. He'd refer to objects as teal, burgundy, mustard. This time, he pointed: "That one!"

There, in my grandmother's bedroom, where we all had slept as children, a tile was missing from where the ceiling had been dropped to save on heating costs. The gap was now a portal. Through it, the original blue of the room was visible. Not pale and grayish like the walls, the blue was bright, like the sky in August.

That one.

Me too, Ian. Me too.

MY BLUE BEGINS here inside her-our-my home. The walls, the shaggy rug, the printed birds that were once perched inside an artificial wood frame by the window, the cotton covers and blue-inked words of prayer on paper tucked in the corner of her vanity. What led her to all that blue? Was it the parade of wildflowers of Alabama: the bluebells, mouse-ears, chicory, bluets, wild hyacinth, dayflowers, aster, or toadflax, and their curving, springing, luscious blues? Was it

just our sky, crisp and divine? Was she inspired by her youth in the country, where having the blues lent passion to the sound of gospel in Sunday morning baptismal waters and mixed with amber liquids and guitars after dark?

Black people sing the blues. She did. I do. Our children too (I rage to think of every time this place has broken their young hearts). And our children's children will, if history is any indication, regardless of whether the center holds or keeps crumbling. Some things are terribly reliable, like suffering. But despite the scourge of injustice and the regularity of misery, we have learned to sing—and therefore live—in a full-throated way, without fear of an ugly mouth or crumpled face. What matters is that our voices are thick and honest. This blue-black living and doing is a bittersweet virtue, mastery in heartbreak, and raw laughter from the underside. We people who created a sound for the world's favorite color—the blues—offer a testimony. We have looked to the blue expanses of even our most treacherous of landscapes as places of possibility: the North Star in the midnight sky, which led the enslaved to free territories; the celestial morning blue, which somewhere out of sight housed the gates of heaven and relief from endless labor. We have even believed, leaping from slave ships, that the deep ocean waters would return us to freedom by traveling back to the past, before the vicious trade in flesh. In the successive waves of reckonings through the steady meanness of life, we have relied upon a blues-soaked sensibility: sustaining, being, and becoming ourselves.

I imagine my grandmother—the mother of a dozen who acquired a sweet yellow house by hook or crook—picking that blue paint. Charming and pretty, it was a color for homemaking. She, a nurturer and a stalwart, chose it. She was a woman who often chuckled softly while looking at her fingers stretched out, one hand gliding across the other. She made a home inside when outside was Jim Crow humiliation, mean cops, too-hard work for not enough, and eventually crack and its companion: neighborhood decline. Inside that blue room, all

danger receded. Contained and abundant, it was and is a place for laughter, rest, self-adornment, and even dying soft. In my grandmother's bedroom, I learned to love blue. I also learned about the blues. She taught me that we who have the blues also have beauty. Both beauty and the blues, inside and out.

I never asked her whether blue was her favorite color. Those questions we forgot to ask while the people we love were living haunt us. But had I asked, I know she would have laughed. If I had asked more specifically why her room was blue, she probably would have said, "That's the color I chose," before reflecting on how pretty it had been when it was first painted. That's just a guess. But I think it is good one.

In 2023, when I asked another elder, Mother Annie Abrams, a retired teacher who runs a museum out of her home in Little Rock, Arkansas, about *her* bright blue house that sits bold on the corner, and why she painted it that way, she said, "That's the color it was," and looked at me as if to say, "Case closed." I smiled. Another answer I already should have considered.

Still, I wondered, why so much blue? And what makes it matter? What makes it mournful and hopeful and Black? How did the ones who Curtis Mayfield called "we the people who are darker than blue" come to *be*?

WRITING IN COLOR

◇◇◇◇◇◇◇◇

IN THE BEGINNING—WHEN I was just calling this "my blue book"—I read books and essays about colors. I loved how the writers ran through the science, symbols, and feelings associated with various hues. Some of these works read more like ornamental lists than narratives. And as much as I enjoyed them, I knew my task was different from their authors'. I didn't want to write an exegesis on blue. I realized I wanted to write toward the mystery of blue and its alchemy in the lives of Black folk.

As far back as I can remember, I was aware of belonging to a group for whom the word "color" was potent. "The color of your skin," "colored people," "colorful people," and "people of color" are all phrases that are associated with us Black Americans. And while "black" is our nominal color, even though our bodies range from alabaster to jet, the blues are our sensibility, hence the designation made famous by the writer Amiri Baraka: "blues people."

Like most of my skin folk, I would guess, I have an intuitive sense of what it means to be "Black." But when I have tried to use my scholarly training to offer accounts of the how and why we are this—for lack of a better word—*thing*, my descriptions feel distorting. Disquisitions about the political economy, about race as an ideology and/or social construct

of modernity, something a little bit phenotypic (brown, coily-haired) but not completely reducible to that at all, genealogical but certainly not biological, an existence born of empire, ships, captivity, colonies, and trade, a living molded by bias and bigotry—all of it feels too clinical. These concepts can't fully capture important truths like how it was that people held in the bottoms of slave ships survived so many figurative shipwrecks. And literal ones too. Academic descriptions of Blackness fail to explain how at the heart of being Black is a testimony about the universal power of existence. I wanted to write you (and me) something more. I wanted to offer truth with a heartbeat. And so, I steadily collected Black stories of blue and the blues—both literal and figurative. As I plotted them out, I found that my collection of tales was already bound together in a tight weave. I wasn't constructing a story; I was revealing and witnessing, quilting something present. Along the way, I learned much more than I already knew about what it means to be a blues people—events, artifacts, sound, color, breath, death, and depth spoke to me and through me. And that is this book. In it, loose threads and frayed patches are as important as seamless compositions and straight-stitched stories. Perhaps more so, because life is neither tidy nor done; it is doing.

BLUE GOES DOWN

◇◇◇◇◇◇◇◇

I CLOSE MY eyes and conjure up our home house, a term Black Southerners use for the dwelling where the family gathers. That yellow house with that blue bedroom was built in 1940. It was part of a development intended for White steel mill workers. My Black family was not imagined inside it when it was built. And yet we—or better yet they, because I wasn't born yet—along with a host of other Black folks, moved into the neighborhood in the 1960s, as segregated sections of Birmingham gradually opened up. My family settled in a place that wasn't made for us and called it home. How is that for a metaphor of Black American life? Indeed, I could write hundreds of pages about the color blue right there in the "Magic City," as Birmingham is nicknamed. But Blackness, no matter how specific the experience, organically reaches across borders. And I followed it. Having lived over five decades, I have heard and seen blue ringing through Black life at every corner of the world, from Malian music and Yoruba cosmology to the testimonies of rural Colombians. In my blue notebooks, I steadily collected blue blues.

There was one story I found unexpectedly from Liberia that especially resonated with me. Maybe that was because it was recorded at roughly the same time that our home house was first built. I love

archival coincidences. Maybe it stuck with me because it felt like the kind of cautionary tale I needed to carry with me as I reveled in the seductions of color. But it was, as I said, unexpected, having been written down by Esther Warner—a White Iowan woman who set sail for Liberia, West Africa, in 1941 with her husband, Robert. Esther and Robert had met in college in Iowa. He was a scientist and she was an artist. He was employed by Firestone, the tire company, to work in Liberia as a researcher, and she followed him there.

Liberia has an unusual history. The nation was established as a colony in the early nineteenth century to address the problem of Black Americans. Not the *problems* of Black Americans, mind you, but Black Americans as a problem for the Americas, particularly the United States. Between 1822 and 1861, over 15,000 Black people of the Americas settled there, encouraged by political leaders who could not imagine free Black people fitting into the New World. Some of the Black settlers went feeling like it was the chance to set history right, a return to the continent from which their ancestors had been so cruelly torn. But their return to West Africa created new problems for those who had been there all along. The Black Americans were installed by the US government as elites. And their English surnames, once a sign of their captivity, were treated as a matter of distinction. Upon returning to Africa, they were transformed from being seen as those who bore the badges of enslavement into colonial rulers.

Even though, as a child of the 1970s and a student of history, I knew a fair amount about the dashed hopes of post-colonialism and how it has revealed that Black people have the capacity for injustice like anyone else, it keeps striking me as astonishing that people who had been so recently enslaved could pivot into colonization and domination so quickly. Learning the history of Liberia is a lesson in the vexing complexity and always just-around-the-bend hypocrisy of human beings.

Although Liberia claimed independence from the United States

in 1847, the country was quite vulnerable. Militaristic encroachments from France and the United Kingdom steadily reduced its territory. Liberian leaders struggled to find a firm economic footing. Even with American support (and influence), it was hard to build a Black nation in a world dominated by Western empires. They were pressured— under existential threat—to make some shady deals.

In 1926, Firestone Tires set up business in Liberia. The company was rewarded with an astounding agreement: a million acres for their use at the price of six cents per acre for ninety-nine years. It proved a boon for Firestone. During World War II, the Allied powers turned to them to make the rubber for war machines quickly and cheaply. In turn, Firestone employed Native Liberians on rubber plantations. "Employ" is too polite a word, however. The Native Liberians were reduced to a status akin to slavery. As the fruits of their labor were being used to fight fascism, they were made unfree in all but name. The contradictions went even deeper. The Americo-Liberian rulers, people who had once been subject to the violence of the American plantation system, grew to be masters of the neo-plantation colonial system that served American economic interests most of all and concentrated power in their minority hands. The shared color and even shared genealogy between the captives and colonizers did little to blunt the brutality, extraction, and exploitation of Africa and her people.

WHEN ESTHER ARRIVED in Liberia, a protest movement was burgeoning. But far as I know, she didn't write about it. She did, however, write a great deal about Liberian people. Esther was fascinated by their culture, and she would ultimately refer to the country as home. Of course one has to be cautious when elite settlers claim a place as home. As a many-decades-deep student of race, and an all-my-life Black person, I was immediately skeptical of her writing about

Liberian culture. I'll admit I initially wondered, who was this White American woman to lay claim to these stories? But I read them anyway. And I felt thankful that she recorded and published them so that they were in books for me to read.

Notwithstanding the fact that these stories had been filtered through Esther, they resonated with me. And that is the tricky part. We human beings are built to love and share stories. It is one of the best ways to connect. Lore transcends difference. And yet storytellers who belong to powerful groups are reasonably met with suspicion because of how the world has been carved up and stratified. They do not speak with voices of the many but rather as members of the privileged few and usually reflect those interests. Wariness is reasonable. After all, the world being the unequal rat race that it is means that even the deepest forms of love must be watched carefully for selfishness and greed. So of course colonials who love native cultures must be too. I loved Esther's stories, and found myself wanting to retell them, especially one called "Blue Goes Down." But was I just like Esther? Maybe. Like her, I wanted to make a home inside Liberian storytelling, even though it isn't "mine" in any organic way. Perhaps that means that I also deserve to be treated skeptically. In fact, I am sure it does. I am American, Black American, as were the colonizers of Liberia. But I'm also likely a distant cousin, a descendant of one or many once stolen away. I am made of colonizer and colonized, with respect to these stories and to history itself. That strange intersection makes it hard to name my relation to people of other nations, languages, and territories, even if we belong to the same "race," according to the history of modernity. Even Ancestry.com's detailed and seductive mapping of genes by geography can't untangle all those threads; in fact, it scrambles them more. And yet I have the nerve to want to tell stories about Black in Blues that extend far beyond my national origin. And Esther Warner offered me a shot with an old story I loved about blue

in Black life. It is a folktale about the origin of indigo. According to her elegant rendering, the beautiful dye is recompense for grief. In it, a holy woman named Asi disastrously allows her child to die while she gorges herself eating the blue sky. I turned the strange details over in my head, eventually attempting to re-narrate it to earn (and learn) its lesson. I wrote at least a dozen versions, each time adding more "color" by adding in details that made it my own. Zora Neale Hurston described a cultural habit of adorning stories in her famous essay "Characteristics of Negro Expression." I seem to possess it. So here is my home-written version of "Blue Goes Down":

Back before what we call the "Norman" days—when American Blacks and their Whites came and never left—

But after the high gods had already stepped beyond human reach (our wanting ways having been too much)—

A blessed mother, Asi, was tired of her responsibilities, that have-to have-to every day from dawn to dusk.

She was resentful of the burdens of divine prognostication and virtue. Indulgently, she took a grave bite of heaven and had no one to tell her otherwise. Eating sky was supposed to be reserved for moments of piety and devotion. But Asi gorged on her own desire. Reckless, each bite was thick like stew and smooth like wine. It made her warm, delighted, and head-spun.

Lying on a cotton lappa, with her baby tucked at her side, Asi's toes pulled merrily at tall blades of grasses.

Her eyes turned fish-blue shimmer

Her body turaco-blazed azure

Tongue coated sweeter than cane juice and thicker than beach swell

To want and take was everything

With a soaked mouth, she sang wild

Floated high away from duty—no oracle, no rite, no responsibility—
Like lightning, she was stricken hot and bright,
Then glimmered: no body, not obliged, no having-to
Just sky drunkenness, beyond sated
She gulped fast, coughed on clouds, drooled rain, spiraled out
Till spent.

At midnight just shy of pitch
Asi came to. She reached to her side. Her heart shook, then dived.
The baby had rolled away like the stone, face down,
A puddle under tiny hips shone blue in the moonlight
Naver string cut now, not just once but forever
All two had breathed, now childless mother alone
Brayed and howled
She clutched the lifeless body tight
Shoved *sasabiya* beads into her eyes
Anguished, spastic freezing—she jerked to depletion.

Dawn came with the gall turned bitter-breath and her throat raw
It was unbearable
Asi reached a crooked arm up for a taste of heaven
Just a little softness, she whispered, because my baby is gone

But the sky had risen
The high gods had left her
And us once again
This time they'd taken their heavens with them

Divinity spoke in a chorus:

To hold blue now
sinew and mind must be exerted.

The ash of evening fires
shredded leaves
and tears
will be worked together.

Indigo

What was the point of this tale? Maybe the Native Liberian who told Esther the story of Asi was offering her wisdom. Maybe it was intended to warn her about the dangers of greed and irresponsibility. Maybe they hoped she would repeat it to her Firestone-employed husband, and that he, one of the bosses, might choose decency over cruelty. And if so, maybe the story is also a clue about why Esther's marriage to Robert failed. Maybe she wanted nothing to do with the greed of rubber plantations. Maybe we, I, need to remember the moral.

Having a having way about you—that is, wanting too hard— can make you do terrible things. Certainly, blue is beautiful. And so is yearning for beauty. But greed is ugly, as is any obsession over possession. And that, along with everything one might want to say about gunpowder, empire, and political economy, is at the root of how Black people became *Black*, as such, that is to say blue-black.

Oral storytelling is improvisational. Like poetry, it explodes the difference between nonfiction and fiction. Imagination, details, and knowledge are all flexible tools in service of the lesson. People, especially elders, repeat stories over and over again with purpose. In the arrogance of youth, we often think they do it because they are absent-minded. Now I know they repeat themselves because they've whittled life down into observations that should not be forgotten. They are authoring scriptures of their own.

But once a story is published, and not just spoken, it qualifies as something else: a document. And it stands alongside other docu-

ments, including the official ones that make laws and judgments, punishment and property. Some of these supplements, alternatives to official documents, are necessary to add flesh and blood, heart and soul, to what we know. They might even expose the lies of the official tales.

I clung to the story of Asi, turned it over with my imagination, and a new version to print, because it helps me remember there was a time before Black, but not before blues.

THE LAND WHERE THE
BLUES BEGAN

◇◇◇◇◇◇◇◇

In 1502, the first shipment of African slaves reached the island
of Hispaniola. As the Spanish, and then the Portuguese, the
Dutch, the French, and the English established systems of
slavery in their American colonies over the next century and a
half, the Atlantic slave trade grew from a trickle to a flood . . .
[S]lavery in the Atlantic world took on a racial definition
that identified slave status with Africans and the black
color of their skin. Over the next three and a half centuries,
approximately 10–12 million Africans survived the misery of
the middle passage to toil in the mines, plantations, factories
and households of the Western Hemisphere. Until the 1830s
more Africans than Europeans crossed the Atlantic.
—ALBERT RABOTEAU, *CANAAN LAND: A RELIGIOUS*
HISTORY OF AFRICAN AMERICANS

"IN FOURTEEN HUNDRED and Ninety-Two, Columbus sailed the
ocean blue."
 The grade school couplet is deceptively cheery. In the US we often
start here. And for several generations there has been an effort to re-

narrate that beginning and make it less romantic and more honest. In that vein, I'll call him by his native Italian name—Cristoforo Colombo—and tell you that he was overwhelmed and confused when he landed in the "New World." It was, to his mind, monstrously beautiful. Upon landing, Colombo and his mates piously and fearfully carved crosses out of tree grape branches, a wood so sugary that sea creatures liked the taste. Tree grapes grew irregular and knotty in the Caribbean, but the European sailors sliced it into symmetrical lines. Of the twenty-nine crosses they made, one remains today. It has long since been capped in metal because so many people over the years had taken bite-sized chunks out of it, carrying a bit with them for good luck.

The Europeans were surrounded in blue, sky and sea. As we all know, Colombo's trip shaped global history. The storm of feeling you have when looking out onto the water might reveal something about the past five hundred years and where your people fit into it. Wonder is a near universal response to deep rivers and vast oceans. But for some, the water also evokes terror. In it, I see God and slave ships both.

Another truth is important to remember but easy to forget. Long before the tragic world-making of the age of conquest-exploration-empire for which Colombo is symbol and synecdoche, humans were already cruel and confusing. War, theft, and domination came before the transatlantic slave trade, before Black was a race, and before Colombo was riding across the Atlantic. And as far back as the first time people wanted to possess blue, not just see it, the color was already a party to some of the worst human impulses, as well as some of the sweetest. Wanting blue was well inside human cultures by the time imperial conquest organized the world, and that desire was carried through its unfolding. Let's tarry there.

The indigo trade is an early and clear example of a global desire to harness blue beauty into personal possession. Indigo blue bound up the world's taste, and traders crisscrossed the earth on merchant pathways to satisfy the yearning for it. By the dawn of the sixteenth century,

it had been prized for hundreds of years in Africa, Asia, and Europe. Indigo wasn't the only source of blue—variations of the color were also produced by woad in England and with sea urchins by the Tuaregs, as well as by various flowers—but indigo was the most resilient and potent of them all.

Indigo doesn't just compel the eye. It attacks multiple senses. It leaves a strong scent and stiffens cotton so much that it has the texture of stale wedding cake and the firmness of a middling branch.

European explorers in West Africa, agents of the transatlantic slave trade, often noticed the predilection for and production of indigo along the African coast. In Kano, Nigeria, there are deep pits in the ground that serve as cauldrons for dyeing indigo that date as far back as the late fifteenth century. Bordered circles, they look like blue polka dots in sand from an aerial view. We can imagine that the Europeans eyed the landscape awash in blue curiously.

In his diary of 1693 Thomas Phillips, the captain of a slave ship called *Hannibal*, offered his observations of indigo use in Benin: "The women are most employ'd in making Whidaw cloths, mats, baskets, canchy, pitto. The Whidaw cloth is about two yards long, and about a quarter of a yard broad, three such being commonly joyn'd together. It is of diverse colours, but generally white and blue . . ."

Approximately a hundred years later, Mungo Park, a ruddy-faced and blue-eyed Scottish explorer in West Africa, described the method of dyeing indigo he witnessed in his book *Travels in the Interior Districts of Africa*. Park's ambition was to be a first. He wanted to be the first White man to finally travel down the Niger River to the storied city Timbuktu, the center of the Songhai empire. Timbuktu, known for elegant geometric sand-colored edifices against a blue sky, was home to a major university established in the sixteenth century. Europeans had heard tell of architecture and education there for many years, but none had reached that far into the African interior. Park failed as well. But he left documents of his efforts, including a record of learning the

Mandingo method of indigo dyeing, which began with the combination of ashes and water filtered through an earthenware pot:

> This potash called "Sai gee" was then poured over indigo leaves
> half full and left for four days with occasional stirring. After four
> days the pot would be completely filled with the sai gee and
> stirred often. The cloth was then put directly into the water to
> be dyed. Cloth had to be dipped repeatedly in the fermented
> dye, exposed briefly to the air, then re-immersed. The number
> of dippings, and the strength and freshness of the dye deter-
> mined the intensity of the resulting colour. After the dyed cloth
> had dried it was customary to beat the fabric repeatedly with
> wooden beaters, which both pressed the fabric and imparted
> a shiny glaze. In some areas additional indigo paste was beaten
> into the cloth at this stage, subsequently rubbing off on the skin
> of the wearer in a much-desired effect.

There is relatively little written documentation about indigo in the nineteenth century or earlier that comes from an African perspective. An exception is *The Interesting Narrative of the Life of Olaudah Equi-ano, or Gustavus Vassa, the African*, an autobiography that was first published in 1789 in London. It is one of the most detailed narratives we have of the transatlantic slave trade written by an African. Equiano was born in the Kingdom of Benin, into an Igbo village in the southeast portion of present-day Nigeria. He and his sister were kidnapped from their homes as children and sold to slave traders. As an adult, with the tragedy of slavery behind him, he recalled the love of blue in his early free life in Benin. He wrote:

> As our manners are simple, our luxuries are few. The dress
> of both sexes is nearly the same. It generally consists of a long
> piece of callico, or muslin, wrapped loosely round the body

somewhat in the form of a highland plaid. This is usually dyed blue, which is our favourite colour. It is extracted from a berry, and is brighter and richer than any I have seen in Europe. Besides this, our women of distinction wear golden ornaments; which they dispose with some profusion on their arms and legs. When our women are not employed with the men in tillage, their usual occupation is spinning and weaving cotton, which they afterwards dye, and make it into garments.

Craft is living history. Over time, even in its most piously traditional form, meanings must change. For example, for centuries in Yorubaland, long before colonialism and the slave trade, those who produced indigo were people who honored the deity Iya Mapo, a governess of craft. According to the Yoruba, indigo had a spiritual significance. And its cyphers are visible yet muted today. In Nigeria, a nation almost evenly divided between Christianity and Islam, traditional patterns of adire cloth are sold in Nigerian markets, a resist-dyeing method that produces fabric with dizzying geometric patterns and multiple hues of blue. According to traditional Yoruba cosmology, blue effects balance and harmony. But with the slave trade, a harrowing change came. Blue became a tool of global imbalance. Imagine being a craftsperson, fulfilling a divine purpose, exchanging your blue for other goods in a bustling market. And then one day you find your meanings turned upside down. You no longer sell or trade the blue. You yourself are sold.

A block of indigo dye could be traded for a "hand," meaning a working slave, a person made tool. Shackled, but to where? Did your sister escape? Does your father know what happened? Could it be true, what they say happens on the ships? Will you see that floating underworld for yourself? You might eye a fine indigo wrapper, so fine perhaps intended for a king, deep blue—and you experience an uncanny moment: you too are now thing, not an agent but material for

the use of rulers. Prisoner of war or prisoner of the Whites, or both—
your counted value is now equivalent to what you once mastered. That
unequivocal disorientation was one step toward what was coming in
global history: Black, not just as a color but as a way of sorting humans.
Every film in your memory bank, plus muscle memory tingling in your
restrained hands, told you it was untrue. You were more than thing.
But it would be easy to forget in hell—dark, shit, vomit, rocking, flesh
to flesh, stinking-ass disease-ridden ship bottom.

THE BEAUTY AND ingenuity of human beings often coincides with
their cruelty. Slavery was and is old, and also global. The word itself
makes the point with an etymological root in Slavic captivity. But
today slavery is associated with Black people in collective global pub-
lic memory, largely because the empires that provided the foundation
to modernity enslaved dark-skinned, coily-haired people and did so
in the service of desires for accumulation and goods. The devasta-
tion happened in waves over centuries. Estimates hover around ten
million people when it comes to the Arab African slave trade, which
began in the seventh century and by some accounts lasted until the
mid-twentieth, and as Professor Raboteau wrote, in the epigraph to
this chapter, between ten and twelve million for the later European
transatlantic slave trade. Over generations of capture, Blackness was
produced. These people, as the logic developed, in these types of bod-
ies, were to be used rather than treated as peers, construed disposable
as humans yet indispensable to the project of the modern world.

There was nothing unique about the love of indigo in the era of the
transatlantic slave trade. Nor was there anything unusual to the condi-
tion of unfreedom. But both, together, offer a window into the story
of what Black Africa would become in modernity, a continent named
from the outside gaze and coalesced underneath the seduction of trade
and the reality of violence.

It didn't have to be that way. In the Middle Ages, the people we now call Black were referred to by the English as "blew," or blue. To themselves, they were variously named: by language, faith, people, region, a continental motley. They differed by body and belief, language, ritual, and culture. The words we know now for calling them/us, a banner under which they were gathered, prescriptions for global ordering, arrived in inconsistent eruptions. "Africa" as an idea was not a foregone conclusion. The word is of uncertain and debated origin, both linguistically and historically. According to most theories, some visitors from another place made up the word, and it gained traction in the seventeenth century: perhaps a reference to the Aourigha, a Berber tribe, or Afer, a grandson of Abraham. Maybe it was a Greek description of a Yemeni leader? By other speculations, it came from within, a word born in ancient Egypt, but not as a matter of identity as much as a description of a territory that is now uncertain. Even earlier, at least in English, the term "guinea," for Black people, came directly from the Portuguese word "Guine," which emerged in the mid-fifteenth century to refer to the lands inhabited by the Guineus, a generic term for the black African people south of the Senegal River, in contrast to the "tawny" Zenaga Berbers above it. "Sudan" was an Arabic-origin word meaning "land of black people" before it was designated a country. There were other words: "Moor," "Muslim," "North African" (which sometimes meant Black from a European gaze), and "blackamoor," a slur or description, or all of the above. "Ethiopian" was once a Greek term for black-skinned peoples generally, and for people specifically from the Kingdom of Kush, one among so many others over epochs: Mali, Songhai, Nubia, Meroë, Ghana, and so on. Ethiopia (the country) was historically referred to as Abyssinia by Arab people. Both terms are in the Bibles we read in English, though we aren't certain precisely what piece of earth they mean. Simply put, the words we say now don't necessarily indicate where and what they once did. And not a one of them has ever been fixed, certain, or permanent. That is what

it means when we say "race is socially constructed." It didn't, doesn't, mean now what it always did or will. And it never has *had* to mean what's been made of it.

More important than all that is that this massive many-languaged landmass with more genetic diversity than any other continent—Africa—is where humanity and civilization began. It has been ascribed and described and diminished in multiple ways over the past five hundred plus years. Much of that description has denied its vastness and variegation. Its people and their descendants call themselves and are called by enough names to fill ten books, and we have held on to our specificity despite the pervasiveness of single signifiers like "African" and "Black." Over millennia, some of our internal distinctions have seemed incommensurable. Nevertheless, sometimes common feeling persists because history—that term of art for document-based imperial storytelling—has collected us. Even when we don't care for each other, we know we have something to do with one another. Today we can say that if "African" is too precisely geographical, and "Negro" too dated, "Black" does mean something, but what exactly is up for debate.

The truth is this: Black, as such, began ignobly—through conquering eyes. Writing that makes me wince because I hold my Black tightly, proudly even. Honesty requires a great deal of discomfort. But here's the truth: we didn't start out Black. Nor did we choose it first. Black was a hard-earned love. But through it all, the blue blues—the certainty of the brilliant sky, deep water, and melancholy—have never left us. I can attest. You might be thinking by now that this blue thing I'm talking about is mere device, a literary trick to move through historic events. And if blue weren't a conjure color, that might have been true. But, for real, the blue in Black is nothing less than truth before trope. Everybody loves blue. It is human as can be. But everybody doesn't love Black—many have hated it—and that is inhumane. If you don't already, I will make you love it with my blues song.

TRUE BLUE

◇◇◇◇◇◇◇

It is the color of ambiguous depth, of the
heavens and the abyss at once . . .
—Alexander Theroux

BABY SUGGS, THE grandmother in Toni Morrison's 1987 novel, *Beloved*, is a chastened curate: resentful, lapsed, depressed. When her hopes for a new life after slavery are dashed by tragedy, she takes to her bed and abandons the work of tending souls. Instead, she contemplates color. I remember, in 1987, when I first read that Baby Suggs says, "Blue never hurt nobody." But surely it did. The word even denotes "hurt." "Blue" has been a word for melancholy in English for centuries. The blue devils haunted people's lives. "Blue" is how pathetic drunkenness was referred to as far back as the eighteenth century. But I can understand her mistake. Blue is lovely too. Blue is contrapuntal. It is itself and its opposite: sweet and bitter.

After Baby Suggs dies, a ghost baby who was called "Beloved" on her headstone returns to their doorstep as an enfleshed woman. Her body is drenched. Beloved is an embodied sorrow—the returned dead—who has to be contended with, coming from the water. Morrison knew Black life is a sea epic—a story of encounters with deep blue. There was no other way to get us so far from where our ancestors began.

Montesquieu was the most widely cited philosopher by the Founding Fathers of the United States. He was particularly praised by James Madison for his theory of the separation of powers. It is rather straightforward to say, in retrospect, that the creation of a nation, and indeed a global order of nation-states, explicitly excluding Black people from the political community was undemocratic and unjust. Montesquieu offered a justification, however, for this approach. And it had to do with the color blue. He wrote:

> If I had to justify our right to enslave negroes, this is what I would say . . . Once the peoples of Europe had wiped out the people of America, they were obliged to enslave the peoples of Africa, because they needed someone to clear the land in America. Sugar would be too expensive if there were no slaves to cultivate the plant it comes from. The people in question are black from head to foot; and their nose is so squashed that it is almost impossible to feel sorry for them. The mind will simply not accept the idea that God, who is a very wise being, would have put a soul, especially a good soul, into a completely black body . . . The fact that negroes value glass necklaces more highly than gold ones, which are worth so much more in civilized countries, just goes to show that they have no common sense. It is impossible to believe that these people are human beings, for, if we did believe them to be human beings, we would have to wonder whether we ourselves are . . .

The most cherished of these glass necklaces that Montesquieu scoffed at were made of blue beads. Valuing beauty over scarcity indicated, according to him, a lack of civilization. He seemed to have no qualms about making human beings into chattel, however. Montesquieu believed people ought to be understood as worthy or not because of their relationship to property, not their labor, goodness,

or imagination. It is evidence of what literary critic Hortense Spillers describes as an approach of treating all differences between cultures as demanding a hierarchy. Someone always had to be better or worse. According to him, "negroes" were failures as humans because they did not understand European market logics.

These Montesquieu-mocked beads were uncommon in West Africa. The way the brilliant sun hit facet cuts, light bouncing, like fire on gleaming dark brown to blue-black skin, was stunning—a fine thing. European traders who came to West Africa brought beads with them. The ones from Venice were especially appealing to the West Africans. Millefiori beads were produced by creating flowers or stripes from glass canes that were then cut and molded onto a core of solid color. Upon purchasing the Venetian beads, African people often remade them. They broke the cylinders, then remelted, restrung, and resold them. The beads were worn in hair, used in spiritual rituals, and held as a mark of status.

The beads were traded for indigo, ivory, and other goods, including an investment: human beings. On outbound trips from Europe, beads could be used as ballast and then replaced by bodies for the next leg of the triangle trade. As with indigo, the trade in beads was a chink in the armor of humanity—a way for a person to be made a thing. It is perhaps strange or even ironic then that among the captive investments—the people who were traded for beads—beads were often the sole possessions they retained on their journeys across the ocean. Stripped naked but for a bead or a few strung around their necks or wrists, a most delicate and fragile reminder of their humanity. Though subject to the greatest degree of human disregard possible, they were people who could sometimes still cherish small goods though they themselves were bought. After arguments, assessments, and finally written promises were exchanged, the contractual obligations on each side were established. The Europeans believed they were getting a

good deal. Moreover, the investment in a human and their labor could potentially yield wealth that might be carried on over centuries as long as the Africans and their descendants survived. And so, before boarding the slaves on the ship, their bodies were examined. Captain Thomas Phillips described this process in detail:

> [Yo]ur surgeon examin'd them well in all kinds, to see that they were sound wind and limb, making them jump, stretch out their arms swiftly, looking in their mouths to judge their age; for the cappasheirs are so cunning, that they shave them all close before we see them, so that let them never be so old we see no grey hairs in their heads or beards; and then having liquor'd them well and sleek with palm oil, 'tis no easy matter to know an old one from a middle-age one, but by the teeths decay; but our greatest care of all is to buy none that are pox'd, lest they should infect the rest aboard . . . and that distemper which they call the yaws, is very common here, and discovers itself by almost the same symptoms as the . . . clap does with us; therefore our surgeon is forc'd to examine the privities of both men and women, with the nicest scrutiny . . .

Examination complete, five or six people at a time were rowed from the coast to the ship. It was a mile and a half offshore. The whole process took over a month. The *Hannibal* eventually set sail with seven hundred enslaved people. Hot irons in the shape of the letter *H*, red, were stuck on their shoulders. The scar turned black, white, crisped over, rubbed with palm oil. *H* for *Hannibal*. The wounded flesh defined the body as chattel. Crushed into a conceptual and literal hold, the people were chained by wrist and leg. A bead or two let the captives know they were still people.

The casual nature of the violence Phillips described on board is astonishing. However, he considered himself less cruel than some others and reported himself as such:

> I have been inform'd that some commanders have cut off the legs or arms of the most willful, to terrify the rest, for they believe if they lose a member, they cannot return home again: I was advis'd by some of my officers to do the same, but I could not be persuaded to entertain the least thoughts of it, much less to put in practice such barbarity and cruelty to poor creatures, who, excepting their want of Christianity and true religion, (their misfortune more than fault) are as much the works of God's hands, and no doubt as dear to him as ourselves; nor can I imagine why they should be despis'd for their colour, being what they cannot help, and the effect of the climate it has pleas'd God to appoint them. I can't think there is any instrinsick value in one colour more than another, nor that white is better than black.

And yet, even acknowledging the arbitrary nature of color, he was a slave ship captain. Oddly, he seemed to be bewildered by the assessments of the human cargo when it came to their fortunes. They leaped out of canoes and ships, held themselves under the water when attempts at rescue were made. "They having a more dreadful apprehension of Barbadoes . . . than we can have of hell"—but he couldn't figure why, believing slavery in Barbadoes had to be better than freedom in their homes.

I do wonder. How could he have believed that they would live better in the strange and brutal slave society—Barbados—than their own country? He had to have a belief in place that contradicted good sense, one in which Africa was always already inferior and

barely tolerable. This fiction justified the evil enterprise, including the deaths on board that hungry sharks learned to gather for.

Slave ships changed ecosystems. Blue-green tiger sharks, with stripes along their sides, took to the taste of human bodies. Tiger sharks will eat anything. Some people chose that end over the hell ship, diving with the belief that the afterlife would restore them to belonging and, better yet, home. There was good reason to escape life. The Middle Passage was a terrible journey through a blue netherworld. I have wondered about the ones who leaped, or were thrown to their deaths, or after death, overboard, ravaged bodies with hollowed eyes flying off the deck, through the air, into ocean. What did they see in all that blue? Perhaps Africans thought you returned to Africa upon death because the ships were essentially caskets. One death was a ship ride to slavery; the other might take you back to an eternal or alternative life. The horror of this Middle Passage was captured in a popular sea shanty: "Beware, beware the Bight of Benin, one comes out where fifty went in." It was an exaggeration. But the actual numbers of the *Hannibal* are a terror. Of the seven hundred enslaved, only 372 survived the passage from West Africa to Barbados. Over forty members of the crew died as well—some in a sea battle with a French man-of-war, others from illness on board and corporal punishment. The dead crew members were named. The Africans were simply enumerated. And owners were remunerated for their loss.

For the survivors, it was a "voyage through death / to life upon these shores," as the poet Robert Hayden described it. The journey was horror turned lore, leaving bones littered on the floor of the Atlantic. Once upon a time, people of hundreds of tongues and hues, blue-black to yellow-brown, were locked inside a moving crypt riding on deep waters as they were becoming something not of their own making. Ritually they were let out for "recreation," to dance or sing

for the captains and crew, and to keep them alive enough to be sold once they reached land. That was regular humiliation. There were also bigger tragedies. Some ships flooded. Under the hot sun with inadequate water, sometimes they all baked.

THE *HANNIBAL*, NAMED after a biblical African king, originated in London. The *True Blue*—in contrast—started out in Liverpool. Its name came from an old expression. "True blue" is a term for dependable honesty. It is thought to come from the quality of woad dyeing that came from Coventry in England. It was a "true blue," meaning reliably colored. Although woad grew better in cold climes, it was not as colorfast as indigo. At first, European powers tried to stave off the appeal of indigo. In the late sixteenth and early seventeenth centuries, laws were passed in Germany and France to prohibit the dye that was then primarily imported from Asia. Once European nations established secure settlements in the Americas, a ship with a name that came from the old dye was a vehicle for the new one and other lucrative crops of the New World.

The *True Blue* took fifteen voyages from 1751 to 1774, traveling between Liverpool, Benin, Sierra Leone, Anomabu, Jamaica, Dominica, Barbados, and Virginia. In November of 1758, the *True Blue* left Liverpool for West Africa. It departed for the Caribbean in May of 1759, after purchasing people in Anomabu first and the Gold Coast second, and then arrived in Maryland on August 16. The passengers spent ninety-three days in the Middle Passage. They intended to carry four hundred slaves, but only obtained 276. Thirty-eight of them died during the voyage. This statistic makes it sound better than the *Hannibal*. That's probably deceptive. It was all terrible.

That cargo was sold in Nanjemoy, Maryland, by a man named John Taylor II, to planters who came to buy from Virginia. There

weren't taxes on buying humans in Maryland, so it was worth traveling some distance to acquire them.

This voyage of the *True Blue* was stacked tragedy. The European crew members were impressed, meaning forced into service. They were hungry. They were sick. They were beaten. The human chattel were far worse off. And this was part of how Blackness was made into the category of "the least of these." It was never that others wouldn't suffer. It was that Black people were designated as those who would suffer worst, and the others who suffered mightily but not so badly could feel both terror and relief at being close to Black life but not of it. Resentment was felt too. The crew worked for the slave trade. They didn't make much money. And in the Americas, the presence of the enslaved would suppress the wages of the poor but free. Their labor would be worth *less*. It must have been unsettling to be so close to captivity and to have such a vulnerable freedom. It must have soured potential stirrings of sympathy into bitter gall.

James Field Stanfield was a sailor aboard the *True Blue* in a 1775 voyage from West Africa to Jamaica and then Liverpool. Stanfield was an Irishman, educated for the priesthood in France and therefore more literate than most crew members. He left behind a detailed record of his time aboard the *True Blue*, in letters and verse. Eventually, he became an abolitionist. Historians have cited his descriptions of the horrors of the trade for Africans. He called the slave ship a "floating dungeon," but his descriptions of the travails of the crew are noteworthy as well. Stanfield wrote in one of a series of letters to abolitionist Thomas Clarkson that at the beginning of the voyage from England, the treatment of seamen was standard and their provisions adequate, but once farther out to sea

and there is no moral possibility of defection, or application of justice, then the scene is shifted. Their ration of provisions is

shortened to the very verge of famine; their allowance of water lessened to the extreme of existence; nothing but incessant labour, a burning climate, unremitting cruelty, and ever species of oppression is before them.

This was more than savings; it was cruelty.

While our captain was placing buoys and other directions on the dangerous bar of the river, for the purpose of crossing it, he used to order the men to be flogged without an imputation of the smallest crime . . . It was his common practice to call his cabin-boy to him, and without any, the smallest provocation, to tear his face, ears and neck, in the most brutal manner. I have seen him thrust his fingers in his mouth and force them against the inside of his cheek till the wound appeared on the outside of the same . . .

He went on to recount other abuses.

While all this horror and disease were preying on the lives of the poor seamen, the business of purchasing, messing the slaves, and every circumstance relative to the trade, was transacting with as little interruption, and as much unconcern, as if no such people had ever been on board.

It is simple to say the slave trade was a massive injustice. It is more complicated and harrowing to understand the cruelty was meted out in degrees as a form of security. Those Africans held in the bottom of the ship were deeper in hell than the crew. But the crew had their own private hell as well. Whiteness did not ensure comfort, or decent treatment, or fairness, or even life. Simply not being at the very bottom, to have one's name called and counted: that could be very little, but also

so much given the alternative. And something else made Whiteness even more appealing; it meant there was a remote yet real possibility of becoming a captain, one who punished instead of being punished. It was sinister to make that the desire. But dominating others seemed to be the safest bet to avoid suffering. If White, it was possible, if not probable, to become someone who gathered up bodies in exchange for money and comfort. Whiteness was possibility itself. A true-blue truth. Blackness was gaining a truth too. In the eighteenth-century Americas, it meant to be documented as *thing* instead of person, with rare exception. A rough approximation of the value of your existence was made in nameless ledgers, all for the sake of risk and investment.

But that fate wasn't quietly accepted. There were repeated insurrections. In 1769, the fourth mate of the *True Blue* described one aboard that ship in which captured Africans from Anomabu cast some of their captors overboard, and maimed others. The insurrectionists found their victory thwarted however for two reasons. The first is that they lost their sense of direction. The second is that their ship was captured by another, which was populated by both Africans and Europeans traveling from Wydah. The insurrectionists "were soon overpowered, and they instantly ripped open the belly of him who acted on board as captain and cut off the hands of three or four others; all the rest were taken to Wydah and sold to a Frenchman." The heart-wrenching and bloody vignette has a simple moral. At the moment of insurrection, the resisters were Black, but also, they were not. Yes, they were Black from the European gaze that determined they had the bodies that marked them as appropriate for enslavement, and they—Black people—refused the status. But they were not yet Black in terms of having a sense of belonging to one another. Hence, their defeat took place at the hands of both Africans and Europeans. My point here is not the hackneyed formulation that "Africans sold themselves." In fact, that quip makes no sense because back then they—the "Africans" or "the Blacks"—did not fit tidily under such designations. They were

peoples, plural. By no rational measure were they of a single group or status. They possessed a plethora of languages, traditions, and phenotypes. The truth is that the multitudes of people of various ancestries and communities of sub-Saharan Africa did not become Black all at once, and when they did, it was under terrible duress. It happened, tide-like, through waves of terror and reckoning that nevertheless led to a realization of the very human capacity to self-create amid chaos. With lives wrecked by ships, lashes, and bullets, this classification of the body became a category of destruction, yet ultimately and miraculously also birthed new selves.

Consider this becoming Black, then, both a parable and a process, one within which people, assorted in every way, gathered. It is interesting that the color that best teaches this lesson is not black or brown or yellow or milky—all the colors Black people come in. It is blue, with its hues of melancholy and wonder.

ANTIGUA, SOUTH CAROLINA, MONTSERRAT

◇◇◇◇◇◇◇◇

THE MASTERS OF neighboring plantations laughed at the girl. Eliza Lucas came to South Carolina from Antigua, where she was daughter of the English lieutenant governor, who was also a wealthy planter. She and her sister arrived in 1738, when Eliza was just sixteen years old. They took residence at their father's low-country Wappoo plantation just three miles outside of Charleston. Eliza had been educated beyond what was standard for a European girl at the time, and her passionate interest in botany was indulged. She was one of many who carried Old World tastes into New World hopes for prosperity. Aware of the recent success of indigo in another part of the Americas, Guatemala, she intended to make Wappoo an indigo plantation. Past was prologue, even in history. Eliza looked forward based upon what she knew of what goods would prosper. But after several seasons, her experiments had consistently failed. Those who mocked her believed that Eliza's aspirations exceeded her ability. Their confidence waned further when an overseer hired from Montserrat, where indigo had also been successfully grown, couldn't (or perhaps wouldn't) help her. Eliza remained diligent. Her father sent

her another man, an enslaved Black one from an unspecified French island, perhaps Guadeloupe or Saint-Domingue. This man taught her how to cultivate indigo successfully. His name was not recorded. That was part of making race—for the enslaved to become mere appendages to the successes of masters.

Eliza kept detailed records of her own achievement, which we can now use to tell history. She sent a sample of the dye she produced to England. It was well received, and soon she was in business.

Eliza married a successful planter named Charles Pinckney after his wife died. His wife had been Eliza's friend, and also named Eliza. And so the indigo-dyeing Eliza became the second Eliza Pinckney. Though she stepped into her predecessor's title, she also breached its norms. He was forty-five, and she was twenty-two. She gave birth to four children who became South Carolina gentry. But she is best remembered for indigo.

Much about indigo cultivation remained the same in the New World as in traditional cultures. But of course forced unfree labor has a different meaning from the work of a community that sustains traditional ways of craft. It was not divine. It was cruel. Once the indigo was planted and grew for a spring harvest, it had to be cut, stacked, and taken to vats, where it was placed in heated water, all work performed by the enslaved. Inside the vats, the indigo crop was weighed down to steep. It stank terribly, attracting bugs and flies and, of course, viruses. Cattle and unfree workers fell ill. Sick, the enslaved steadily stirred the hot liquid as it turned varying shades of blue. The liquid was strained, and in the next vat it was oxidized and beaten before the addition of limewater. The stench grew worse. Sediment rose to the tops of those vats, and was skimmed off. That was the dye. It was dried, cured, and cut into blocks for sale.

The process lasted all summer into early fall. Brown arms were dyed blue, sometimes permanently, like a tattoo of bondage.

Though Eliza Lucas is credited with bringing indigo to South

Carolina, its proliferation arguably has more to do with Moses Lindo, an English merchant who arrived in Charleston in 1756. He'd been enchanted by the indigo he'd seen on the royal exchange and decided to seek his fortune at the source. In South Carolina, Lindo became the inspector general of indigo. He bought and sold the dye, as well as coffee. But indigo was his specialty. Lindo owned people who worked the crop—that was his domestic situation. And he promoted every step of the process, from planting to merchandizing—that was his public influence. It was all a part of how he made his wealth and his place in history. Though its production was incredibly difficult for the enslaved indigo workers, it proved so lucrative for the property owners that they decided all the suffering was worth it. Over the course of eighteen years, Lindo led the American colonial production of indigo to an increase of more than a million pounds annually before the indigo trade began to collapse in the States—competition being what it was.

Something fascinating emerged. Although the market for blue was part of the suffering of the enslaved, the color also remained a source of pleasure for them, and that too is an important detail in this story. Some tastes were retained across the Middle Passage. For example, in several West African cultures, it was traditional that, after a vat of dye had been used up, villagers used the remaining sludge to color their doors and windows. And in South Carolina, similarly, it became traditional for walls and ceilings to be painted blue with indigo like heaven. The people, now Black, believed the color could chase some hauntings and evil away. It certainly meant that, laws and ways notwithstanding, they were not mere chattel, and their lives would not be only joyless burden.

An eighteenth-century English textile trader, Isaac Hazard, was astonished by how much planters deferred to the aesthetic desires of enslaved people when it came to attire—and in particular their insistence on the color blue. He observed, "We have little Idea how particular such persons are in purchasing for their Negroes. It appears they would

sooner purchase an article for their own use that did not exactly suit than for their Negroes." The fabric, he noted, "must be very thick and stout or the negroes will complain." And color mattered. "It must be blue or their negro woman would not have it," he reported. This consideration of the sartorial desires of enslaved people wasn't universal, however. State legislatures, in fact, could be quite strict about how enslaved Black people dressed. It was one way of marking their status as inferior. In 1735, for example, the South Carolina sumptuary law forbade the majority of slaves from wearing their owners' old clothes. Only those who drove carriages or worked as butlers could wear nice items. The rest were restricted from wearing anything "finer, other, or of greater value than negro cloth, duffils, kerseys, osnabrigs, blue linen, check linen or coarse garlix, or callicoes, checked cottons, or Scotch plaids."

However stringent, sumptuary laws were difficult to enforce. Slaveholders often used clothing as a system of reward, and some simply violated the law to maintain their own plantation-based order and stratification. The pieces of evidence we have about the varied clothing of enslaved people show that blue was a consistently desirable color for unfree Black people in the Americas. Runaway notices attest. In one, Alexander Warfield, of Anne Arundel County, Maryland, offered eighty silver dollars' reward for the return of the runaways Dick and Lucy. Both had taken sumptuous clothing in their escape. Dick had "a green cloth coat, with a crimson velvet cape . . . a deep blue camblet jacket, with gold lace at the sleeves, down the breast and round the collar" and "a pair of pumps and buckles, with sundry other cloaths" along with more mundane items. While Lucy "had with her two calico gowns, one purple and white, the other red and white, a deep blue moreens petticoat, two white country cotton do, a striped do, and jacket, and black silk bonnet, a variety of handkerchiefs and ruffles, two lawn aprons, two Irish linen do, a pair of high heel shoes, a pair of kid gloves and a pair of silk mitts, a blue sarsanet handkerchief, trim'd with gauze, with white ribbon sew'd to it, several

white linen shirts, osnabrigs for two do, hempen rolles petticoat, with several other things . . ."

We often think, and reasonably so, that the condition of the enslaved is one of indistinction and disregard. But taste and even idiosyncrasy show both collective and personal self-regard. The enslaved fashioned themselves with care, even as their lives were considered fungible and not their own. This sense of self that existed, even when wholly dispossessed and literally being the legal property of another, became a feature of what it was to be Black in the New World.

As time went on, and cotton became the leading crop associated with plantation slavery, the designation "negro cloth" referred specifically to the roughest weaves of cotton. In the first three decades of the nineteenth century, US cotton exports exploded from approximately one hundred thousand bales to over a million. Cotton was produced by the enslaved, and it also clothed them. Denim was sturdy and durable, and it was dyed with indigo because of how colorfast—or how *true*—the dye was. It kept its appearance through the roughness of labor.

Indigo crossed status and color, worn by slave and elites across the globe—even as the texture, warp, and weave of the fabric worn depended on the status of the wearer. During the Napoleonic Wars (1803–1815), for example, when Great Britain created a blockade that made it impossible for France to import indigo from Asia (and it had already lost Haiti as a source in that country's revolution), Napoleon offered a reward of a million francs to anyone who could find a way to make woad dye as good as indigo. They tried for a few years, but it never could compete, so France ultimately switched to using red for military uniforms. In the United States, Brooks Brothers, the luxury clothier founded in Manhattan in 1818, clothed enslaved foot- and coachmen as well as presidents in their signature blue. A blue label was sewn in at the neck of all their frock coats and blazers, humblest to finest.

And blue was made by Black hands for Black pleasure. While the bulk of enslaved people received very basic allotments of clothing, some learned to weave and dye cloth for their own use, and that revealed tastes and dispositions as well. In an interview conducted after emancipation, Millie Evans, a woman who was enslaved as a child in Arkansas, described the process she learned:

> We planted indigo and hit growed just like what. When hit got ripe we gathered hit an we would put hit in a barrel an let hit soak bout er week den we would take de indigo stems out an squeeze all de juice outn dem, put de juice back in de barrel an let hit stay dere bout nother week, den we jes stirred an stirred one whole day. We let hit set three or four days den drained de water offn hit an dat left de settlings an de settlings wuz blueing jes like we have dese days. We cut ours in little blocks. Den we dyed clothes wid hit. We had purty blue cloth. De way we set de color we put alumn in hit. Dat make de color stay right dere." Another woman, Josephine Bristow, who had been enslaved in South Carolina recalled: "De people used to spin en weave, my Lord! Like today it cloudy en rainy, dey couldn't work in de field en would have to spin dat day . . . Old time people used to have a kind of dye dey called indigo and dey would color de cloth just as pretty as you ever did see.

Even enduring the harsh labor conditions of slavery wasn't enough to prevent the desire for, and creation of, something pretty with which to adorn the body. Testifying to this, after freedom, was itself a way to keep a record of who they were, and had been, beyond the ledgers and the official records of labor.

A woman named Frances Willingham who was enslaved in Twiggs County, Georgia, fondly remembered blue as her bridal color: "When I married Bob Willin'ham, I sho' had a nice weddin'. I was

married in a blue merino dress. My underskirt was white as snow wid trimmin's on it. I wore long drawers what was trimmed fancy at de bottom." The Willinghams weren't legally married according to the laws of slavery. They jumped the broom, a ritual in the stead of recognition. But they were married according to their own definitions, and she was pretty in blue. Slavery could have taken her husband with a bill of sale or a zealous punishment—law was no respecter of Black life—but it could never have taken that moment of beauty and love from her memory.

Sometimes color was a passionate effort to transgress the antebellum limits that were imposed on Black people who were noncitizens, regardless of whether they were slave or free. In an anonymous 1844 account of the balls held by the free Black population of Antigua, Eliza Lucas's home island, a European observer noted: "The dress of the gentlemen consists of a blue, brown, or purple coat . . . with velvet collar, and shining brass buttons; pantaloons, which would rival in whiteness the snows of great St. Bernard; a many coloured vest, a very smart cravat, silk stockings, and well-polished pumps or fancy boots, with tassels."

The attire of the women was even more elaborate:

Their favourite colours are pink, blue, and bright yellow, and of these their dresses are generally composed; but the manner in which these several shades are arranged defies all description. For example—a dress of white gauze or net, over a yellow slip, is profusely decorated with quillings of blue ribbon, interspersed with red flowers; or perhaps a blue dress is ornamented with green trimmings.

The White writer expressed amusement at the excesses of the Antiguans. They exceeded what he considered appropriate taste and station. It was funny, to him, that they dared revel in adornment.

Reading past his scorn, I am delighted by the pleasure they took in fancy dress. They weren't meant to find themselves so deserving, according to the making of race. Nevertheless, they did.

JAMES WASHINGTON, BORN into slavery in 1854 in Mississippi, would remember a dress his mother wore when he was just a child, many years later. He said of it: "It wus blue en had picturs uf gourds in it en mammy sed I wus 3 years old when she hed dat dress." I wonder if the gourds were of her own design. Gourds, the plants that hung thick and round from trees, were both African and Southern. Nights intended for running away from slavery were ornamented with the song "Follow the Drinking Gourd." The words referred to the constellations that shone in the midnight blue sky. Their shape would guide fugitives to freedom.

THERE WAS A relation between the habits that the enslaved held on to for themselves—habits that anchored them spiritually, as well as ones that met desires and allowed for people to mark themselves as individuals and bring some joy and laughter and delight into the day-to-day—and the ability to hope. Self-regard takes many forms, and it is the precondition for seeing to a future not yet realized but deeply yearned for—that is freedom. These traces of blue are evidence.

In the ground where enslaved people's bones rest in unmarked graves, to this day archaeologists find beads. Many of them are blue. It is believed that for some the burial beads were adornment and for others a form of spiritual protection. A formerly enslaved woman named Martha described the beads this way: "Dem blue and white beads what de grown 'oman's wore was jus' to look pretty. Dey never meant nothing else." But in that demurral to me it sounds that perhaps they did mean something more. Liza Smith, born in Richmond,

Virginia, said, "All de men and women wore charms, something like beads, and if dey was good or not I don't know, but we didn't have no bad diseases like after dey set us free." Whereas a man named Alec Pope stated: "Some [slaves] wore some sort of beads 'round deir necks to keep sickness away and dat's all I calls to mind 'bout dat charm business."

Beliefs changed. They always do with time. The encounter with the power of empires, the law of slavery, and other people—from the Americas, Africa, and Europe—as well as the conditions of their local environment and their literal captivity, meant that the ancestral beliefs could never have been expected to remain wholly intact. No wonder that the matter of the beads is indeterminate. But regardless of the precise reason, these Black people were buried with adornment and other small personal possessions, and that matters. These people who made lives and loved despite their condition took their necklaces to an afterlife, which was imagined—we can surmise—in a variety of ways. We know through the record of African American spirituals that once Christianity was adopted, the people believed in, or at least hoped for, a sweeter life after death. But regardless of the particulars of their faiths (and there were others—Islam, hoodoo, Vodou, Santeria, and more), they carried precious things with them from this life to the other side, meaning that despite all hardship, enough life had been lived *here*, on this side of the veil, to warrant holding on to a little bit of it.

SAINT-DOMINGUE AND HAITI

◇◇◇◇◇◇◇◇

WITHOUT A PORTRAIT, you just have to imagine Julien Raimond's face. And color. He was, in the human taxonomy of colonial Saint-Domingue, un quarteron—one-fourth African, and more generally described as a member of the "gens de coleur," meaning of partial African descent but not the blackest, perhaps light brown, perhaps near white. And he was wealthy.

Raimond owned an indigo plantation in the countryside and the over one hundred people who worked on it. The child of a Frenchman and a brown-skinned woman, he was born into prosperity in 1744. And he was not alone. Forty-seven percent of the free population in Saint-Domingue in his time was "of color," and they owned approximately one-third of the land. A number of them owned indigo plantations, and many were the acknowledged children of French landowners. Yet despite being legally recognized as the children of French men, these gens de coleur were not considered legitimate French citizens. Yes, they were enslavers, but they were not White. This distinction was exploited for power on the island. The Caribbean-born but fully European French people insisted upon legislative categorizations that separated them from their darker brethren.

Saint-Domingue was then known as the "jewel of the Antilles." Beautiful and prosperous, it was a powerhouse producer of sugar, coffee, rum, indigo, molasses, and timber, a small place with a global reach. For Raimond and others like him, this prosperity was both rewarding and vexing. There was a cap to how much they could reap from the slave society because of their mothers, women of African descent whose membership in the disfavored race they carried despite the bounty of their fathers' wealth.

Raimond was both civically minded and economically self-interested. In 1784, he traveled to France to testify to the injustice meted out to the gens de coleur by the hands of the colonial government. Over a decade, he published two dozen political pamphlets in France. In one, "Observations on the Origin and Progression of the White Colonists' Prejudice against Men of Color," he authored a history of the prejudice experienced by his class on Saint-Domingue. Why ought color matter when the meaningful difference—as far as he was concerned—was slave and free? And he appeared—then—to be comfortable with the order of the slave society, despite the fact that he was inspired by the universal language of the Declaration of the Rights of Man and of the City adopted during the French Revolution, which held that human rights were universal. Raimond argued that full legal recognition must be accorded the gens de coleur but not the Black people. He was not alone, of course, in seeing no necessary conflict between slavery and democracy—the Americas were built that way. But it is striking when it comes from someone whose vexing genealogy and mixed status—free but not citizen—were a consequence of the law and culture of slavery.

However, Raimond joined a group called Amis des Noirs in 1789. That organization had taken an official position against the slave trade in the colonies. And though Raimond was still a slaveholder, he began to find their arguments about the indecency of holding human beings

in bondage compelling. Over the course of a year, he grew invested in the ideal of liberty. His essays changed. They gradually read less like those of a plantation owner simply seeking recognition despite his race, and more like someone fighting for liberty, generally speaking, for those of his color and darker. In August of 1790, Raimond emancipated his slaves and began to commit to the ideal of abolition.

As the political arguments of the Amis des Noirs gained attention and traction in Paris, backlash was swift. In 1791, one of their leaders—Vincent Ogé, a Bordeaux-educated coffee merchant and mixed-race slaveholder—was executed. A few months later, in May, the French Assembly granted free people of color suffrage rights. It was intended as a concession to quell the protests of the gens de coleur, but the spirit of liberty couldn't be easily contained. It excited and inspired the enslaved. That summer, the insurrection that fomented revolution began.

Raimond, though heartened by the change in his legal status, and growing in his belief of the virtue of abolition, was not immediately a revolutionary. As revolt grew around him, however, so did his courage and passion. In 1793, he wrote a pamphlet demanding the immediate abolition of slavery in all French colonies. Soon thereafter, Raimond was arrested and charged with causing discord in Saint-Domingue. He was incarcerated for fourteen months. Captivity was his watershed. Upon his release, Raimond joined forces with Toussaint L'Ouverture, the hero of the revolution. Rather than appealing to France for recognition, he was now fighting for the island nation. One of ten men, Raimond participated in the drafting of the Constitution of 1801 for a free Saint-Domingue, the nation that would be known as Haiti.

A slaveholder, an elite, formally learned, and likely only slightly brown, Raimond recognized in the end that race *did* matter in the modern world and the age of revolution, despite his and his peers' initial best efforts to be French. His fate was linked to that of his

property, despite the gap in their color and status. Halfway free, he determined, wasn't free enough. He wouldn't be the last to come to this conclusion.

Jean-Jacques Dessalines was called, at first, by the surname Duclos, which belonged to the man who owned him and the plantation on which he worked. He labored in the sugarcane fields and, having commanded respect, rose to the level of foreman on the Duclos plantation. In adulthood, he was sold to a gen de coleur who affixed his own surname to Jean-Jacques: Dessalines. And it is the name he kept, even after freeing himself. Dessalines is storied for his military leadership in the Haitian Revolution. Less well-known is the woman who trained Dessalines as a warrior. She was known as both Victoria Montou and Abdaraya Toya. Here we will call her Toya.

Toya was a midwife and a military woman. She had been a soldier in the West African kingdom of Dahomey before being captured and brought across the water into slavery. Her rank in Dahomey is not known. But she certainly wore blue. Dahomey hunters, called Gbeto, were attired in blue shorts with brown blouses, while the riflewomen, the Gulohento, wore blue blouses and white and blue shorts. They carried rifles as well as banana-leaf belts filled with cartridges. Experts in close combat, they also carried swords and spears. Archers, the Gohento, wore blue tunics and white skullcaps decorated with blue caimans. Gohento shot with poisoned arrows, and once they'd felled their targets, they carried the dead and wounded to burial or slavery.

In Saint-Domingue, Toya maintained her military prowess and a feature of her previous blue-toned life: an indigo knife was always strapped through her waistband. Jean-Jacques called her Matant, or Auntie. In his youth, on the Duclos plantation, she trained Jean-Jacques in hand-to-hand combat and knife throwing. In the revolution, she trained his men as Dessalines took his place as a commander. She took up arms as well. When the revolution was

victorious, Toya was granted the honorific Duchess by the leaders and lived in Jean-Jacques Dessalines's home. Jean-Jacques's former master was taken into the residence as well, and offered a job. Jean-Jacques was a man made a slave, and then a slave made into a master. And his revered aunt gave him the necessary courage and skill to make that transformation. Upon her death in 1805, she was given a state funeral, complete with a procession of sergeants as her pall-bearers.

Blue clothing and indigo cultivation were to be expected as part of the material culture of the Haitian Revolution. As we've already contemplated, indigo was loved the world over. Blues were everywhere. Azure was the color of the heavens to which the French soldiers prayed for their victory. And Marian blue would have been invoked with every rosary asking for the holy mother's grace as they were steadily defeated by the enslaved. But we also know that blue took on particular meanings in specific contexts. On the revolutionary side, it was a color of Black self-adornment in the face of disregard. It reflected tastes retained across the oceans. And blue had an array of symbolic spiritual meanings. In this context, the spiritual resonance of blue came through the particular theology of Saint-Domingue: Vodou.

In addition to military efficacy, intelligence, and a deep determination to be free, Vodou is considered by some to be an essential element in the success of the Haitian Revolution. It is a spiritual tradition rooted in West African theologies that developed in colonial Saint-Domingue and have been sustained throughout Haitian culture and history. Vodou, like other New World African theologies, is the product of people from distinct traditions encountering each other in a new context facing sharp spiritual crises—most dramatically that of having been made unfree.

Spirituality was an integral part of slave revolt across the Americas. For example, in Jamaica, a woman named Nanny led a Maroon colony

of escaped Africans up in the Blue Mountains. She is said to have practiced Obeah, a syncretic African religion. In Virginia, insurrectionist leader Nat Turner was led by divine visions and served as a preacher. And in Saint-Domingue, Dutty Boukman, a houngan (the Vodou name for a priest), would be a spiritual and political leader of the revolt. Boukman had been captured in Africa, and was first enslaved in Jamaica before arriving in Saint Dominque. It was where he attended a historic Vodou ceremony at Bois Caïman (Alligator Forest) under the cover of night. As the story goes, in August of 1791, worshippers in those woods made a pact with Erzulie Dantor—a deity in the Vodou pantheon who dresses in blue. She would usher them through liberation in exchange for devotion. The pact was sealed with the dance of a local priestess named Cécile Fatiman. It promised them freedom.

Boukman stepped into history as a spiritual leader of the enslaved people. His proclamations of the right to emancipation spread quickly, fomenting and sustaining revolt. French forces, eager to squash the rebellion, killed Dutty Boukman in short order. In November, they displayed his chopped-off head on a stake. But rather than strike fear, as they'd hoped, it seemed to deepen the resolve of the revolutionaries. And that is unsurprising. If a people believe that fighting for freedom is divinely ordained, death can't snuff it out.

The insurrectionists used military and political strategy, of course, but they also relied upon the testimony of Boukman and called upon the Vodou pantheon of deities—loas—throughout the battle for their freedom.

Husband-and-wife loas Agwe and Sirene were most invoked in the revolution, and both their traditional colors are blue. The Africans who were killed by the French in the fight for freedom were believed to be carried by Agwe through the blue waters to life after death in Guine—the nineteenth-century term for Africa in Saint-Domingue. You see, death was no end, and a return to Africa was the promised reward for revolt, even if one didn't survive to see a free Saint-Domingue.

To curry favor with Agwe, the freedom fighters sent offerings of food and drink out to the water surrounding the island nation. For Sirene, more particular items were required: watery fruits, and cakes with decorative icing of blue and green, and bursts of flowers. Imagine these humble altars floating between French ships. Tender and small bounties of human care on one side and heavy artillery on the other, yet against all odds, the loas and their people prevailed. Victory would be sweet if terribly achieved.

As the revolution came to an end, believers said the divine couple drove the French into the ocean, back where they came from. In February of 1803, the political leader of the gens de coleur, Alexandre Pétion, and Jean-Jacques Dessalines, leader of the Black people, together decided to make their declaration of independence. On May 18, at their congressional gathering, Dessalines held a French flag—red, white, and blue—aloft. He ripped it into three sections, discarding the white at the center. The red and blue stripes were resewn together, and "freedom or death" was inscribed on this newly stitched banner. Some sources say the red represented the gens de coleur and the blue, the Black people. Together.

Haiti has suffered. The first free Black republic was punished for its valor. The debt imposed upon it in exchange for a too-meager and inconsistent political recognition has kept it beholden to France, and along with that, it has born the weight of the US empire's strategic investments and habitual efforts at military control. Internally, color and caste continued to matter long after the French were gone. Raimond changed, but the legacy of that plantation hierarchy is felt even today.

Some of his class, caste, and time who maintained loyalty to France, or at least to their own prosperity, escaped from the revolution to Louisiana. The Louisiana Purchase in 1803, which brought the French colony into the United States, can be described as a casu-

alty of the imminent French defeat in Haiti, which led to the establishment of the first free Black republic in 1804. The gens de coleur who abandoned Saint-Domingue and the prospect of a free Haiti left behind their indigo plantations. Upon arrival in Louisiana, however, that blue color that had been the source of their wealth could still be found on some local plantations but also in the Louisiana irises that lined the riverbank and the eyes of the lightest among them. The gens de coleur of Saint-Domingue were enfolded into Louisiana communities with people who shared their French surnames and mixed genealogical ancestries. But under Anglo authority now, their intermediate statuses—elites but not sovereign citizens—were less secure than they had been on their island home.

The population of New Orleans doubled in the first decade after its acquisition by the United States. And the population of free people of color tripled. George Washington Cable's 1880 novel, *The Grandissimes*, depicted this complicated historic period with painstaking attention to the architecture of class, color, and culture. Cable was a White man from New Orleans who believed in racial equality and wrote novels and essays to that end. When he published *The Grandissimes*, the brief promise of Reconstruction had ended, and Jim Crow was being established throughout the South. Cable exposed the origin of the postbellum iteration of racial injustice by writing fiction about the antebellum period. Looking to the past to make sense of the present is a useful practice in every instance.

In *The Grandissimes*, the color caste system of New Orleans is depicted through the intersecting lives of two brothers with different mothers. Both men are named Honoré Grandissime; however, one carries three letters after his surname: "f.m.c.," standing for "free man of color." His burdensome appendage limits his ability to move freely, even if technically free. The novel is an intriguing romance, but what interests me here is a blue-toned subplot that concerns a fictionalized

version of a historic figure, an enslaved man called Bras-Coupé—i.e., "cut arm"—because his arm has been severed in punishment for his efforts at escape.

Bras-Coupé is in this novel—and was, in real life—a Wolof man (from what is now Senegal) with blue-black skin. His lover is a "quadroon"—the American equivalent of "quarteron." Her name is Palmyre—a consequential one, as the palm tree is known for enduring in even the harshest climes, and antebellum New Orleans was indeed a treacherous place for women on the African side of the color line. The quadroon woman among them was a figure of lore in New Orleans, acclaimed for her desirability and a symbol of the titillation at the crossroads of the color line. For example, the Blue Book—New Orleans's historic and notorious guide to the red-light district—listed White and Negro sex workers separately, and placed quadroons right in the middle of the volume, a place of special record. Only White men were allowed to buy time and favors from these women, and they could take their pick of all three groups. But in Cable's novel, Palmyre is not some mythic quadroon succubus. She is tough, and her one-fourth Africanness is of great import. She is Wolof, like her lover, Bras-Coupé. Though more European than African, Palmyre lives inside her "blackness," and Cable symbolizes that by placing her in a home draped in indigo fabric, as though in homage to her blue-black origins.

The love between Bras-Coupé and Palmyre is cut short. He escapes and is recaptured. On the plantation again, Bras-Coupé defends himself against a White overseer who attempts to beat him. Afterwards, Bras-Coupé runs into the swamp, chased by a gang of wealthy White Creole planters. They lynch him.

Before his death, Bras-Coupé curses the indigo plantations with a series of plagues. First come the worms that chomp day and night upon the young shoots and leaves. Then a mortal fever spreads through the enslaved population. Survivors are left emaciated, inca-

pable of working the land, and complaining "the voudou's spells are upon me."

In the novel, the indigo plantations carry the curse for seasons and generations to follow. What had been cultivated returns to wildness. It is as though colonialism and slavery had never happened to the land, as though blue had never been enlisted to create such suffering. It is a bitter justice. As for the romance of Cable's story, it is tragic. Palmyre is widowed. The quadroon and the Wolof warrior would have no future. And, as his readers of 1880 well knew, the entire promise of emancipation was being dismantled as the architecture of Jim Crow was being built. Maybe Cable wanted us to consider multiple things at once: the obvious horror of slavery, the sin of Jim Crow, and how the history of transatlantic slavery and racial caste at once made Black people a group and separated them through a hierarchy of color? The color line was absurd, as evidenced by the wild variation of genealogy among African Americans, especially in Louisiana. But it was also mean and jealously guarded. Over generations and across the Americas, the range of Blackness, from blue-black to near white, would sometimes be a sustaining thread of connection, and other times it would be the basis of rupture due to the way they were ranked according to relative light and darkness of complexion. Consistently, in most places in the New World—as varied as Haiti, Liberia, South Carolina, Jamaica, the Dominican Republic, and Louisiana—and among most people, the creation of Blackness meant that proximity to Whiteness, while favored, was not Whiteness. Whatever Raimond's color was, it mattered.

A SIGN WHICH WILL
NOT BE CUT OFF

<><><><><><><>

Instead of the thorn bush the cypress will come up,
And instead of the nettle the myrtle will come up,
And it will be a memorial to the Lord,
For an everlasting sign which will not be cut off.

—ISAIAH 55:13

The vast majority of American slaves came from West Africa,
which extends from the Senegambia region to the Bay of Benin,
and from west central Africa, the area of Kongo-Angola . . .
Different African peoples were drawn into the Atlantic slave
trade at different times. For example, the Wolof and Serer,
from the region between the Senegal and Gambia rivers,
were enslaved from the start, whereas the Yoruba of modern
day Nigeria did not cross the Atlantic in significant numbers
until the nineteenth century, and people of the Kongo came
both early and late . . . No less than the language, music and
art, the religion of Africans showed a wide range of diversity.
Although Muslim and Christian Africans were swept up in the
Atlantic slave trade, the vast majority of those enslaved in the
Americas practiced the traditional religions of their ancestors.

—ALBERT RABOTEAU, *CANAAN LAND*

ACTS OF FAITH may be most illuminating when none of the traditional artifacts of religion are available because empty-handed supplication must be the rawest, most honest kind. That is what I make of the periwinkle beds in the South. They were cultivated by hands looking for God's mercy.

THEY LIE IN beds: bunched up, pretty, and rough. Periwinkle is not native to North America. Europeans first brought them as decoration. But their density and vigor makes them appear natural here. The purply blue blooms border on invasive. In recent years, historians and archaeologists have begun to notice something about their patterns in the Upper South. They cover Black people's bones. Research reveals that during slavery, bondspeople marked graves with the blue flowers. If you find scattered patches of them, human remains are likely underfoot.

There were no headstones for the unfree. But to be undocumented was not to be unremembered. Ritual and spiritual improvisation (making do with what you had) continued to do the work of the past on the present, even in a place and time in which humans were defined by ledgers and written law. Cultures do memory work in a range of different ways. One technology of race was to name Black people as unworthy of historic recordkeeping. But people claim places and spaces even when the law of property is not on their side. Home is where your dead are buried, even if you are only there by duress. To be unrecorded and have their rituals thieved did not prevent Black people from creating new selves with old roots. After death, under the cover of night, the graves were "dressed," as we say, with personal effects for the departed to carry on their journey. They were sent to the other side with syncopated claps and song. Faith lies in state. Ancestors lie in this ground, and that, and the other. They planted remnants over generations. Beads

are wrapped around neckbones six feet under. People make do where they are, standing in life, settling when possible. Traces endure.

Death was a transition but not a conclusion in the theologies of these scattered Africans, and in each place it was considered necessary to manage the crossroads between the living and the dead. In the Deep South of America, there were other blue patterns of the crossroads. In the low country, cobalt blue bottles adorn crepe myrtle trees, and porches are painted haint blue, close to periwinkle. This is what is called a "dressed" yard—it was and is a portal. Bottle trees originated with the Kongo culture, the kingdom from which a significant number of enslaved Black Americans came. Among the Kongo, reflective materials of various sorts were used to deflect the bad and attract the good. In the United States, the bottle trees have done the same, their glass reflective like the waters one must cross to enter or exit the realm of the dead, welcoming ancestral power and keeping restless spirits at bay.

The crepe myrtle trees on which the bottles are hung are conduits too. In the Bible, the myrtle appears frequently. It stands for unwavering faith. I look at bottle trees deeply curious about how they came to be. Who decided this was the way to protect vulnerable souls? No one can answer specifically or precisely. That isn't just for the obvious reason, that there are relatively few accounts of the interior lives of enslaved people, especially going back into the eighteenth century. It is also because faith and culture aren't solo-authored and never pure in origin. They are always in flux and even promiscuous. The Kongo people who were brought in chains to the Americas knew this well.

Those of us who think about Blackness from a US perspective often forget, or never realized, that on the African continent, there were a wide variety of impactful cross-cultural encounters before the slave trade, ones that could not be reduced to imperialism or slavery. The fact that Black people enslaved in the Americas created new traditions, resourced from their range of origins and interactions, was not only a result of the devastating ruptures of slavery. Their ancestors had already been

impacted and shaped by encounters with people from all over the African continent and across the waters. And those on the continent continued to change, even as the displaced Africans of the Americas changed as well. There was no such thing as a static Blackness, either before or after it became a sign and a title.

THE KONGO PEOPLE are an example. The Kingdom of Kongo was located in west Central Africa and founded around 1390 CE. Its citizens farmed, fished, and traded. Artisans were valued. Their expansion was largely based on alliances rather than conquest.

The Kongo had contact with the Portuguese early on in the history of European contact with Africa. Portuguese explorers and King Nzinga a Nkuwu met in 1482 and developed strategic alliances. As a result, the Kongo king converted to Catholicism, the faith of the Portuguese, and changed his name to João. But "conversion" might not have been the right word. Catholicism entered into the spiritual economy as part of a fabric of theological practices. But it did not require, for the Kongo, a disavowal of everything else. This makes sense despite the jealousy of Christian doctrine. Religious practices across the globe have always morphed as a result of encounter and experience. But the contact between Europe and West Africa would not be a mere encounter. Catholicism and other forms of Christianity would become tools to control and dominate enslaved and colonized people. The Kongo did not meet the Europeans with that assumption. They would learn it the hard way.

The Portuguese empire was avaricious and voracious. Their wealth and weapons would prove ultimately to shape history and destroy a nation. When King Nzinga Mbemba, Nzinga a Nkuwu's son and successor, also willingly converted to Catholicism, he changed his name and title to King Afonso I. It was a political move, and perhaps a spiritual one too, but also a choice. Then he took a further step: he

named Catholicism the state religion and adopted a Portuguese monarchic style. Kongo elites took on new names, titles, and religious ceremonies, and sought European education for their children. For Kongo elites, it was at first a lucrative transformation. The slave trade was central to Portuguese interest in the Kongo kingdom. And though King Afonso I was nominally opposed to slavery, he practically accepted it, so long as those who were enslaved were their war captives or those who were being punished for wrongdoing. However, he balked when Portuguese merchants began demanding Kongo citizens as chattel slaves in exchange for Portuguese goods. The Portuguese turned to taking Kongo citizens with abandon, despite the king's protests. Outraged, Afonso began to write letters to the Portuguese king, João III. His message was that the slave trade must end. He wrote and wrote again. And again. Ultimately, the king sent off twenty-four angry missives to João III.

The Kongo had no standing military. The Portuguese had arms upon arms. The Kongo didn't rule through lineage or conquest, but rather kings were elected and people joined the kingdom through agreements of mutual benefit. They'd developed a relatively egalitarian society. Arguably, they couldn't have anticipated the violent greed of the Portuguese merchants. Afonso knew, however, that the Portuguese were obligated to obey the will of their king. He sought recognition and respect from his Portuguese counterpart. However, to Afonso's great dismay, King João of Portugal sanctioned his royal subjects' brutal business.

The damage was incalculable. Stealing citizens became rampant. Afonso asked João to stop allowing his subjects to set sail for Kongo. His appeals went unanswered. He had envisioned a place of shared prosperity between the Portuguese and the Kongo under a common God. Instead, he witnessed his kingdom converted to a hellscape in which his people were terrorized by the prospect of being snatched and shipped to the New World. Villages were devastated by the theft

of human beings. The trade in flesh cut the Kongo kingdom off at the knees. It fell. Slavery rose.

Historians believe one-fourth to one-third of the Africans imported into the United States were Kongo. They brought the traditional ritual of adorning burial sites with them across the waters. Flowers, or trees, or shells were used to decorate graves, along with the personal possessions of the deceased: objects like shards of saucers and pipes. They turned to ways older than the Catholicism their elites had adopted in order to protect them from evils greater than any had anticipated. And they acquired new ways as well. The crafting of New World culture was source work, a regular turn to the varied stores of knowledge in order to negotiate a world defined by theft and captivity. In Trinidad, for example, Carnival initially began with the ritual burning of sugar-cane fields, "Cannes Brûlée," at harvesttime. The scorched leaves fell; the cane remained to be cut. This was slave labor. Cannes Brûlée became Canboulay—a pre-Lenten ritual. Barred from participating in the European masquerade festivities, the enslaved made their own rituals of dance, song, and play. Indeed, nowhere is Carnival more elaborately celebrated than by the descendants of the formerly en-slaved in the Atlantic world. Subversions of power, political theory, and extravagant costuming that echoed secret societies and harvest rituals of West African cultures would make Carnival Black.

When African Americans adopted Protestant Christianity in large numbers following the Great Awakening of the eighteenth century, they cleaved to the Old Testament and specifically Exodus. It made great sense for a people held in bondage, imploring God for freedom, to be inspired by this example. The details and settings for faith as they tried to find their way through the morass of subjugation had to be ever-moving. Their hush harbors—sites for religious ceremony under the cover of night, where they practiced spiritual ablutions and held funerary services—blossomed under a midnight sky. These rituals that existed outside of the gaze and punishment of masters were spiritual

resources that could be sustained even in a condition that undoubtedly created spiritual crises. Finding a way to a higher power in the worst of times became their way.

When a person was placed on an auction block, they were actively removed from civil society. But when the enslaved adorned burial grounds and even their own bodies, they sustained a belief in their souls and intellect. To that end, they carried necklaces and small bags bearing elements of spiritual protection. These "mojo hands"—also called nkisi (according to the Kongo tradition), gris-gris, and juju—were fastened about waists and necks. Inside them, Islamic scriptures—often written in blue—were frequently deposited. Why? Because by some estimates 10 percent of African captives brought to the Americas practiced Islam. Enslaved people from varying theologies found themselves cast in the same lot and traded twelves in many traditions, all of which found their way inside mojo hands. The Yoruba, Bakongo, and Mandinke, as well as Muslims, were considered especially wise when it came to matters of spiritual protection. Influenced by these traditions, New World Black people created amulets of bone, feather, animal parts, dust, stone, and prayer. What was already a cosmopolitan African spiritual landscape took on a particular urgency under conditions of utter domination. Free in belief if not in body.

Blue porches, planted blue flowers, written blue scriptures, blue attire, trees festooned with blue bottles: these became the cultivated habits and rituals of people denied civil society and legal recognition. Imagine working six days a week from the dawn to dusk—"kin see" to can't, living at the constant whim of a powerful person or three or ten with whips, guns, and property deeds to your body. Contemplating blue, working with it, praying for it to be a bulwark, meant people kept becoming. It was under duress, of course, but vital with their gaze and deeds. In the low country, looking through the glass hanging on trees, I can see it: a way, if not a simple truth.

JAYBIRDS SING

◇◇◇◇◇◇◇◇

. . . listen to them chasing life falling / down getting
up in this / house of blue mourning birds . . .
—Sonia Sanchez

A BLUE JAY is born black. As the chick matures, its belly turns gray and body becomes blue. Nevertheless, into adulthood, it remains bridled about the neck in black. Some folklore said the black was scar tissue from pulling a plow. And I suspect the devil was his master, because the folklore of blue jays in the American South has everything to do with the handiwork of Satan. In plantation days, Black folks would say you couldn't find a blue jay—or jaybird, as they are popularly called—on Fridays because that was their day to visit hell. According to them, the jaybirds spent that day in communion with the devil, reporting on all the evil White folks had done the previous week. On Saturdays, they returned to the living world and were especially animated, garrulously free of the burning hellfires.

Blue jays are loud. Animals, being largely unintelligible to people, have more freedom to tell the truth. And so perhaps that is why they were able to express disgruntlement when it came to the meanness of White folks, no fear of retribution. Maybe the blue jays weren't the devil's companions but Black familiars, testifying to the obscene

magic that Whiteness could be. It would explain the verse from "Miss Mary Mack": "Away down in jaybird town, folks have to work, til the sun goes down." They knew the endless struggle.

To make the metaphor even finer, jaybirds aren't really blue at all, but brown. They appear to be blue because of the cellular structure on their surface. But their feathers are pigmented by melanin just like Black folks' skin. Blue jays are also humanlike in their independence. Unlike other birds, they migrate—or don't—according to their own business and preferences. And jaybirds can be selfish; they even occasionally wreak havoc by eating other birds' eggs. They play like birds of prey, mimicking hawk calls. But really, they are not that tough. Scolds of scrub jays, falls of woodpeckers, and even everyday squirrels can beat them back. Maybe that's why they reported to the devil? Could it be that he offered a begrudged protection? Or it might have been that jaybirds were two-faced. Double agents testifying to White cruelty in order to please the devil, but also acknowledging Black suffering to make a holy appeal. At least one folk ballad suggests that despite their willingness to sing, they weren't trustworthy allies:

> Way down yon'er at de risin' sun,
> Jaybird a-talkin' wid a forked tongue.
> He's been down dar whar de bad mens dwell,
> "Ole Friday Devil," fare-you-well!

Culturally speaking, the idea that the devil's will might be operating as powerfully as God's is consistent with the way West African theologies were remixed in the Americas. Power is neither fixed nor pure in those traditions. Meanness is just part of living, no way around it. There was good reason to maintain that belief even when it lay in tension with the proclamations of Christianity. How else could one sustain faith while living in a slave society? If heaven was real, that

was a matter for the other side; on this one, power had to be negotiated carefully.

A forked-tongue jaybird would confess his moments of unkindness. For example, according to folklore, the jaybird admitted that he tried to make Brer Rabbit fall to his death. And he reportedly laughed at a man who collapsed at the kickback of a gun he shot. Just 'cause the jaybird told on White folks didn't make him righteous. And just because the devil was morally wrong didn't mean he wouldn't win in the end.

But jaybirds did do some measurable material good in the US South, even if the folklore was skeptical. Their taste for acorns benefitted everyone in the region. Dropping food bits in flight, they spread the oak trees that canopy so much of the hottest land, offering inadvertent blessings amid abundant mixed storytelling.

Contradiction is the most consistent theme. Stark or butt naked people are "naked as a jaybird," which is a counterintuitive expression, given that birds are well-dressed by feathers. Among their species, there isn't anything unusual about the jaybird's attire or lack thereof. However, the expression goes as far back as the nineteenth century. The early version was "naked as a fledgling jaybird." Fledgling birds are young, unsteady in flight. And perhaps the tiny black baby jays are naked, not yet dressed in grown-up blue, and therefore still so vulnerable.

By the twentieth century, the word "fledgling" was gone from the expression. The expression became simply "naked as a jaybird," and there is some speculation that it was a conflation of two associations. In jail or prison, they stripped you naked, hosed you down, exposed you. A jailbird, a j-bird, was ritually naked as part of intake. Think about the prison farms throughout the South, so akin to the condition of slavery, with suffocating heat, corporal punishment, and rows of Black people assigned to suffer. Naked.

Animal tales, like those of the jaybird, are common in virtually all traditional cultures. And Black Americans retained some such figures from West Africa, as well as adopted others from Europeans and Indigenous people of the Americas. What is most important, however, is that the stories served a philosophical purpose. Speaking secret languages that were unintelligible to those who would dominate, along with the power of flight and therefore escape, meant that a bird's freedom could set things aright, or at least allow for the truth. Such was the case with the popular blue jay, but also, more subtly, when it came to other blue lives.

Another pesky small animal of black and blue that made its way into plantation song was the blue tail fly. It is *called* blue, but it is, in fact, a black horsefly. The blue is only visible under the sunlight when its opaque belly shines with a blue cast. The fly let folks know that a little black something shining blue could do a great deal of mischief. The classic antebellum song "Jimmy Crack Corn" is the story of a slave who notices the presence of blue tail flies in the South Carolina heat. He waves away the flies to maintain the master's comfort. But one day, the master is out riding his horse, and as expected, a horsefly buzzes about. The singer is charged with swatting away the flies rapidly with a hickory broom. But he misses and, upset, the blue tail fly bites the horse, whose "jump and pitch" knocks his master over into a ditch, leaving the master dead. When the matter comes to trial, it is the tiny little blue tail fly that is declared guilty. The refrain, from the singing slave, is "Jim crack corn, I don't care." His is a thinly veiled delight that the master has been bucked to death. But it is also fascinating because the tiny, bothersome, inconsequential fly had had a mortal impact. It might have been a warning about the meek of the earth.

Following this pattern, I even found a story of a horse that counted as a blue-animal tale. Blue-roan horses, ridden by the Black jockeys, who were highly regarded in the antebellum United States,

were good for racing. And in 1770, a blue-roan quarter horse named Blue Boar had gone undefeated in every race he entered. He was a star on the track, pretty, sleek, and well-bred. Blue Boar, the pampered victor—unlike the enslaved man who rode him—was a star in Dobbs County. A newly settled Scotsman who is recorded to history simply as Henry, unwisely agreed to race his pony "Trick Em" against the Blue Roan. Eager to take advantage of the Scot, the local gentry eagerly bet on Blue Boar. They put up other horses, livestock, and even Black people they owned. Henry's team included a ragtag assortment of lower-status Whites and Black folks, which was bad enough, but then he chose an old fifty-pound slave to ride Trick'em. Making matters worse, Henry bet his general store and all his belongings on Trick'em. The townspeople weren't concerned about stupidity. Let him lose it all.

Except he didn't. Trick'em won.

HENRY HAD BROUGHT wagons to the track early that morning, hours before the race, in anticipation of his abundant winnings. He departed quickly upon victory, taking the townspeople's wealth away with him so fast that he and his team were long gone before everyone realized they had been taken. You see, Henry's team included a Black horseman named Willie Jones—now free in victory—who had trained Blue Boar. Jones knew much more about Blue Boar than even his owner, including how to beat him. And that was their error. Sometimes, as the folktales went, the smallest man prevailed. And the last could be first. It was not only storytelling; it was an article of faith.

BLUE GUMS AND
BLUE-BLACK

◇◇◇◇◇◇◇◇◇

AS POISONOUS AS a diamondback rattlesnake, a Black person with blue gums must not be crossed. Their bite could kill with certainty. It doesn't seem like this was simply a racist myth because the information came from Black people themselves. And it was a warning of particular potency because Black people were awfully close, physically speaking, to the most powerful of White people: feeding them, dressing them, bathing them, serving them, nursing their babies, tending their wounds, making their death shrouds. Imagine, then, the fear that some among them in close quarters could open their mouths, sink in their teeth, and end a White life and their own subjugation.

The folklore was spectacular, troublesome, and alluring. This superstition, or belief, so strangely deterministic and unexplained (why would they bite you, and what possible relation was there between the color of gums and poisonous saliva?) made its way in the nineteenth century from Black American folk culture into the mainstream. Reportage came from deep in the well of folkways of knowing. Newspaper accounts were sensationalistic. One out of Warren, Arkansas, warning of

a "Deadly Blue-Gum Negro Bite" is amusing but deeply disconcerting: "While this has been the superstition there have been doubts about the existence of a 'blue gum negro.' Many people know of other people who have seen the so-called poisonous negro, but few have ever been found who have actually seen such a person." When I first read this account, in the winter of 2022, I told a group of my friends about it on a Zoom call. We were five Black women. Three smiled, and lifted or lowered lips to show me their bluish gums. We cracked up. Unlike this newspaper writer, I've seen many a blue gum in my life. And I suspect so had plenty of Black folks of the nineteenth century. The man out of Arkansas simply didn't have good sources.

He went on to report that the suspected danger had been proven in one neighborhood along the Saline River, a 202-mile-long waterway in south-central Arkansas where a Black family lived in a cabin along the banks. They were common poor folk, except for one troubling young man. "He has been in constant trouble with his neighbors and with the authorities on account of certain thieving and fighting tendencies." He fell into a common archetype of the American South, called a "bad nigger," the type who flouted authority and lived as a glorious outlaw. The journalist reported that this young man was shunned by respectable types of his race, and had a conflict with another bad sort at a dance. "In this fight he bit his opponent through the hand with the result that the bitten man became deathly sick in a few minutes and in about three hours died from the poison in the wound. Afterward when the negro was arrested he bit two of the constables and both died within four hours after receiving the wound."

Tales of a murderous Black man who struck fear in the hearts of local White people were not all that unusual. But that it was based upon a bit of lore rather than a fictional saga of Black licentiousness was somewhat different. And the man needed no weapon. His mouth was enough.

Even medical doctors were intrigued by the myth. In 1889, a Dr. A. A. Young wrote the following inquiry to the *Southern Dental Journal*:

> About two years ago, in the vicinity of Como., Miss. Mr. Douglas Durrett became involved in a difficulty with a blue gum negro by whom he was bitten upon the hand. Inflammation and suppuration of the hand and arm ensued from the effects of which he died in about ten days; the poisonous nature of the wound being attributed to the peculiar color of the negro's gums . . . Unable to recall any allusion in medical literature to the fact that the bite of persons possessing blue gums (no race save the negro, has) is peculiarly poisonous, I write for light on the subject; and shall be glad to hear from you, or any other member of the profession. There being a shadow of foundation for such a belief, if by investigation the fact can be established beyond question, why should not our legislatures make the biting of another by an individual having blue gums something more of an offense than a mere assault.

He would go on to attempt to pursue such legislation but does not appear to have been successful. Notably, in the twenty-first century, it is known that human bites are dangerous. For example, when my younger (pink-gummed) son was a toddler, he playfully bit me, and I required a course of strong antibiotics to manage the infection. So maybe some of these stories of bites leading to death were factually true, but the myth around blue gums revealed a lot more about what "Black" meant to people, both inside and out of the group.

"Blue gums" or "blue-gum Negroes," as they were called, were usually dark-skinned people, but blue gums were not, like the popular nickname "Blue," simply a way of referring to very dark impeccable skin, so luminous it shone blue. That is to say, a "blue gum" was

related to, though distinct from, someone who was "blue-black." Both terms came out of a not fully articulated—mystical and fearsome—connection to an African past. "Blue-black" was at once a description of admiration and derision. The blue-black person is undeniably African, and indeed singled out among Black people in the Americas by that designation. By way of example, "Blue" appears repeatedly as a nickname in the literary tradition of African diaspora literature. It is in the work of writers as various as Bajan George Lamming and Mississippian Jesmyn Ward. "Blue-black" as a descriptor appears in the work of Martinican psychotherapist and social theorist Frantz Fanon and Ohioan novelist Toni Morrison. The marvel traverses borders and dialects.

And though not all blue-black people were "blue gums," the belief that those with blue gums were dangerous does imply some of the stigma that could go along with color-struckness, that bigotry that ranks paler skin, even if not white, superior. In Opie Read's short story "The Waters of Caney Fork," the narrator—a White youth—describes a fellow child as "intensely black with blue gums" and added that the aversion to his skin and mouth was so strong it led to maternal alienation: "His mother who was my 'black mammy' deplored her offspring. She declared that a blue-gummed negro was born to be either hanged or to see ghosts."

In another work of fiction, published several decades later, Emma Lou, the protagonist in Wallace Thurman's Harlem Renaissance novel *The Blacker the Berry*, feels cursed by her dark skin, and as she contemplates the hostility with which she is treated by other Black people as a result, she thinks: "A black cat was a harbinger of bad luck, black crape was the insignia of mourning, and black people were either evil niggers with poisonous blue gums or else typical vaudeville darkies."

But blue gums were never universally demonized. And maybe that's part of why even when they were described as dangerous, there

remained a lingering admiration. In some parts of both West and East Africa, for example, where gleaming blue-black or mahogany skin is more common than in the Americas, gums were and are dyed purply blue through injections of a colored powder. The result is a striking contrast to white teeth. Even with my Western-trained gaze, I can see the beauty. I also routinely wonder how anybody could deny how pretty blue-black skin is. I like to think looking at the gorgeous mixtures of black and blue in bodies seeded a niggling doubt about the hierarches of beauty. Blue and black in gum and flesh weren't just powerful; they were alluring.

In the late nineteenth century, the *Atlantic Monthly* published a fictional conjure story—that is to say a story depicting the folk magic and rituals of Black Americans—that featured a "blue gum." Written by a White author, it nevertheless suggested familiarity with the folkways of Black Southerners. In it, a planter is appealed to by one of his servants. He's told about a woman who has been put under a spell, i.e., conjured—hoodooed-goophered—by an old woman on the same plantation. In fact, the planter speculates that the elderly woman also caused the death of his house servant's husband. The planter, through whose eyes and voice we witness the unfolding of the story, goes to see the old woman in her cabin and describes her with some horror:

> The moment I spoke to her, the wretched old centenarian, a mere bundle of bones and clothes in the chimney corner, began to mumble and chatter. The cob pipe dropped unheeded from her blue gums, and would have set fire to her dress but for the nimbleness of the pickaninny who had the care of her.

The woman proclaimed her innocence, though the writer means for us readers to be circumspect. She protests, "De Lawd knows I am' done nothin' to de gal." She suggests that instead of bothering her, the

planter ought to send for a medical doctor, who she is confident will affirm that the girl is in good health.

The planter goes next to see about the suffering younger woman. Immediately after his arrival, two figures who are even more frightening than the old woman join him in her cabin. One is a "very tall man" with "thick African lips and woolly hair." His skin and clothing are both black. His companion is a woman with light reddish-gold skin whose "large, brilliant black eyes gave her singular beauty." Her head is adorned in a colorful turban, she wears what were called "Creole hoops," and a string of blue beads was "twined round and round her throat, and fell in festoons, longer and longer, until they touched the waist of her white tunic." Her wrists are similarly draped, her feet bare, and her skirt indigo blue.

This duo are conjurers or root workers or, stated another way, hoodoos—community experts in that folk theology. And they reveal the truth. The ailment is not a consequence of the old woman's conjuring (though she had tried) but rather grief. The house servant's husband had died. The old woman, her mother-in-law, held the young woman responsible for her son's death. Mystery solved, the story concludes with the widow weeping.

I cannot say how the readers of the *Atlantic* took the story, whether they believed it was true or understood it was fiction. In truth it could have been either. Local color fiction of the late nineteenth century was often highly influenced by either real events or local folklore. Some readers, I am sure, considered it nothing more than a depiction of local superstition and a colorful tale of the underdeveloped reason that was common in the Southern region because its culture had been shaped by the presence of Black people. But I imagine others felt "chill bumps" encountering the blue-gummed old lady whose shadowy power could only be visible when her teeth were fully bared. Under the surface of such phenotypic features and adornment like blue beads and Creole

hoops was the truth of gallons of sadness in the lives of Black Americans. Such sadness had to haunt even the most fervent of adherents to the color line. Fiction reveals fears, after all.

In Charles Chesnutt's tale "The Wife of His Youth," blue gums show up as well. The protagonist is a Black man who has made good in his journey up from slavery. He is well educated and has made his way north, where he finds himself invited into the inner circle of Black elites colloquially called the "blue veins" because their skin is light enough for the veins to show underneath. Chesnutt depicted an authentic social practice of some light-skinned Black elites having color criteria for some of their social and civic organizations. In this story, he placed them in an unidentified city of the Northeast after the Civil War. The goal of their club "was to establish and maintain correct social standards among a people whose social condition presented almost unlimited room for improvement." This not incidentally meant to them that all members were more White than Black in ancestry. And though the story is fictional, the term "blue veins" was not. Chesnutt's Black readers would have immediately been able to identify such people in their own cities.

Our protagonist has arrived at the blue vein gathering, ready to be feted, but finds an unexpected visitor at the host's door, looking for him: She is a tiny wrinkled woman with very dark skin, short gray hair, and faded attire: "a blue calico gown of ancient cut, a little red shawl fastened around her shoulders with an old-fashioned brass brooch, and a large bonnet profusely ornamented with faded red and yellow artificial flowers." And her gums are blue. This woman is certainly not of the same class of the Black people gathered there: "She looked like a bit of the old plantation life summoned from the past by the wave of a magician's wand . . ." She is seeking our protagonist, blue-veined, erudite, and ambitious, because once upon a time, on the plantation where partnerships were often determined by masters and marriage wasn't legally consecrated, she had been his wife. It is a cau-

tionary tale. Chesnutt on the one hand reminds the reader that the lot of those blue veins and blue-black folks had been deeply tied together in the recent past (and even in the present), despite the distinctions the blue veins (including himself) might have wanted to make. They were bound by history, culture, law, and tradition. But also, he juxtaposes two distinct forms of power: that of the blue veins, people who could gain access to the material world's benefits more easily with greater resources and palatability, and that of a blue-gummed woman, who held the power of conjure and deep ways of knowing.

Chesnutt's early literary career had been made with the publication of conjure stories that depicted the folk beliefs of Black North Carolinians. In virtually all of his stories, conjure served to subvert the power that White people had over Black people, as was common in Black American folklore. In this one, the power held by "the wife of his youth" might also be greater than that of Black people who perceived themselves to be superior. Chesnutt, a blond and straight-haired Black man with blue veins and keen features, spoke to those like him, warning them against being too eager to separate their fortunes. In his fiction, he often revealed the delusions of color hierarchies, even those jealously guarded in Black communities. The blue-gummed and the blue-black were to be respected and not just reviled and feared.

Even William Faulkner, that brilliantly confusing Mississippian, had thoughts about blue gums. In his novel *The Sound and the Fury*, blue gums are believed to be contagious and could even afflict White people. You could be conjured into blue-gum-dom if you didn't watch out. The gothic horror of a slave society could distort your soul, causing decadence and depravity. The deeper meaning behind his use of the folklore is hard to puzzle out, in part because Faulkner's deep familiarity with Black people coexisted with his moral ambivalence and sometimes viciousness regarding their lives. But suffice it to say, for our purposes, a simple observation holds: blue gums were considered powerful by Black and White folks alike.

And perhaps that is the most important part of the strange belief. The slave trade, and the incursions into Africa, had made it a place that could seem powerless. But as long as its children maintained some ways of disturbing the order that put them on the bottom, all was not lost. From the perspective of those who held them down, the belief in that kind of mystical power probably reflected a fear that one day Black people would rise in retaliation against them. But for Black people, it was one of those glimmers that offered a bit of sustenance in a bitter landscape.

HOODOO BLUE

<><><><><><>

... conjure was one area in which European and African
traditions resembled and thus reinforced one another ...
—ALBERT RABOTEAU

Conjurers act on their worlds, transforming circumstances,
escaping danger, and upending standard assumptions
about how the world should work. Conjurers revealed
a different kind of agency among African American
slaves and their descendants. They offered a sense of
control in what was otherwise an absurd situation.
—EDDIE S. GLAUDE JR.

MAKE A SALVE of mutton suet mixed with powdered bluestone
and quinine. Rub it on the bottom of your feet every morning, and
you will save yourself from all harm. If you don't want to have a baby,
make two teas: one of red shanks root and gunpowder, the other of
blackhaws root with a little bluestone. Sip some of each every new
moon. As a general protective measure, leave a saltshaker by your
bedside. If a boo hag comes to harm you, knocking over the shaker
as she approaches, she'll be waylaid because she can't help but count
every grain.

Standard English words fail to describe these ways. And maybe that's why a suite of terms is necessary: "conjure," "root work," "mojo," "juju," "hoodoo"—and that's just we call it here in the United States. These are words describing various aspects of traditional Black spiritual-medical-ethical-social practices that don't constitute a religion, formally speaking. Offering tools for navigating the world, hoodoo—an umbrella word of sorts—is a form of study that lies outside of imperial norms. It is boundary-breaking. Every source of information can be used; observation is key, as is method—but spirit is never inferior to science. They work in tandem.

If we were to only document Black American life as the crimes against us, all we would have to name ourselves would be a travelogue of immorality and tragedy. And that would not have been or be of much use to Black people. And a catalog of achievement against the odds might bolster, but it doesn't necessarily sustain. Plus, we do not always conquer. The widely embraced Christian God works in mysterious ways, not certain results. Hoodoo was therefore a necessary partner. Prior to emancipation, or widespread literacy, it was a system for collecting and preserving information to navigate life. As I've said a bunch of times already, yet it bears repeating, "Black people"—not as a description of our bodies but as a category of human beings—is a relatively new concept. Black people as such were conceived of through and in modernity. Capitalism, globalization, and empire made "Black people," who in turn remade themselves and did so with the ideas they adopted as well as the information they could gather.

In the US South, hoodoo is a knowledge system born of disruption and cosmopolitanism. It is the outcome of both a quilted existence— all kinds of people's ways are inside its fold—and a creative cultural disposition. Of course every culture's theologies and folk practices transform through encounter and over time. But the sheer range of encounters in a short period of time—a result of slavery and separation, of dozens of peoples, kingdoms, empires, and nations from three

continents—made a particularly complex quilt. And hoodoo is joined together by threads of blue. The color courses through its recipes and rituals.

But before we get to that, it's also necessary to explain what I mean by saying that it is a folk practice. "Folk," here, does not mean old or past. The term Folk describes the relationship to institutional power, wealth, and the built environment. It is humble, not because it isn't powerful, but because it has no armies or navies, no treaties and borders. Hoodoo teaches that if one conducts certain rituals, the natural world might yield to human desire. In fact, forms of natural indebtedness to practitioners could be earned through habits, incantation, recipes, and pieties. Mind you, the tradition grew among people—slaves—who by law were essentially and fundamentally indebted to masters from birth. This form of natal indebtedness meant beginning under the thumb of an unethical system. The possibility of ethical relation—in contrast to that of the lawful yet unethical theology of the slavocracy—existed in hoodoo. Hoodoo was direct: Do what you were supposed to do, and the natural world would yield accordingly, unless some other root work or conjuring—at the hands of some other person—was at work. Then you might be thwarted. And it could be by anyone. If religion was imperial, hoodoo was insurgent.

There is no simple distinction between spirit and medicine, nor between literature and ritual in hoodoo. For example, in the world of African American storytelling, High John the Conqueror is a folk hero. He is always the victor. By some turns, he is the son of an enslaved African king who resisted enslavement in every tale. At others, he is simply an extraordinarily powerful, albeit enslaved man who could constantly outwit and defeat the master even though he nevertheless remained a slave. Clearly, a great self could be held in bondage. High John was a symbol of immediate possibility in a life of containment. And a trickster. His name graces the roots used in conjure.

High John the Conqueror is, in fact, the most powerful root. But in practice, it has always been more than one plant. Which one of the many at hand gets the name High John depends on local environment and tradition. That said, it is usually one of the morning glory family—that usually blue (but sometimes pink or purple) flower—which is dried and then used for candles, talismans, floor washes, and teas to manage trouble. High John can heal what ails you, but also can be put to use for exploiting another human being, igniting lust, protecting against ill will, and a wide array of other specific spells. Shriveled up, it resembles sexual organs and is carried in mojo bags or chewed up and spat. If you know morning glories, imagine those flowers that bloom in the morning, drawing butterflies and delighting the senses, having their heads sliced and preserved for nighttime wisdom along with companion roots, little john and low john, that are less powerful but equally useful for various remedies. This is medicine in the classic sense, a learned art of care and healing.

If you want to treat it skeptically, you should know the language does not bend easily into dismissing hoodoo as naive myth. There are demonstrable pharmacological uses for roots. Research and evidence exist, and the power of folkways are supported by the popularity of the naturopathic and supplement section of high-end grocery stores. But in hoodoo, the color, the blueness of remedies, matters too. Color is not inconsequential in hoodoo the way it is in Western allopathic medicine. According to recorded hoodoo spells of the early twentieth century, blue candles should be burned to gain positive outcomes in court cases, unfix roots that have been worked on someone to do harm, and to fix (as in control) someone else. They say that if you combine blue candles with other objects—pennies, hair, urine (known as chamber lye), weeds, string, ants, animal organs, and words written in blue ink, in all manner of elaborate preparations—much of life can be handled. Other colors, especially

white and red, are used for various remedies, but none are as broadly applicable as blue.

Blue water can be used to chase away evil spirits and undo the evil eye. Floor washes of blue, or simply setting out pans of blue, can also work. Sugar, glasses, and loaves of bread are also paired with colored water for various ends. I hasten to add that I use the present tense because even though these ways are rare today, they aren't gone. There are still avid believers.

Sulfur burns blue and is useful to harm an enemy, according to contemporary hoodoo root workers. But bluestone, which is also called copperas and has a bright electric color, was once a far more common hoodoo ingredient, and immensely powerful. Bluestone helped gamblers win hands in a clutch and made evil cower. In one reported story of a root worker's instructions, a man named Jack was terribly fixed. Somebody had mixed his hair with bluestone and wrapped it inside red flannel with needles running through it, causing him anguish. To unfix him, the root worker rubbed him down with a liniment and then had Jack place eight dimes inside a mojo bag that was tied to hang around his neck and right over his heart. It isn't clear if Jack was cured, but it was reported that he wore the money-filled mojo bag for a very long time.

As a matter of everyday living, carrying a piece of bluestone could bring you good love. If you said the name of the one you wanted while carrying it, they very well could be bound to you indelibly. That is unless they, or their beloveds, had some otherwise working hoodoo of their own.

But bluestone is toxic. Touch it for more than a moment, and it can cause skin discoloration. If you inhale its dust, immediate vomiting follows. If you ingest it, it can burn your stomach, cause excruciating pain, and make you lose consciousness. Too much and it will kill you. As they witnessed the side effects of mishandled bluestone in the mid-twentieth

century, root workers transitioned from using bluestone to the similarly brilliant but mostly harmless laundry bluing—finely grained blue iron powder that, if used in the wash, makes whites whiter. (I keep some in my laundry room, as well as on my spiritual altar.) Apparently, with the color being of singular importance, the transition was fine. As one ritual attested:

> You will put into the water with which you wash your store-house floor the azure stone powder, called blue stone, or Lucky Bluing Powder. With this you will scrub the floor of your storehouse. This you will do on the days wherein the great gathering in the marketplace wherein your store is placed. You will mix of the francincense of myrrh and the Berries of the Fish and the flowers of the lavender plant each two drachmas, and this offering you will burn every day in your storehouse, so that the spirits of contention and strife will leave and only good spirits of friendship and help will remain within your storehouse.

That the once much-used curative ingredient bluestone turned out to be toxic was not altogether unusual when it came to nineteenth-century remedies. And so the danger did not prove hoodoo wrong. All medicine was experimental back then, and ailments were ubiquitous. For example, bluemass—a dangerous concoction made of licorice root, rose water, honey, sugar, and mercury—was another blue-colored remedy, but prescribed by physicians, that was used to treat various afflictions, including syphilis, parasites, dysentery, and tuberculosis. Even colicky and teething babies were treated with the cobalt-colored concoction in either liquid or pill form. Enslaved people received doses of bluemass from masters when they were sick, in addition to quinine, Epsom salts, mustard seed, castor oil, and aloe leaf, and were also subject to cupping, a healing treatment performed with suctioned

cups placed on the body. Even though they paid relatively little attention to the well-being of those they had enslaved, masters didn't want to lose their investment value either. So treatment, while minimal, did exist. And the enslaved supplemented the masters' medicine by going to root doctors. However, bluemass was even given to the powerful.

For example, Abraham Lincoln took it for his chronic melancholy. In fact, some historians believe that he experienced neurotoxicity as a result of it, but thankfully ceased consumption before suffering permanent mercury poisoning. The point here is that like root work, medicine was an experimental and sometimes haphazard combination of lore and knowledge. But as medicine was standardized, hoodoo remained instructively impure. Hoodoo knowledge was steadily integrated from all available sources of all types, and placed in the care of human storers of information: root workers, conjurers, and spiritualists. One popular spiritualist, L. W. De Laurence, a White man from Ohio who published a series of occult books in the early twentieth century, was so influential in US hoodoo and Jamaican Obeah that the Jamaican authorities banned his books for conflicting with Christian doctrine.

Even if hoodoo is a new or unfamiliar concept to you, you likely have a vague sense of how it operates because it is part of a holistic system of Black folk culture that appears in various ways in public cultures. In recent years, for example, there has been a renaissance of African American quilting in the art world. Art historians trace it to strip quilting in West Africa, as well as Scots Irish techniques. And critics have noticed that a functional practice, making bedcoverings, has deep aesthetic value. Quilters experiment with shape, pattern, and color. Their most consistent color, it's worth noting, is blue. But the quilt is also a metaphor, or better yet an aesthetic statement, that is evident in hoodoo too. Out of the remainders, the bits and pieces of discarded and worn fabric, life was crafted. Its use could not be limited to what we call "utility," though it was functional, even aesthetically speaking, because beauty is a function too. And beauty—if we release

its meaning from the colloquial prison of whether a human body is ranked worthy—is one of the most democratic of virtues. Anyone—with a gesture of kindness, a moment of sweetness, a twist of ribbon, a beating drum—can make, be, and feel beauty. Gazing up into the sky, or out into the water, is, we now know, as essential to the human condition as a sip of water and the taste of oxygen. The living made from underneath the law and inside the category of Blackness was holistic and beauty-full to its very core.

Hoodoo today is a form of preservation. Not many people live by it. And when they do, as with everything else, the ways of the present are not identical to those of the past. And much is fleeting when remembered at all. But the hoodoo lesson, as I see it, isn't so much about how much is remembered and held on to. The lesson is how it shows a habitual resourcefulness that became part of being Black in the modern world: move by hook or crook and make it pretty. That disposition to life is still at work.

THE BLUE NOTE

◇◇◇◇◇◇◇◇

YOU MAY BE old or familiar enough to remember that country Southern US folks of the generation that was dying at the end of the twentieth century sometimes pronounced the word "beautiful" with a soft *r* sound between the *u* and *t*. I haven't seen that sound written down and with good reason. Writing the pronunciation phonetically as "beaurtiful" would be crude and inaccurate. It looks too hard. You just have to know the word as it was spoken. And that is just like the blue note.

The musical blue note slurs and shifts. It is bent. It is "worried"— that is to say the sound is made to tremor with technique—and it is stretched. Critics often say a blue note is "flatter" than one would expect, according to Western musical scales. But even this flatness may take on several forms. It can be a single slurred sound or one made across several different notes, a shimmer or shimmying or even a vibration. Though a formal term, "blue note" is a contingent one. B-flat and E-flat, for example, are both often "blued." And so have been described as unstable but reliable outliers when played in songs that fit a European form.

You can see the blue note isn't one thing. It is a flexible relation to the scale, and the most African of interventions into Western music.

That kind of sound is, in fact, a window into the entire tradition. A blued note is so distinctive that someone who knows nothing about music, formally speaking, can hear it is special. That's a big deal. We writers of words are forced to concede that our marks on paper are base in comparison to the wonder of the world. But composers, as far as I can tell, are less ready to admit this, though they should admit it, and the blue note explains why. There's a lot more *there* there than we can quite fully apprehend. Think, for example, of the parabolas of sound growing wider by the moment in Aretha Franklin's song "Chain of Fools." You can hear her breathing, and the breathing isn't just a necessary pause. The breathing itself is a cultivated work of sonic art. She must inhale and exhale because human. But that breath is offered in precise time and cadence. Song, sound, and silence, curve into a spiral so clean that the recording glimmers, exceeding musical notation and the technology of reproduction as well as words.

Letters and dots, lines and spirals fail at providing much more than a general choreography when it comes to Black music. Notation is clumsy in comparison to what can be done with the body as both an instrument and as a tool to bring a musical instrument to life. And that is the point I need to make here. To focus only on the artifacts— i.e., the guitar, the sheet music, or the piano, even the glory of perfect pitch—is to miss something. The Black musical tradition has just as much to do with how the body relates to object and air in active relation as it does with the notes on a particular artifact or an isolated sound. And so, it simply isn't true that Black people are "naturally good dancers," but rather we learn the stern discipline of music inside the body and through the body from an early age: the stomp-stomp-clap of a cheer on the corner, of a crowd at a basketball game, of a bandleader keeping time, of a stride piano player's sway, of a washboard strike in a country blues band. Is there a notation devised yet to tie that thread together? I haven't seen it. The closest we get to explaining it is deed.

Hence the rhythmic quip "Ain't nothing to it, but to do it." (Say it in time.)

Historically speaking, scholars argue that the roots of the blue note and blues scale can be found in Muslim West African musical traditions and the folk styles of the Scots Irish, people who encountered each other in colonial America. The Old World sounds that developed in the Americas, influenced by both groups, provided a foundation that was taken up and remixed by subsequent waves of Africans and Europeans. As with many things, old ways were repurposed for new times and terms.

Within the scales that have more recently been applied to blues music, the ones called blues scales (in contrast to the conventional Western scales), the "blued" sounds sit organically. Context matters, as does content. Likewise, inflections that we refer to as blue notes are not outliers in the vocal patterns of traditional West African song. But in the West, they sit in contrast to Euro-American forms. Still, those flexible pitches and patterns have an integrity of their own, even as they sit inside Western keys and chords in much of jazz and blues music, for example. What I mean is that blue notes are wholly expected to ears like mine. They are part of what makes something sound good. To my ears and heart, the wail of a gospel vocalist and that of an electric guitar are kin. I know that we organize sound by genre, but I also know that genre confuses the architecture and genealogy of sound. My grandmother slapped her knee when we watched *Hee Haw* because country music is kin to blues. Indeed, the blue note sits, like Blackness, within a tradition that is now a central part of, but also far exceeds, the Western empires that named it. We are local and we are global.

The body of the enslaved person was regimented, restrained, treated violently, treated as commodity. It was marked as other and outside. But each day each person made slave stood inside life. People who were born, lived, and died enslaved had to live too. That's not an abstraction. It is a fact. Their lives were endurance, survival, anguish,

and yet also love. They laughed. They chose to dance. They had distinct personalities, nicknames, idiosyncrasies, and illnesses. They played with sound. They made music. They bent, slid, elided chords. Blue note living.

Imagine what it must have been like, to be a person with faculties—thoughts and imaginings that lay far beyond that which those who claimed to own you could reach. They—masters—could possess body but not mind. Your thoughts, your feelings, your prayers, your art were yours. A sound could be released to attest to all of that, a sound to make the hairs on the back of a body's neck stand up. A sound without words but fully imbued with meaning. Held but never possessed.

A BLUE NOTE.

BLUE POTS

◇◇◇◇◇◇◇

THERE IS AN Ashanti folk tale about Anansi the spider in which the sun god offers Anansi a clay pot filled with the wisdom of the world. Anansi is directed to share it with everyone. But upon seeing all of the wonders the pot holds, the spider becomes greedy. He decides to keep knowledge for himself by hiding the pot in the tallest tree, where it will be masked by branches and leaves. Anansi struggles mightily while carrying the heavy pot up the tree. His daughter suggests he might ease his burden by placing the pot on his back instead of balanced between his legs. Rather than being glad at the useful suggestion, Anansi is enraged. How could someone so young have a better idea for carrying his load than he, possessor of all the world's wisdom? In his fit of anger, Anansi casts the pot to the ground, where it shatters, scattering wisdom far and wide across the globe. The moral as I see it: vessels for "truth" are vexing.

Josiah Wedgwood, the White American ceramicist famous for pots and pitchers, experimented with over five thousand formulae before arriving at what we know as jasperware in 1774. The preserved pieces are stunning. Jasperware is dense. Its delicate raised images are made in a crisp white, usually against a sky blue background,

although sometimes it is found in other colors. The blue, however, is distinguished by its combination of clarity and richness.

Wedgwood was an innovator. He used transfer-printing techniques that allowed him to produce ceramics far more rapidly than hand-painters. Wedgwood also produced illustrated catalogs and offered some of the earliest "buy one, get one free" promotions, as well as money-back guarantees. In addition to being a marketing master, Wedgwood was an abolitionist.

In 1788 he created cameos for the Pennsylvania Society for the Abolition of Slavery. Using an image made by fellow abolitionist William Hackwood of a Black man in bondage kneeling in supplication as a model, Wedgwood donated cameos that were sold to raise money for the anti-slavery cause and to offer abolitionists a way to publicly display their politics on their persons.

Wedgwood also used the kneeling image on blue jasperware candleholders. On these, the Black man is fashioned in white, but his Blackness—in feature, posture, and hair—is undeniable. Other abolitionist tableware included sugar bowls that announced that they were filled with sugar that didn't come from slave labor.

Such objects were a counterstatement to more popular blue household luxury items, ones that celebrated the peculiar institution of slavery. Tobacco jars made of blue Dutch delftware were in high demand, holding the intoxicating crop that was miserably worked in dizzying fields. Some tobacco tins even indicated the point of origin for what they held, emblazoned with the word "Martinique" or "Cuba." Others were adorned with images of Black and Asian people though instead of the sorrowful face of a person in supplication, these were exotic images of men in turbans. Sugar bowls in homes were also signs of bourgeois domestic life made sweeter by slavery. Subtle status symbols, they were signs that whoever possessed them had the means for everyday indulgence at the expense of lives.

In a sense, the gap between the human condition of those whose

labor filled sugar bowls and tobacco tins and those who would possess such luxury items was one of the clearest ways to see how race was organized. This would persist beyond the age of slavery, as race and labor remained tightly connected well into the twentieth century. And while gentry wouldn't be all White, and the oppressed wouldn't be all Black, Indigenous, or Asian, where and how the bulk of each group lived and worked shaped modern life.

I am a collector, of stories, of course, and art, but also ephemera. I wanted to own one of Wedgwood's ceramic Black men. I bought a tray. But because of the blue, I'm not sure where to put it. It is too clear, light, and pretty for the rooms where it can be seen by guests. I keep those jewel- and earth-toned. Only my minty bedroom has the kind of delicacy the color requires. But it is strange too, that a depiction of slavery—even an abolitionist's depiction—is pleasing to my eye. I don't know how to describe it. It is not serviceable. I cannot in good conscience rest anything on top of that Black man made in white relief. Wedgwood's tray is my uncomfortable ephemera.

Thomas Commeraw was also a ceramicist. He made German-style stoneware. It has a more organic look than Wedgwood's. And he also worked in blue, though his was of a deeper color. Commeraw was born sometime in the late eighteenth century, though the exact date is unknown. He lived in New York. And though his pottery has been long recognized for its quality and distinctiveness, only recently has the fact that he was a Black man been historically documented. Scholars believe he was enslaved by William Crolius of the Remmey-Crolius family, influential New York potters, and was trained to work by and for them. Once emancipated, after the Crolius patriarch died, Commeraw became a competitor to his former master's family.

He had a flourishing business. On his pots, he wrote, "Comeraws stoneware n. York Corlear's hook" to tell purchasers that the piece was made by him at his studio in Corlears Hook, New York. Location was an important part of Commeraw's self-identification. And he added a

flourish to his signature: the *s* in his name and the *n* (an abbreviation for "new") were both written backwards. With a flair that would resonate with a twenty-first-century graffiti artist, Commeraw's decorative style was more original than Wedgwood's—his pieces were often covered with freehand clamshells, half-moons, and curlicues, painted in deep blue. Looking at his pieces today, hundreds of years after they were crafted, I think he drew flower buds more than blooms—because possibility and anticipation are captivating. He makes you think of what might be, in containers that were practical and also pleasurable.

If you read American literature, you may remember that the place where Commeraw worked, Corlears Hook, is referenced by Herman Melville in his classic novel *Moby-Dick*: "Circumambulate the city of a dreamy Sabbath afternoon. Go from Corlears Hook to Coenties Slip, and from thence, by Whitehall, northward. What do you see? Posted like silent sentinels all around the town, stand thousands upon thousands of mortal men fixed in ocean reveries." Melville was insightful. In 1820, Commeraw was indeed moved by ocean reveries. He was successful, professionally, but he undoubtedly faced discrimination and mistreatment as a Black man, and he took to the water. Commeraw joined the American Colonization Society and moved to Sierra Leone in anticipation of the nascent colony of Liberia, which was established for Black people of the Americas to return to Africa. As I mentioned at the beginning of this book, the society's boosters included White Americans who saw Blackness and US citizenship as incommensurable. Enslaved or expatriated were the only acceptable Black possibilities, as they saw it. But for Commeraw, and others like him, Liberia promised what its name indicated, a much-vaunted but exclusionary American ideal: liberty.

Once there, Commeraw found himself impressed by the land but deeply frustrated by colonialism. He and his peers weren't as free in Africa as anticipated. Shortly after arriving, they were forced to move from the rich farmland on which he had originally settled and travel

farther inland, where they were exposed to an unfamiliar environment and tropical diseases. His wife grew ill and died. Commeraw returned to New York a single father in 1822. He died back at home a year later. Today, Commeraw's pots are held in high regard and preserved, but it is only very recently that his full history has been uncovered. I can see why he was so committed to signing his name, leaving behind a call for recognition, even though our heeding it is belated. I wonder what would have happened if he hadn't come back. If Commeraw had stayed in Liberia and claimed his place as a leading colonial citizen, he might have been better known. But for what? I hope that writing down both his mastery and his heartbreak, his hope and his defeat, is a storytelling that he would find fitting.

I cannot afford a Commeraw pot. They run upwards of $100,000, if you can find one. But if I could, I would probably habitually put my face in its opening to see if I could catch the scent of brine and old oysters.

One of the remedies we who study Black life have pursued is diligent recovery in the face of being forgotten, obscured, or submerged. We piece together clues and uncover hidden stories. This work is important because the work of remembering is also the work of asserting value to what and who is remembered. It matters to know Commeraw's name and cherish his work. And yet it also matters to remember his personal adversity, even in a life of achievement. And all the shattered stories and names that will never be recovered.

On the Caribbean island of Saint Croix, ceramics were, as in many places, an important artifact of colonial culture. They were brought by a sequence of colonizers and enslavers: Denmark, the Netherlands, France, and England. To this day, broken pieces of dishes and cups still litter the grounds of the old sugar plantations. Some of them are broken because old things just break. Others were splintered because of the Danish tradition of smashing plates on New Year's Eve. Still others cracked in riots and rebellions. Shards adorn Saint Croix.

Over generations, bits were swept into the water and settled into sand below the crystal blue and white waves. Today, it is considered good fortune for swimmers to come across these shards. Locally they are referred to as "chaney," a portmanteau of "China" and "money" first adopted by island children who used them as play money. Who knows whose great-grandmother's forehead was once sliced by a ceramic chunk dashed by an angry planter? Who knows which ancestors' Black hands held them at dinner and wondered at the contrast between the plate and flesh, a contrast that kept them standing and laboring while others sat and partook in delicacies. Whose children's children's children play with unmatched and discarded parts that had been touched by their elders, Black and White, Indigenous and Asian? There is no way to make these sugar bowls and gravy boats and who carried them and when and why whole again. If I am ever in Saint Croix, I will say a little prayer that walking along the sea one morning, a soft bit of chaney will run with the tide over my feet. I'll pick it up and notice a blue delft torso with working hands on it, a decorated shard to hold. The smooth and faded blue and white shapes covered in illustrated bits and flourishes are souvenirs of a fragmented history. It belongs now to the descendants, who gently hold the softened leftovers and decide for themselves if they are of value. I think they are.

LONELY BLUE

✧✧✧✧✧✧✧

The gold brow plumbs the blue. The diver sun—slow dived from
noon—goes down; my soul mounts up! She wearies with her
endless hill. Is, then, the crown too heavy that I wear? . . . Yet it
is bright with many a gem; I, the wearer, see not its far flashings;
but darkly feel that I wear that, that dazzlingly confounds.
—HERMAN MELVILLE, *MOBY-DICK*

BILLY BLUE WAS born sometime in the 1760s in Jamaica. Which
one—the island or the New York City neighborhood—historians
can't say. Archives haven't yet coughed up that piece of evidence. But
we know he earned his freedom from slavery during the Revolution-
ary War by fighting alongside the British Loyalists. After their defeat,
Billy Blue made his way by ship to London. There he worked on
the docks, unloading cargo, and took on a second job making hot
chocolate. The latter is probably what lost him his freedom again.
Billy Blue stole sugar—which was wrapped in blue paper cones to
emphasize its whiteness—that he tastily disintegrated into the dark
beverage. Hot chocolate was a powerful but bitter stimulant with
even more kick than coffee, and he did what he could to make it pal-
atable and profitable. In 1796, Billy Blue was convicted for having
absconded with eighty pounds of sugar in a single day. As punishment,

he was forced to serve his sentence as a convict laborer on the docks. After a few years, he was shipped out to the convict colony, Australia.

Blue arrived in Sydney in 1801 and continued to do his time. After two years, he was free again and married a fellow ex-con, a White Englishwoman named Elizabeth. Together, they built a life. With six children to care for, Billy continued to work several jobs related to the water, including selling oysters. He was a jocular and idiosyncratic man. Eventually his reputation grew. Billy Blue was known as an entertaining character and well regarded enough to become a constable, a harbor watchman, and eventually the proprietor of a farm.

In 1818, Blue was arrested again, this time for rum smuggling. He claimed innocence, that he just happened to find the barrels of rum on the water, but his protests were in vain. Blue was again incarcerated for a year. While he was away, other landowners attempted to take ownership of his property based upon his conviction. But Billy Blue appealed to the governor, citing his years of service, and was allowed to maintain his land—after which he and his family changed businesses again. They turned to running a ferry boat and selling produce.

Elizabeth died in 1834, and subsequently Blue's behavior grew erratic. He donned a top hat, naval uniform, and cane, and demanded everyone refer to him as Commodore. He became routinely argumentative with passersby and was arrested often. Blue must have been lonely. He'd seen more of the world than nearly everyone in his midst. He'd left and lost people forever on at least three different occasions. One wonders what he remembered and what he forgot over the course of those trips and whether he ever had a sense of belonging. It is possible that his wife, Elizabeth, was his only friend and his one true home. The Blues together seem to have been a force as a family. They left their mark on the area. One can still find the Billy Blue Inn and Blues Point, along with several other places in Sydney, named after him and his descendants. We know he was there. But how he felt about it all, that we have to guess.

THE DISPERSAL OF large numbers of Africans across the globe brought groups of various Black people into contact with one another, and into contact with others—some who were also called Black and some who weren't. Blackness was treated as a troubling stain yet also became a sort of magical ink. One Black person could make more; each touch of African ancestry made more Black people. The Blue kids, for example, were Black. And as such, Blackness grew vaster and even more varied than the large and varied continent of its origin. It had myriad permutations of languages and cultures that nevertheless shared habits of syncopation, arms akimbo, cut eyes, teeth sucked and kissed, propulsive laughter, and call-and-response and recursive storytelling and speaking styles. For this reason, I would guess, as varied as Black people are, we are so often quick to laugh heartily at our similarities and dance to each other's music. The rhythm sustains. It teaches us how to survive and improvise, lessons we've all needed. Maybe that's why we teach our babies to dance before they even walk.

BUT ALL THAT said, part of the story of Blackness must focus on those who ventured into White spaces largely or completely alone, like Billy Blue. Singularly marked, or one of few, without the cushion of a common culture with an active font or the prospect of revolt, a lonely Blackness could make a soul blue. These folks often fended for themselves in isolation—usually at the bottom of the barrel of a given community. Or distinguished themselves, though still were dismissed. Examples abound in history. We might consider the poet Phillis Wheatley in this number. The first published Black woman poet in the United States, who is famous to this day, died without a marker. Her bones might lie in the Old Granary Burying Ground or Copp's Hill cemetery on Boston's peninsula, where the gravestones look bluish in morning light. But there is nothing that reads "Here

lyes Phillis Wheatley," as exists for the people who owned her, the ones for whom there is far less historic significance.

Likewise, the Black people who Henry Thoreau found living around Walden Pond when he retreated there as part of his spiritual and political quest lived lonely lives. He called them "Former Inhabitants and Recent Visitors"—i.e., Black squatters who lived in the woods. Mistreated in town and enterprising but poor, they took refuge in the wilderness. He described how one of them, a woman named Zilpha, "had her little house, where she spun linen for the townsfolk, making the Walden Woods ring with her shrill singing, for she had a loud and notable voice."

Thoreau continued:

> At length, in the war of 1812, her dwelling was set on fire by English soldiers, prisoners on parole, when she was away, and her cat and dog and hens were all burned up together. She led a hard life, and somewhat inhumane. One old frequenter of these woods remembers that as he passed her house one noon he heard her muttering to herself over her gurgling pot,—"Ye are all bones, bones!" I have seen bricks amid the oak copse there.

Zilpha White had been enslaved by a local physician, Charles Russell. Russell was a British Loyalist in the Revolutionary War who, fearing for his life as someone loyal to the Crown, freed his captives in 1774 and escaped to his in-laws' plantation in Antigua. Zilpha took to the woods and remained there long after her home was burned down.

In nineteenth-century New England, more Black people chose the water than the woods. Especially men, because what was hardly possible for Zilpha as a single woman was far more possible for those men who chose to venture out like Billy. On the water in New England—Nantucket, Newport, Providence, and New Bedford—numerous

Black men boarded whaling ships. They could be gone from home for years at a time, and crews were routinely disconnected from families and communities. Up to a third of these whaling crews were Black, but they were a varied bunch. Many were Cape Verdeans, the first significant Black immigrant community in the United States (in that they arrived here mostly free rather than enslaved). The Cape Verde Islands, at the end of a peninsula off the westernmost tip of Africa, are home to a mixed-race population of Portuguese and West African descent. The Cape Verdean whalers in New England were joined by Black men from coastal communities all along the East Coast and the Gulf of Mexico, as well as Barbados and other Caribbean islands, and White Europeans from Portugal, the Azores, and Canada.

The water, which had been so harrowing in bringing Black people to the New World, seemed to invite those who had the courage to venture out separately from kin and friends. In its sublime power, it had been the place for thieving lives. But it also could be the harbinger of hope. Up and down the coast and into the Caribbean Sea, maritime life became a way for Black men to strike out on their own. It was one way among many. Empire meant that there would be Black people—if only subjects and not citizens—who ventured to centers of commerce and power, and others who escaped conditions of capture and colonialism, in hidden fugitivity or on the open water, seeking. All over, some found others, some found themselves, some found nothing.

CRISPUS ATTUCKS, THE martyr of the Revolutionary War (who served on the American rather than the Loyalist side chosen by Billy Blue), escaped from slavery in the South and made an itinerant living on whaling ships. Hierarchies existed at sea as on land. And although the life of a sailor was preferable to life on a plantation or in the hold of a ship in the Middle Passage, race mattered. Melville understood this. In *Moby-Dick*, the Black cabin boy, Pip, suffers a tragic accident. He

is plunged into the ocean and comes up "blue choked." Pip is rescued but broken by the trauma, dissociated from himself and always feeling as though he is deep in the water.

> The sea had jeeringly kept his finite body up, but drowned the infinite of his soul. Not drowned entirely, though. Rather carried down alive to wondrous depths, where strange shapes of the unwarped primal world glided to and fro before his passive eyes; and the miser-merman. Wisdom revealed his hoarded heaps; and saw the multitudinous, God-omnipresent, coral insects that out of the firmament of waters heaven the colossal orbs. He saw God's foot upon the treadle of the loom, and spoke it; and therefore his shipmates called him mad . . .

Having witnessed what must have been Ezekiel's wheel—a holy tool made, according to the Bible, of pale blue beryl stone—Pip also seems to have had a Jonah experience, swallowed up and now more intimate with God. Before they boarded the ship, the narrator, Ishmael, heard a priest, Father Mapple, sermonize about Jonah's fidelity to God even in the belly of the beast. The truth is that fidelity to anything divine in a world organized around your fungibility (Stubb reminds Pip that a whale would sell for more than him) could be literally maddening. Pip's story was a fictional example that works like evidence. I cannot help but consider that the mermen he saw could have been Agwe and the Africans he ushered to Guine; maybe the fictional Pip can be read, with some compensatory effort on my part, as the visionary of an African Atlantis. Departing from it drove him mad.

Whaling ships were not the only watery way to escape captive conditions and venture out into the unknown. In the antebellum period, narrower waterways were traveled, like the Inner Passage through the South Carolina Sea Islands that could lead to Mexico and freedom. Some were beckoned by water and woods, crossing lakes or

the sea before ultimately finding themselves in Maroon colonies in Jamaica and Brazil, or the Great Dismal Swamp in Virginia. Even when destinations promised community, the solitary nature of so many of the journeys had to have been harrowing. They were traveling into an unkind world in a body marked for suffering.

Daniel Blue was another courageous soul. He traveled across expanses of land. This Blue had been enslaved in Kentucky, and after he was emancipated, he made his way out west to Sacramento, arriving there in September of 1849. Blue became a miner, sifting gold out from sand and gravel, and made enough money to buy property and build a laundry on land adjacent to Peter Burnett, the first governor in California. Burnett had previously sought to prevent African Americans from settling in California and so could not have been pleased about his new neighbor. Nevertheless, Blue confidently made himself at home. And he invited other Black folks to his door. A year after his arrival, he established St. Andrews African Methodist Episcopal Church out of his house. Later, he met and married a woman named Lucy from Alabama, and together they had a family. Not only did he settle where his neighbor didn't want him, he set down roots.

In 1864, the Blues learned of a tragic situation: a Black girl-child named Edith was being held as a slave in Sacramento by a man named Walter Gammon. Slavery was illegal in California, but Gammon had purchased Edith in Missouri. Residents saw her brutally beaten and barely clothed. Blue resolved to do something about her condition. He brought a case seeking a writ of habeas corpus on behalf of Edith against Walter Gammon. Gammon defended himself by claiming that Edith stayed with him of her own free will. Blue brought witnesses to testify about Gammon's brutality and in turn filed for guardianship. Blue prevailed, thankfully, and Edith became a member of the Blue family.

Edith's case was an echo of the *Dred Scott v. Sandford* case, which was decided before the Supreme Court in 1857. Scott and his wife and

child had been taken to free territory, where they argued they should have been emancipated. In that case, the court ruled on behalf of their owner. This case, however, took place in the middle of the Civil War, American history's crossroads. These Blues were part of a tiny remote island of Blackness, while the bulk of Black Americans were in the throes of the war-torn country many miles away. Still, the Blues' small community remained connected by circumstance, if not geography, to the larger Black world. Vulnerable to defeat, but hoping the nation and its law would finally ensure freedom.

IN THE SOUTHEAST, thousands of enslaved men fled to Union lines, and by 1863, they were allowed to don the blue uniforms of the Union Army. Their enlistment was no gift; they were necessary to save the Union. Black people had been essential to the nation since its foundation, and the Civil War was no different. What was different was that it was their battle as much as anyone else's. They were fighting to free themselves. The public understood that. A popular photo diptych circulated during the Civil War of a boy named Jackson. It showed his transformation from slave to soldier. In the text below the left photo, he is described as contraband. Jackson is barefoot, unkempt, with raggedy clothes, having arrived, orphan-like, behind Union lines. In the photo on the right, he is clean and sharply dressed in a Union blue uniform and boots, holding the drum that he played on the battlefield.

Though the image is black-and-white, today I know—like viewers would have back then—that he is wearing a uniform of deep Union blue. On the left, he is a child version of the imploring figure on Wedgwood's abolitionist image; my eyes shift to the right, and he is a member of society. Jackson's name is recorded in history.

Black people who didn't serve but who experienced the arrival of Union soldiers to plantations would often recall the visual symbolism of the "boys in blue." The boys in blue made a striking presence,

sometimes intimidating or even cruel, but most often making hearts leap. Freedom was coming! It was here!

After the war, those Union uniforms were repurposed. Soon, they attired police forces. Blue became the color of cops out of practicality, and then tradition. It was the color of emancipation and became the color of law and order. Just like the Radical Republican federal government, which abandoned the Black South just as things were beginning to look like freedom, dashing hopes for equality, these other "boys in blue" would become known as unreliable protectors of vulnerable Black citizens. I'm not projecting the present onto the past. Black American newspapers in the nineteenth century and all through the twentieth are filled with stories of frustration, outrage, and sometimes devastation when it comes to Black encounters with police forces. Protection is a strange concept when you have been constructed and often treated as the enemy within your own country. When your presence is deemed lawless and disordered, the force of law and order often puts you at odds. When you are one of the lonely people, misfitted in the nation's self-image, you can look like threat even when you're the one with the foot on your neck. That is not intended to be poetic. It is just a way to name the raw consequence of a long history in which Black yearning to be free was verboten for longer than it has been accepted. Sure, things have changed. We are not slaves. But what is is still not good enough.

In the twenty-first century, the retaliatory response to the slogan "Black Lives Matter" was "Blue Lives Matter." Think about it. The quip contrasts Black life with police survival—one must choose, it implies. And that is a blues song indeed.

BLUE-EYED NEGROES

◇◇◇◇◇◇◇

LITTLE BURGHARDT DIED of diphtheria. His father remembered the gaze and weight of his son:

> his eyes of mingled blue and brown, his perfect little limbs, and the soft voluptuous roll which the blood of Africa had moulded into his features! I held him in my arms, after we had sped far away from our Southern home,—held him, and glanced at the hot red soil of Georgia and the breathless city of a hundred hills, and felt a vague unrest. Why was his hair tinted with gold? An evil omen was golden hair in my life. Why had not the brown of his eyes crushed out and killed the blue?—for brown were his father's eyes, and his father's father's. And thus, in the Land of the Color-line I saw, as it fell across my baby, the shadow of the Veil.

In 1903, W. E. B. Du Bois published this personal essay, "Of the Passing of the First Born," in his book *The Souls of Black Folk*. He was thirty-five years old. A native of the tiny Black community in Great Barrington, Massachusetts, Du Bois had traveled far beyond his origins. After completing his undergraduate degree at Fisk Uni-

versity in Nashville, he'd attended Humboldt University in Berlin and finally was the first Black person to earn a PhD from Harvard. A prolific scholar, at thirty-five, Du Bois already had a long list of publications, had taught at Wilberforce and Atlanta University, and pursued groundbreaking sociological research at the University of Pennsylvania. He was a force to be reckoned with globally—having forged connections with intellectuals of African descent across national borders, as well as White American and European thinkers who believed in racial equality.

But *Souls of Black Folk* was different from Du Bois's traditional scholarly writing. Since 1897, he'd been penning essays of appeal for the *Atlantic Monthly*. They were cogent and emotionally compelling pieces. *Souls of Black Folk* was written with that voice. It was an account of Black living and yearnings under the yoke of Jim Crow. A plea for the "darker brethren" who lived "behind the veil," composed with every tool at hand, the book defies genre. It is at turns expository, fictional, social criticism, and economic analysis, a collage or quilt of writing. Most poignant is Du Bois recounting a story of the death of the son he had with his first wife, Nina. She was a homemaker, and he was a professor at Atlanta University. When Burghardt fell ill with diphtheria at a year old, several doctors they visited refused to care for him because he was a Black child. Though an antitoxin existed for diphtheria, it was not made available for Burghardt. His death was preventable.

Burghardt, with blue-tinged eyes and golden hair, was Black according to what the concept meant in the United States. His father, knowing the weight of that status and fully grieving, allowed himself to consider what might have been, had his child survived. The baby might have grown up to be stifled and stymied by Jim Crow. He had been spared that fate. On the other hand, he might have been a leader who shepherded his community toward justice, a hero in the vein of his heartbroken father. Baby Burghardt died at the hands of the color

line. And the tinge of blue in his eyes spoke quiet rules: the segrega-
tion statute and the laws against interracial marriage never meant that
human beings of different races would not have sex and children. It
meant that the children of the nation would be sorted and stratified
into heirs and slaves, or citizens and their second classes, based upon
the tinge (or more) of Black.

In another chapter of *Souls* about the Black Belt region of the
South, Du Bois wrote:

> It is a land of rapid contrasts and of curiously mingled hope
> and pain. Here sits a pretty blue-eyed quadroon hiding her
> bare feet; she was married only last week, and yonder in the
> field is her dark young husband, hoeing to support her, at
> thirty cents a day without board. Across the way is Gatesby,
> brown and tall, lord of two thousand acres shrewdly won and
> held. There is a store conducted by his black son, a blacksmith
> shop, and a ginnery.

The blue-eyed barefoot girl and her dark husband are linked,
legally speaking, on two counts: by marriage and by race. The rule of
hypodescent in the United States treated Blackness as a stain, a drop
of it, like the bad apple, ruining the body. Inside the group, there was
an arc, a colorful one, from blue-black to blue-eyed, which made a
stratified yet eclectic community in both body and experience. The
law of race, however, was absolute. An 1858 case before the Supreme
Court of Arkansas, *Gary v. Stevenson*, in which a young man born of
an enslaved woman sought to be acknowledged as White, made this
abundantly clear, stating, "Where, in a petition for freedom, there is a
preponderance of testimony that the petitioner belongs to the negro
race, the presumption of law at once attaches that he is a slave. Where
it is a matter of doubt whether the petitioner belongs to the negro race,
evidence that the woman reputed to be his mother, and owned to be

such, was lawfully held in slavery, repels any presumption that he is entitled to freedom." This was the ruling despite a doctor's testimony that there was no apparent African descent in his family tree.

In recent years, there has been a great deal of debate over whether it makes sense to hold on to the definition of Blackness in the United States that includes those who don't, to borrow old-fashioned language, "show color." The debate hinges on experience, bias, and beauty—with some arguing that Black should only belong to those who are seen as undeniably Black. But turning to historic literature allows for a different kind of lens, about how race has been a technology through which we are produced, not just a matter of being seen but of coming into being in the world, from cradle to grave.

In one slave narrative titled "Aaron's History," the following passage makes the ironic yet fastidious working of the color line clear:

> I got to conversing with a yellow man with light hair and blue eyes, and he told me he shipped on board a ship to go to South Carolina at the time of Nathaniel Turner's insurrection in the State of Virginia. They then passed a law that no free man of color should land on the soil of South Carolina. The constables and other officers came down to search the vessel to see if there were any free men of color to take up and put in the Calaboose. This yellow man that had light hair and blue eyes, he told the constable he was the colored man, and the constable told him he was a damned Yankee and a liar, and went down into the kitchen and saw a white man that had black hair and black eyes, but he was a full blooded white man, but he took him and put him in jail and kept him four days until the vessel was ready to sail, and the white man swore he would never go to the south any more, and he is now one of the greatest abolitionists in the state of Connecticut. This fact can be proved by several white men in Norwich.

Race is messy and exacting business. It pretends to be precise, but it never has been and can't be. Human beings are far too varied and intimate. When abolitionist Black writer William Wells Brown wrote about his life in slavery, he commented on how uncomfortable blue-eyed slaves made mistresses of plantations. Sometimes their mothers had skin that was jet-black or brown, while they—with straight hair and blue eyes—took on the likenesses of their fathers: men who were their masters. Brown recounted the story of a visitor to his plantation:

A gentleman, whose acquaintance Dr. Gaines had made, but who knew nothing of the latter's family relations, called at the house in the Doctor's absence. Mrs. Gaines received the stranger, and asked him to be seated, and remain till the host's return. While thus waiting, the boy, Billy, had occasion to pass through the room. The stranger, presuming the lad to be a son of the Doctor, exclaimed, "How do you do?" and turning to the lady, said, "how much he looks like his father; I should have known it was the Doctor's son, if I had met him in Mexico!

Mistakes notwithstanding, being born into Blackness usually kept one there regardless of appearance. Abolitionists used images of blue-eyed Black people as evidence of the perfidy of slavery, an institution in which sexual violence was institutionalized. White wealthy men in the antebellum South made blue-eyed Black slaves by wielding indecent power. Enslaved women with light skin and blue eyes were often designated for the "fancy trade," meaning that they were bought and sold for sexual exploitation. This practice, and the women who were subject to it, were discussed in speeches and pamphlets that circulated among abolitionists in New England and Great Britain. Though the "sin" evidenced by a blue-eyed slave was supposed to

convince readers that emancipation was necessary, the whiteness of her body was also supposed to elicit sympathy. The reader was made to imagine someone who looked like them held captive. The suffering of a white-bodied Black woman was more moving to the White public than that of a dark woman. That color-struck method of pulling heartstrings with the image of golden-haired and light-skinned Black folks in order to advocate the cause of Black people continued long after emancipation.

In the late nineteenth century, Black women writers, often brown or dark-skinned, used near-white protagonists to appeal to their White female readership. For example, the virtuous heroine of Frances Harper's *Iola Leroy* is described by a dark-skinned older Black woman in the following terms: "My! But she's putty. Beautiful long hair comes way down her back; putty blue eyes, an' jis' ez white ez anybody's in dis place." And there is something profoundly sad to this strategy. Consider these writers imbuing so much feeling and imagination into their texts, but diligently keeping their bodies out of it.

In the early twentieth century, the instability of the color line allowed for useful subterfuge. Literature of the Great Migration era, when millions of Black people moved from the rural South to urban centers abounds with stories of light-complexioned Black people who passed for White, and this makes perfect sense. Separated from one's Black family and home community, and inside the anonymity of the urban landscape, people could and did remake themselves as White. And this provoked fear in the public.

Early twentieth-century criminal law cases reference blue-eyed Black thieves as a particular horror and threat precisely because they might be taken for White and therefore elude appropriate suspicion and capture. Today, in the era of genetic testing, we're learning more and more—at least on a scientific basis—about how much crossing

of the color line happened over the past five hundred years. And now the one-drop rule is softening to such an extent that those blue-eyed Black folks who once could only escape the Negro category through elaborate subterfuge are sometimes being told they should be cast out of the group to which they have known themselves to belong. Whatever changes in the coming generations regarding who counts as Black, it is undeniable that the history of the one-drop rule meant that within Black American communities, a unity in degradation that was attributed to "the blood" became a unity in ritual and culture that exceeded surface assessments. Not without rifts, of course, and not without pain and exclusion, yet the physical motley of people assigned to Blackness made a there there. We have been known to use formulations such "Black is Black" to attest to this. As a Black American of a certain age, raised and reared by multihued people who were known as "Negroes," I must admit that the thought of abandoning the one-drop rule feels like a dissolution of some of who we are. I want to keep the blue-eyed as well as the blue-black in our number.

Even in places that did not have as severe a one-drop rule, the blue-eyed person of African descent has been described as a curiosity. In the Haitian village of Cazal, for example, where there was once a significant Polish population, many residents have bright blue eyes and caramel skin. Even the spiritual identity of the village is shaped by the blue-eyed populace. The Black Madonna from the Pauline monastery of Czestochowa, Poland, has been blended with Vodou loa Erzulie Dantor into a local patron saint of sorts with brown skin and blue eyes. Visitors are fascinated by the eyes of Cazal. They are unusual, but the particular way in which they are unusual is interesting because it unsettles racial symbolism, unravels the idea that race is anything more than a social arrangement. Blue eyes are a mark of Whiteness in the racial shorthand. But it doesn't work so well in the presence of blue-eyed Black people.

Famous twentieth-century White American writers who frequented Bermuda often talked about a famous Black boatman named Joe Powell. Powell piloted Mark Twain and Eugene O'Neill, among others, around the island, and they never failed to mention that he had blue eyes. Frank Baum's Land of Oz, filled with strangeness and contradiction, was based on Bermuda. Perhaps Baum saw in Powell's eyes a reflection of the magic he'd imagine in Oz, a lush land all in blue: blue grass, trees, clothes, and homes (with the one exception being the Emerald City). Mr. Powell was a laborer, but he was also—in their eyes—an exotic local feature. Being seen, however, is very different from ways of seeing.

Jean Toomer tried to express his own "blue lens" from the inside out. A renowned Harlem Renaissance writer who, in his later years, disavowed his Blackness created a character named Kabnis. The story "Kabnis" closes out Toomer's modernist masterpiece work of creative writing, *Cane*. Kabnis is a Northerner who has arrived in Georgia to teach at a Black college. Upon reaching the Deep South, Kabnis is unsettled by the bluntness of race in the region, even for someone like him, who walks the line phenotypically and culturally between Black and White. Trapped between the conservative respectability of the Black college and the violence of White supremacy, Kabnis grows hysterical. He asserts, "My ancestors were Southern blue bloods." His colleague Lewis answers back, "And black." Kabnis retorts, "Ain't much difference between blue and black." Lewis: "Enough to draw a denial from you."

The exchange is heavy with meaning. Here is our history: the most elite men forced coupling with most degraded women, and the offspring were deeply integrated into Black America such that all our families carry the story. Yet the least degraded among Black people were the ones who had the bluest veins beneath the palest skin, a look inherited from blue bloods in the family tree. To be light-skinned in the early twentieth century offered, if not a certain escape hatch from

race and racism in the United States, a special status. It could afford greater ease, but it could also be quite lonely.

Toomer, for whom Kabnis was a fictional avatar, eventually called himself a "blue man" instead of Black, meaning a racial amalgamation, i.e., the product of "red, white and Black." We know that amalgamation, in some degree or another, exists in virtually all Black Americans. Science makes any attempt at classification even more absurd, regardless of how many categories are added. There were places that tried that fool's errand. In Latin America, there was a long history through the eighteenth and nineteenth centuries of charts and paintings that served as taxonomies of racial mixture. In the United States, we have had more casual and colloquial recent versions of the same. People say, "I'm mixed with X, Y, and Z." But Black Americans still often respond, "You are just Black," restating the old rule. Even if that is too doctrinal, and veers into an obnoxious projection of American race ideas onto the world, both past and present examples make clear that greater genealogical detail—such as the dozens of names for race in Brazil—does nothing mute the violence of racial injustice. In some instances, it can even make it worse, given that the parsing usually hinges on the value of being not quite as Black as the next person. Whether in Brazil, the Dominican Republic, or Cuba, the darker you are, the more likely you are to suffer.

Toomer sort of "passed" for White. But he was the rare passing person for whom the abandoned Black life wasn't a secret. The society just let him cross over. Others had to jealously guard the way they'd been classified at birth if they wanted to live White. And although passing meant that the White population grew marginally larger, a simple consequence of the social construction of race, passing itself held a strange reality. Black people protected those who passed. That was itself a sign that the people who passed still belonged to Blackness, and it reflected a set of commitments upon which they relied.

Passing is, in fact, a Black thing. The stories of secret family meetings, of walking past loved ones and pretending to be strangers, are legion. And still a danger persisted. In African American literature, the dreaded "reversion to type"—a child born too dark, who would reveal Black origins—was a threat. In real life, Carol Channing, the celebrated actor and singer, described late in life how her father only revealed that he was a Black man passing for White to her mother because of this worry. But Carol came out white-skinned. She only revealed her Blackness in her final years, and by that point it wasn't a liability to her career.

As much as I delight in all the colors of Blackness from blue-eyed and blue-veined to blue-black from the comfortable position of being "brown," the shorthand term for being in the middle critical mass of color, I know this isn't a happy motley. Grief can be carried in color. For some, it is the grief of being close to but not quite White, or of carrying a strangeness within Blackness that makes other Black people skeptical or resentful. For others, it is the grief of being considered too Black even for Black people, and having a body that is marked as a kind of shame, as though blue-black flesh is a disaster. What Du Bois saw in the blue tinge of his late son's eyes—a color that betrayed the brown of his father but revealed the origin of many of his forefathers—was more than genealogy; it was a marble of sorrow.

BLUE-BACK SPELLER

<><><><><><>

From the time that I can remember having any thoughts
about anything, I recall that I had an intense longing to
learn to read. I determined, when quite a small child, that,
if I accomplished nothing else in life, I would in some way
get enough education to enable me to read common books
and newspapers. Soon after we got settled in some manner
in our new cabin in West Virginia, I induced my mother
to get hold of a book for me. How or where she got it I
do not know, but in some way she procured an old copy
of Webster's "blue-back" spelling-book, which contained
the alphabet, followed by such meaningless words as "ab,"
"ba," "ca," "da." I began at once to devour this book, and
I think that it was the first one I ever had in my hands.

—BOOKER T. WASHINGTON, *UP FROM SLAVERY*

BOOKER T. WASHINGTON was born into slavery in 1856 and
died the most powerful Black man in the United States. On his path
to such stature, Washington worked his way through the newly
founded Hampton Agricultural and Industrial School in Virginia,
now Hampton University, and went on to become the founder and
first president of the Tuskegee Institute, now Tuskegee University

in Alabama. The freedpeople's passion for learning made his leadership possible. After emancipation, they wanted three things: land, suffrage, and education. When it came to the third of these, Noah Webster's guide to reading, called the blue-back speller, a literal description of its cover, was the most treasured artifact for their aspiration. Before the war, reading was a dangerous activity for bondspeople. You could be maimed or even killed, certainly sold away from loved ones, as punishment for an activity that was believed to make slaves unsuitable for servitude. People sneaked learning. Enslaved children hovered around the lessons for White children to get a little bit of book knowledge. And even those who had no chance to learn to read gathered by candlelight around those who could, who could read aloud the words of abolitionist tracts, the word of God, and news about the war. After emancipation, they flocked to schools, from toddlers to the elderly. The ones who served on Reconstruction legislatures insisted on public school systems for all of the South's children. The ones who worked the fields ended their evenings with necks bent over the blue-back speller, copying the exercises, practicing sight words, and taking in the moral instruction Webster wrote as context for literacy lessons. Booker T. Washington was one among many people who used and raised encomiums to the blue-back speller. It was the key that opened a world that he would be part of creating: Black formal education.

TUSKEGEE'S FOUNDING WAS the result of political negotiation. Lewis Adams was a prominent member of the Republican Negro Congress during Reconstruction. When Wilbur F. Foster, a former Confederate colonel, was running for election to the Alabama senate, he negotiated with Adams for Black votes. With Foster's promise to introduce a bill for a Black academic institution, he won a critical mass of Black support in Macon County.

Washington, faculty, students, and community members built the institution from the ground up. Hand to earth, they raised classrooms and dormitories. The institute was sustained by their large farm in the rural Black Belt. Tuskegee was a marvel. But the very thing that made it possible, Black political power, was soon denied completely. And as an institutional leader, Washington wouldn't rock that boat.

Washington gained the ear of the leadership class of the country, but it was given in large part because of what he wouldn't insist upon: full political and civic rights for Black people. He was largely responsible for the expansion of schools throughout the South for Black children, but he iced out Black educators and intellectuals who rejected his accommodationist program. Without the basic protection of one's rights, it was difficult and even impossible for Black farmworkers to protect themselves from being cheated out of their yield of a harvest, or for those who aspired to other kinds of work to gain access to workers' guilds or professional associations. Yet and still, Washington, along with many others, built a world—as his fervent critic W. E. B. Du Bois would call it—behind the veil. Du Bois railed against Washington for failing to advocate for suffrage rights and access to a classical education of the sort he could provide students at Atlanta University. Tuskegee was different. It was a working farm in the midst of the Black Belt with threat right outside its gates. Inside, there was aspiration and attainment as well as lament. Tuskegee was conservative, rural, and demanding. It produced scientists, engineers, health care workers, artists, teachers, and critics. It was also, for many, a Black oasis. And it all started with Washington getting his hands on that blue-back speller. Du Bois attested to its potency himself, from his time teaching in rural Tennessee: "There they sat, nearly thirty of them, on the rough benches, their faces shading from a pale cream to a deep brown, the little feet bare and swinging, the eyes full of expectation, with here

and there a twinkle of mischief, and the hands grasping Webster's blue-back spelling-book."

MATERIAL CULTURE, ARTIFACTS and objects, tells you something about what mattered most to people. Noah Webster believed that an educated populace was good for democracy. The blue-back speller emphasized moral virtues and religious precepts, yet was also deliberately composed, making it easy for an autodidact to use. In Frederick Douglass's narrative, he describes how he learned to write by copying letters from the blue-back owned by his master's son: "I commenced and continued copying the italics in Webster's Spelling Book, until I could make them all without looking on the book." Years later, Booker T. Washington would describe these labors as essential to Douglass's victorious path to freedom, writing:

> Everything . . . contributed to his enlightenment and prepared him for that freedom for which he thirsted. His occasional contact with free coloured people, his visit to the wharves where he could watch the vessels going and coming, and his chance acquaintance with white boys on the street, all became a part of his education and were made to serve his plans. He got hold of a blue-back speller and carried it with him all the time.

There were so many millions of blue-backs sold that it isn't hard to find one now. It will fit in the palm of your hand and, to today's reader, seems quite modest. But imagine what it meant to possess what had once been forbidden—because you were a slave. Books belonged to the free.

Molly Brown, a former slave, when asked about her education in the late nineteenth century, replied proudly, "Course I learned

to write . . . What kind of books did we have? I read and spelled out of the Blue Back Speller." A man named Hemmett Dell explained it as literally the tool of his transition: "After the war he [Dell's former master] took me by the old brass lamp wid twisted wick—it was made round—and lernt me outer the Blue Back Speller and Rithmetic. The spelling book had readin' in it." Dell's touchpoints, light and study, are resonant. They held the promise of dawn; the prohibition against literacy—a rule of slavery—was behind him. And even when Reconstruction ended and Jim Crow became the law, cruel and swift, learning was something to hold on to.

In a time and place where people caught hell quicker than a cold, a country harder than iron if you were born Black, books became an anchor, heavier than a plow in Jim Crow America. Account after account of Black education refers to the speller. So much so that it becomes a clever reference point in Ishmael Reed's 1972 novel, *Mumbo Jumbo*. Papa LaBas, a hoodoo man and private eye who runs the Mumbo Jumbo Kathedral, "a factory which deals in jewelry, Black astrology charts, herbs, potions, candles, talismans," has his own blue-back speller, which is required reading for all conjurers who come to study. Reed's carnivalesque satire strikes a powerful note. Literacy was the goal of the newly free. But it was also a habit for staying free. Jim Crow controlled where one walked, shopped, worked, rode, ailed, died, and wept. And that was according to law. Outside the law were lynch ropes and burned towns. Against that backdrop, education was one thing no one could take away from you just when it seemed like damn near everything promised was snatched away.

EGYPTIAN BLUE IN ALABAMA

◇◇◇◇◇◇◇◇

> Young Carver used to study an old blue-back speller by
> the dim light of the burning logs in the fire place. It was
> in this way that he learned this little book by heart.
> —RALEIGH HOWARD MERRITT

CARVER WAS DARK, darker than most. Ed Pryce, an art student
and later professor at Tuskegee, noticed that. Carver was meticu-
lously groomed, broad-shouldered, and thin. His voice was unusually
high-pitched—Louis "Mike" Rabb, a student and later administrator
at Tuskegee, told me that. And when Carver sang, it was in a beau-
tiful soprano register. People who remembered George Washington
Carver after his death would comment on his presence, not just his
work. His brilliance was unquestioned. But his persona unnerved
more than a few. Raleigh Merritt, however, was a man who adored
him, writing:

> While studying agriculture at Tuskegee, I was brought into
> somewhat intimate relations with Dr. Carver, and began an
> acquaintance which has continued to grow . . . Dr. Carver
> prefers not to be made the subject of any biography. He has
> felt, however, that if it is to be written, it is best done by a

friend who has known him for several years, and whose judgment and discretion he can trust, and one who, because of his knowledge of the facts, will not misrepresent him.

George Washington Carver arrived at Tuskegee Institute in 1896, where he would teach and live for over fifty years. The impressive young scientist was invited by Booker T. Washington to serve on the faculty and left his appointment as the first Black faculty member at Iowa State to do so. Before moving to Tuskegee, Carver had never lived in the Deep South, though he had been born into slavery on the Moses Carver plantation in Diamond Grove, Missouri, around 1864. His father had died before George was born, and as a baby, he was stolen, along with his mother, by slave raiders during the war. Perhaps they considered the baby too much trouble because they returned infant George to the plantation but kept his mother. Mother and son never met again in life.

THOUGH HE HAD effectively been made a motherless child, Carver grew up under the care of a local Black family that nurtured his interests. As a child, he loved plants, crafts, music, and learning. A motherless child, he cherished a few inherited possessions from his mother, including her old spinning wheel and polar lamp. He carried them with him whenever he traveled to acquire more education. A gifted student, Carver first enrolled at Simpson College in Iowa to study piano and painting. One of his professors, however, encouraged a practical course correction: botany and horticulture fit Carver's interest in nature and great facility with plants. He heeded her advice and flourished in those fields. After Simpson, Carver completed a degree at Iowa State with a focus on plant breeding in 1894 and immediately began teaching.

Haint Blue Door
Dawna Moore

Reckoning: Grief and Light
Vanessa German, 2021, The Frick Pittsburgh

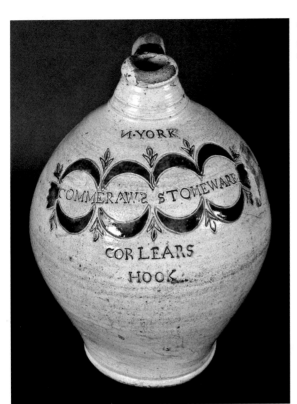

Thomas Commeraw Jug
Circa 1810, The Thomas
Commeraw Project

Image of Ashon Crawley's *Homegoing*
Photograph by Steve Wienik

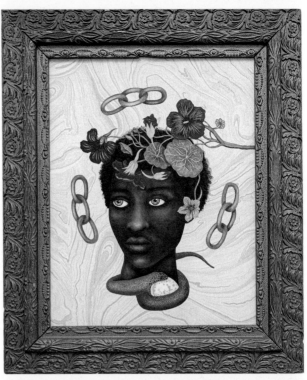

Anastacia Martyr
2023, courtesy of the artist
and Various Small Fires

Children Now Play in the Serf
Photograph by Alexandra Yingst

ABOVE:

Finding Freedom
Sonya Clark, 2019–2020,
collection of the artist.
Installation view at High
Museum of Art in Atlanta,
Georgia. Photograph by
Alphonso Whitfield.

LEFT:

Collide
© Lorna Simpson,
courtesy of the artist
and Hauser & Wirth

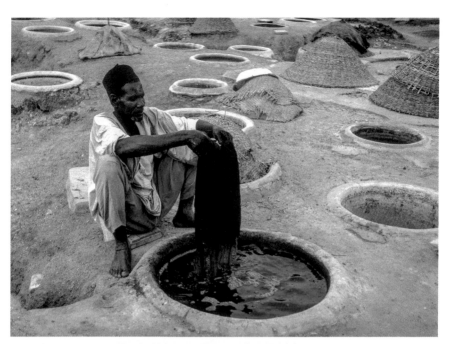

When Carver first arrived at Tuskegee, there was little money and few resources. Nevertheless, he was charged with building an agricultural department. Carver made do. Along with his students, just a generation out of slavery, with Jim Crow yoking them all, Carver collected bottles and broken glass and used glassblowing techniques to create makeshift test tubes and sample dishes for the laboratory.

Carver was different, but he behaved in a way that was familiar to Tuskegee locals. He wandered the forests and hills, observing and collecting flora. This was the common behavior of a hoodoo man. And though he wasn't one, like those seers, Carver moved through nature with a spiritual purpose. He described how God spoke directly to him through the plant world. Local folk turned to him for guidance in the way they were accustomed, as though he were a root worker. Carver responded in kind: distributing topical salves for ringworm and oak rashes made of the juice of black nightshade leaves and sweet cream, among other remedies. Though he wasn't apprenticed to an elder conjurer, Carver did learn about medicinal plants from his relationship with the local community—for example, they had a plethora of healing uses for blue gentian, the bottle-shaped royal blue perennial flocked to by bees, and he recorded them. Carver also noticed their efforts, even in the most modest of circumstances, to live with some elegance: whitewashed walls, swept yards, and hand-stitched textiles. He ached at the depth of their poverty, and as a scientist worried about the exhaustion of the soil they worked for a pittance.

Carver brought everything he learned along the way, and all his observations, into his lab. The purpose of education, as he understood it, was to contribute meaningfully to humanity. He instructed his pupils that they were to be humble and observant researchers, believing that humility was not as a mark of inferiority but a sign of decency. He taught local farmers the latest in agricultural knowledge he'd learned in Iowa. He also shared health and wellness information

he acquired through regular correspondence and study. Carver remained both an educator and pupil throughout his adult life in order to best serve the community where he made a home.

Carver's greatest impact on the lives of people in rural Alabama grew from his desire to repair the damage caused to the land by the wild pursuit of cotton wealth. Carver described the problem in this way: "Everything looked hungry: the land, the cotton, the cattle, the people." And it was all a result of misuse and greed.

> The virgin fertility of our soils and the vast amount of unskilled labor have been more of a curse than a blessing to agriculture. This exhaustive system for cultivation, the destruction of forest, the rapid and almost constant decomposition of organic matter, have made our agricultural problem one requiring more brains than of the North, East or West.

And so, Carver introduced the practice of crop rotation. That's where his famous peanuts came in. He instructed the people to grow cotton one year, then peanuts the next. And so on. Carver believed that if you loved anything enough, it would tell you its secrets. He loved the Alabama soil, and it was his teacher.

IN 1915, A boll weevil infestation did major damage to cotton plants across the Deep South, leaving behind a wasteland. But Carver was ready. Peanuts came up in 1916 as promised. They were bountiful. Too bountiful, in fact. There were far more peanuts than anyone knew what to do with. Carver set about finding a solution. They had to be put to good use. He sent out a bulletin sharing all imaginable uses for the harvest. With peanuts—and also pecans and sweet potatoes—he created recipes for hundreds of products that ranged from soups and fudge to soaps, lotions, laxatives, and liniments. Alleviating suffering,

satisfying hunger, and providing some sweetness—all the formulae fit into Carver's mission.

Carver worked incredibly hard, but he indulged as well. Carver loved desserts, companionship, and beauty. An art enthusiast, he painted canvases with large extravagant flowers. Photographic portraits taken of him standing next to his paintings, palette in hand, show a man who is a composed and confident artist. He didn't only make paintings, however. He made the paint too, and not just for his own use, but for the surrounding community. Carver called them "rich colors for poor people." Using the skins of sweet potatoes, he made lavender and orange, and from tomato vines and peanuts, he made yellows, slates, and browns. So that they might be reproduced by anyone who wanted the rich colors, Carver maintained detailed records of his formulae, written up in his even, florid script. To share what he had learned, Carver traveled many a country road with his color swatches, encouraging rural folks to explore all the options for making their homes distinctively beautiful.

In a letter to his friend Sophia Liston, a White woman he had befriended during his youth in Iowa, Carver wrote about his fascination with blue and efforts to create it with local materials:

> It is pleasing to know that you are still interested in art . . .
> I have just received the 1928 Maxfield Parrish Calendar . . .
> There are two figures sitting upon a rock . . . He has worked in
> those marvelous blues which nobody except Maxfield Parrish
> can do . . . I do not know whether I told you that I am making investigations on the possibilities of our southern woods,
> plants and hurbs, making paper . . .

Parrish's colors were saturated. The calendar Carver was describing featured two women, with light shining upon them, but it was the rich background blues that Carver noticed, not the people. He might

have already made his own rare blue by that time. We don't know the exact date he came upon his mixture, but perhaps it was the calendar that inspired Carver's path to re-creating a historically famous color known as Egyptian blue. He called it Oxidation #9. It caused an immediate sensation. By detailing the oxidation number and process, Carver showed the world how to replicate a color that had been cherished two thousand plus years prior. But no one in the Western world had yet been known to re-create it precisely until George Washington Carver. Representatives from paint companies excitedly trekked to Tuskegee, Alabama, to purchase his formula for Egyptian blue, along with his other paints, including a striking version of Prussian blue. And as is common in such stories, Carver does not appear to have been fairly compensated for his innovation. But that didn't dissuade his constant innovation. He was driven by beauty and care rather than accumulation. He described the things that money could not buy as the "imperishables" and treasured them accordingly.

Egyptian blue, like indigo, had captivated the world in waves. Egyptmania was cyclical in the West, the subject of exotic fantasy and a model for designing luxury items. But that was rather remote from Carver's concern. He spent most of his life in a humble place. He was a queer man, the subject of gossip (to this day people repeat fantastical stories about his genitalia) in addition to admiration. And as long as Washington lived, Carver was often at odds with the founder and president of the institute. But he nevertheless made a rich and beautiful life living in a rural corner while having a global reach.

At home, Carver liked to eat peanuts covered in chocolate for breakfast. In the evening, he weaved baskets, crocheted, and embroidered. And if you visit the museum on Tuskegee's campus today, you can see the samplers he made. They are small and elegant, mathematically precise works of craft, with even stitches worked into lace, flowers, and crosses. His embroidery is layered, filled with three-dimensional

geometries of flowers and scrolls. One can imagine that he was replicating what he observed in nature and through microscopes: the organic and divine mathematics of the earth. Like living fractals, his crafts were a ritual repeating nature's beauty. As with his paintings, in photographs where he holds his needles, he looks content, even radiant.

The effort to categorize and professionalize human beings can be a tool of misdirection and misunderstanding. Taxonomies of all sorts cost a lot. Carver gave us formulae, but he defied categories. It is not enough to say he was a scientist. Or to add artist and teacher and aesthete to his labels. We do better to fully acknowledge the conjure-like nature of all his ways. He once said, "The first thing one must learn about a sweet potato is that it is a morning glory." The lesson: ordinary things are beautiful and varied beyond what we might guess on the surface. He also said, "The difference between a weed and a flower is a judgment." I know that because I once got the sentence in a fortune from a fortune cookie, which I saved. One day, years later, I posted a picture of the fortune on Instagram, and my colleague, friend, and fellow writer Tracy K. Smith responded to tell me these were George Washington Carver's words. It was welcome kismet—I had been writing and thinking about him at the time. It was as though Carver were speaking directly to me many decades after his death.

In his abundant insightfulness, Carver understood the utter generosity of nature, which was in stark contrast to the greed of civilization. To set civilization aright in its relationship with nature is among the greatest tasks of freedom and justice. This was at the heart of how Carver connected with people and his place.

Tildy Collins was a native of Alabama who remained there all her days, as far as we know. She was not distinguished in history like Carver. Upon walking up to Ms. Collins's house, a WPA worker who interviewed her noticed its beauty:

In front of her one room cabin is a neat garden of vegetables and flowers combined, with morning glories trained carefully over the fence nearly all the way around. There is a saying in the South, that cotton will grow better for a Negro than for any other race, and this might well be extended to include morning-glories in Aunt Tildy's case; since none in Union-town are quite so fine in growth or brilliance of coloring.

We can imagine. Perhaps she or her kin had learned from Carver, or taught him, about the daily blooming flower. Tildy might have considered them only ornamental, or perhaps she believed their blue-ness chased away evil or honored West African deities. Maybe they reminded her of the holy mother or a dress her own mother wore.

There are 1,400 different kinds of morning glories. They are perennials. Some travel along roadsides and some gather in thick-ets. Some are invasive and are called appropriate names like witches' shoelaces and strangleweed. They line fences and make tracks on sandy beaches. They will grow even if disregarded. Tildy Collins's flower patch might still be growing where she planted it. Decorative gardening of the sort she did, and Carver painted, did not originate in West Africa. Rather, it was something that Black people took on in the Americas, having learned it from Europeans. But it was no less "theirs." Who you are is what you stand in. Gardening was especially precious as a pleasure that flourished despite captivity and cruelty. It is a delicate thing to say. Every time you allow for joy, it seems to invite those who would say it wasn't that bad. It was horrific. And still there was joy. Telling the whole truth, including delight, cannot, should not, absolve the nation of its shame. It should make the indecency even more apparent.

A contemporary of Collins, Clara Davis, also a former slave, re-called the sweetness of her youth even within the ugliness of bondage:

I wants my ole cotton bed an' de moonlight nights a shinin' through de willow trees an' de cool grass under my feets as I runned aroun' ketchin' lightnin bugs. I wants to hear de sound of the hounds in de woods after de 'possum an' de smell of fresh mowed hay. I wants to feel de sway of de ol' wagon a goin' down de red, dusty road an' listen to de wheels groanin' as dey rolls along. I wants to sink my teeth into some of dat good ol' ash cake, an' smack de good ol' sorghum offen my mouth . . . I wants to see de boats a passin' up an' down de Alabamy ribber an' hear de slaves a singin' at dere work. I wants to see de dawn break over de black ridge an' de twilight settle over de place spreadin a sort of orange hue over de place. I wants to walk de paths th'ew de woods an' see de rabbits an' watch de birds and listen to frogs at night . . . Dey tells me dat when a pusson crosses dad ribber, de Lawd gives him whut he wants. I done tol' de Lawd I don't want nothin' much . . . only my home . . .

Could she have possibly meant this description? Maybe she was just trying to appease an interviewer, thinking that was what a White person wanted to hear. But I don't think that's it or that's all of it for one reason: the language sings. And if you've been out in the country, that sweetness she describes is familiar enough to bring tears to your eyes. The truth was that there had been poetry in the worst of times. Heavenly ground after death wasn't in Africa for Clara Davis. It was right there in Alabama. I know exactly what she means as a daughter of the moving tabernacle. Home is where your prayers lie.

BLUE FLAG, GOLD STAR

◇◇◇◇◇◇◇◇◇

I like hearing the note behind the note.

—Suzan-Lori Parks

A negro in a British forecastle is a lonely being. He
has no chums. Yet James Wait, afraid of death and
making her his accomplice, was an imposter of some
character—mastering our compassion, scornful of our
sentimentalism, triumphing over our suspicions.
But in the book he is nothing; he is merely the centre of
the ship's collective psychology and the pivot of the action.

—Joseph Conrad

JOSEPH CONRAD, THE Polish British writer whom I read for
school repeatedly from ages sixteen to twenty-five, started the
American edition of his book *The Nigger of the Narcissus*, which
was published under the less offensive title *The Children of the Sea*,
with the foregoing description of the condition of the West Indian
sailor, Wait. Though Wait is "nothing" in the story, the narrator
claims to hold him in high regard. A plot device is a terrible thing
to be.

IN THE UNITED States, we frequently read Conrad's work—in which Black figures appear consistently, albeit always in shadow—in English courses. But he and his subjects, including the Black ones, are not American. The way we learn Black history in the United States is overwhelmingly a domestic matter, but in truth, Blackness is not, and has never been, solely a domestic matter. The over there is here, and the right here is over there too. Which brings me to the pale blue flag with a gold star in the center that heralded the "Congo Free State." It was a horrifying watershed, a nail in the coffin at a global turning point.

THE AGE OF emancipation in the late nineteenth century followed the age of revolution, which began in the late eighteenth century, by almost one hundred years. Slavery coexisted with republicanism across the European and Anglo-American world. And so, when slavery ended in the Western hemisphere, it might have meant the final achievement of the promise of universal rights. But it didn't, here nor there. In Belgium, King Leopold aspired to become a great power. But he'd failed to establish colonies like other European nations. He chose a different tack. He hired Henry Morton Stanley to help him establish a foothold in the Congo, ultimately under the banner of an association he called the International Association of the Congo, in 1879.

HENRY STANLEY, THE man who coined the term "Dark Continent," was in his employ. Stanley was a fickle adventurer. He went to the United States from Wales during the Civil War years and first fought for the Confederacy before defecting to the Union cause. Later, he hired himself out to Germany to go into the interior of the African continent.

Before the nineteenth century, Europeans had little direct knowledge of Africa beyond the coast, but their maps were already filled with

details about the continent gleaned from various sources of information. Before embarking, Stanley claimed to have read 130 books on Africa. Riding down the Congo River, he set up stations to be used by Leopold's men. After returning, he wrote books describing his journeys into the continent, with titles like *Through the Dark Continent* and *In Darkest Africa*. Stanley, working on King Leopold's behalf, also negotiated with leaders of communities along the Congo River to sell their land to him. By the time of the Berlin Conference of 1884–1885, Leopold was prepared to argue that the Congo Free State, privately owned by the king himself, should be recognized as a sovereign nation.

Leopold marketed his venture as benign. He claimed to want to suppress the Arab slave trade, to unite the natives and civilize them as well as modernize the economy. He spoke a good deal about free trade and monopoly. He claimed to have a similar intention as the United States had in Liberia, and perhaps that is why the United States became the first nation to recognize the Congo Free State. Through the story of the Congo Free State, we learn a number of things. One is that "free" is a word as contrapuntal as "blue." For Leopold, "free" referred to his own freedom to buy up land, to build his personal wealth through rubber, not to the Africans whose labor made that possible.

HENRY HAMILTON JOHNSTON followed Stanley in traversing the Congo River. He was British, and also an explorer as well as a writer who published forty books on Africa. Perhaps because he was also an artist and a botanist, his writings of the Congo are much more colorful that Stanley's. Perhaps because of his multilingualism, they are far more detailed when it comes to the lives of Africans. Regardless of why, in Johnston's account of the Congo, blue is everywhere.

Johnston is one of many who describe the commerce in blue glass beads that were approximately three-eighths of an inch long and a quarter of an inch thick, which, thread by the hundreds on cotton, were a

form of currency. But he cautioned his readers to understand that the region had no single currency, that value depended upon place; beads worth a fortune in one place could be worth nothing in another. And although Johnston saw the Africans as many colonists did, less sophisticated, less intelligent, he was more attentive and therefore his words are more informative.

Johnston reveled in the landscape. He described crimson canna lilies set against dark purple-green foliage and other flowers he called strange, classifying them with irises and lilies, as well as shrubs with long blue bean flowers, and the bright blue blooms that we now call Asiatic dayflowers, and yellow mallows and mauve and white cleomes, or what we popularly call spider flowers, and "the commelyna . . . one of the commonest genera, displaying everywhere its beautiful deep-blue flowers . . ." The landscape is vibrant in Johnston's account:

> For absolute gorgeousness nothing can compare with the divers gourds and seed vessels of the many species of Cucurbitaceae, which when ripe, split open to expose the crimson interior, where the black seeds are laid in tempting rows to invite the birds to assist in their distribution. Indeed, the whole effect in floral colouring like this is to suggest a tremendous competition going on amongst the many plants for the favourable notice of birds and insects, as if the flowers were advertising their advantages as if saying to the bees 'Your patronage is earnestly solicited.'

His vivid and blue-laden descriptions were not limited to plant life. The mandrills "leaden blue faces" gaze "wistfully from the doorway of some native hut[s] and "little jewel-like kingfishers, smalt blue and verditer, with scarlet beaks" made their way among the water while "hundreds of buttlerflies, many of most beautiful colors, azure blue and brilliant leaf-green" gathered by bunches. At night, under the midnight sky, he waxed:

During my repast, I enjoyed the aesthetics delights of bright moonlight shining in softened radiance through the overarching forest, while numberless fireflies like little points of electric light, whiz round the thick bushes . . .

And in the day:

Looking up towards the sky, you see the cerulean blue chequered with a fantastic lacework of leaves, and little specks and dapplings of sunlight are scattered lightly over the outer groups of foliage.

Johnston repeatedly described the "Great Blue Plantain Eater": "a beautiful bird, found in the forests all along the Upper river." The bird had "a general plumage of verditer-blue, relieved by a yellow-green stomach, chestnut thighs and a violet crest. This bird is difficult to shoot, as it is very shy and hides much among the thick foliage of the great trees; but on occasion I managed to back him, and, after taking off his beautiful flesh, we roasted him for dinner and his flesh was most juicy and delicious." I pulled up a contemporary image of the bird. Its color is deeper yet more electric than cobalt. Reading Johnston's quick turn from its beauty to its taste alarmed me. But it got worse:

One day a party of men arrived with a very stout lady of whom they wished to dispose for her value in blue beads. She was quite the thing for me, they were convinced, and would make an excellent lady-help for my next expedition . . . Unfortunately the price asked was quite beyond my means . . .

Johnston commented on the usefulness of the women: they would carry as much as men with less complaint and were better cooks. They were also for sale.

There it was again, people traded for blue beads. But in historical retrospect, when I think about what would happen in the Congo Free State, Johnston's florid account attests to something else important. Before the violence unfolds, there is beauty. The Kongo kingdom was a home before it was raided for slaves, before there was a Congo Free State, and it remained a home all along through seasons of terror. The story isn't just one of geopolitical maneuvering, law, and sovereignty; it is one of unimaginable loss.

KING LEOPOLD PUT together a military to enforce his private ownership of land. In 1878 and 1879, a group of European men, some soldiers, some mercenaries, were sent to the Congo to be officers in the "Force Publique." Under them were groups of soldiers. Some were Zanzibari, some West Africans; others eventually would be conscripted men from the Congo. The officers wore white uniforms and pith helmets. The soldiers wore blue linen suits with red trim down the front and scarlet fezzes. They carried Albini rifles with short bayonets, and the White officers carried Mausers, with additional weapons stockpiles: Krupps, Maxims, and Nordenfelts.

THE FORCE PUBLIQUE, the boys in blue of the Congo Free State, enforced the demands of King Leopold, making red rivers of Congolese blood. Rubber was the commodity with the greatest wealth potential— and the hardest to work. Beatings and whippings were used by the Force Publique to make the workers work harder. They snatched up those who refused Leopold's employ and took them into the interior anyway. It was not just like slavery; it was a form of slavery. Sometimes Leopold's forces kidnapped wives and children, subjected them to sexual and other physical violence, and then told the men that they must meet a quota of labor to have their families freed. Inevitably, it

was an unattainable quantity of work. When Congolese people organized resistance to Leopold's Force Publique, the military massacred the rebels and burned their villages. They were also known for cutting off insurgents' hands, including those of children. Soon there was a sea of one-handed and handless Africans who learned that if they weren't working for Leopold, they wouldn't be allowed to work at all.

I read Joseph Conrad's novella *Heart of Darkness* repeatedly from my sophomore year in high school through graduate school. It is an impressionistic story of the horror of the Congo Free State. In Conrad's novella, a sailor, Charles Marlow, describes his journey as a steamer captain for a Belgian company in the African interior. I do not know what prompted Conrad to move from his *Narcissus* story about a lonely Black man of the Americas dying on the water, to a story of the journey of a British man into King Leopold's Congo Free State. But *Heart of Darkness*, published in 1899, is often described as one of the greatest novels of the English language. It fictionalizes Conrad's journey down the Congo River and into the Congo Free State. *Heart of Darkness* has been interpreted as a criticism of the corrupting forces of colonialism upon Europeans. Conrad's Africans are shadowy figures, and the Europeans are debased. Conrad implicitly argued that there was little difference between those deemed civilized and those called savage, which was a challenge to European assumptions, and I was taught it as such. Yet I cannot recall a single class in which I was encouraged to read it from the perspective of the Congolese.

A few years after Conrad published *Heart of Darkness*, when the public outcry grew loud against the ravages of the Congo Free State, Conrad said he hadn't witnessed any of the brutality that was described. Perhaps that is true. Horror is present in his account, but it is more a haunting than an accounting, a subtle if harrowing blue note. Things did get much worse after he visited in 1890. And historians have noticed that witnesses' accounts varied by virtue of what route

they took through the Congo. But another writer, an African American man named George Washington Williams, who was there at the same time as Conrad, rang the alarm bell against the horrorscape of the "Free State."

George Washington Williams was what they called a race man. His every achievement—and they were considerable—was applied to the cause of Black freedom. He had served in the Union Army, had been a member of the Ohio House of Representatives and a pastor, and was a pioneer in the study of African American history. Williams, also a journalist, read a newspaper interview with King Leopold in which he described the suppression of slavery and advocacy of free trade and economic development in the Congo, and decided to go see this work for himself. What he found was bone-chilling. Ringing an alarm on the horror, he published a document to expose the sins and lies of the Congo Free State, titled "An Open Letter to His Serene Majesty Leopold II, King of the Belgians and Sovereign of the Independent State of Congo by Colonel, The Honorable Geo. W. Williams, of the United States of America." In it he wrote:

> It afforded me great pleasure to avail myself of the opportunity afforded me last year, of visiting your State in Africa; and how thoroughly I have been disenchanted, disappointed and disheartened, it is now my painful duty to make known to your Majesty in plain but respectful language. Every charge which I am about to bring against your Majesty's personal Government in the Congo has been carefully investigated . . . When I arrived in the Congo, I naturally sought for the results of the brilliant programme: "fostering care", "benevolent enterprise", an "honest and practical effort" to increase the knowledge of the natives "and secure their welfare."

But, Williams asserted, he found nothing of the sort.

I was doomed to bitter disappointment. Instead of the natives of the Congo "adopting the fostering care" of your Majesty's Government, they everywhere complain that their land has been taken from them by force; that the Government is cruel and arbitrary, and declare that they neither love nor respect the Government and its flag. Your Majesty's Government has sequestered their land, burned their towns, stolen their property, enslaved their women and children, and committed other crimes too numerous to mention in detail.

According to Williams, sexual violence and murder were common. It seemed that sadism exceeded the production of wealth,

. . . The labour system is radically unpractical; the soldiers and labourers of your Majesty's Government are very largely imported from Zanzibar at a cost of £10 per capita, and from Sierra Leone, Liberia, Accra and Lagos at from £1 to £1/10 per capita. These recruits are transported under circumstances more cruel than cattle in European countries. . . . they are exposed to the heat and rain, and sleep upon the damp and filthy decks of the vessels often so closely crowded as to lie in human ordure. And, of course, many die.

It must have occurred to Williams how similar this condition was to that of his own ancestors on slave ships. It must have haunted him to see the world of difference that existed between Leopold's marketing of the Congo and the truth within its borders, not unlike what was happening in the US South, where Jim Crow and lynch law were taking hold, while "lost cause" propaganda was promulgated from every Southern statehouse. The truth was clear: "slavery is over" and "freedom is here" were not statements to be taken at face value. Racism was an imaginative philosophy. It adopted new names and kept old habits. Williams

commented on the interracial sexual relationships he witnessed in the Congo:

> Whenever children are born of such relations, the State maintains that the women being its property the child belongs to it also. Not long ago a Belgian trader had a child by a slave-woman of the State, and he tried to secure possession of it that he might educate it, but the Chief of the Station where he resided, refused to be moved by his entreaties. At length he appealed to the Governor-General, and he gave him the woman and thus the trader obtained the child also . . .

The state refused when Europeans wanted to show even the most basic human decency. They were supposed to be cruel even to their own children. And the more common occurrence than an effort at caring for them, according to Williams, was one of "white men bringing their own flesh and blood under the lash of a most cruel master, the State of Congo . . ." That would have been quite familiar to him as an African American as well.

How dare Leopold describe Africans as savage and his own mission as civilizing? Enraged, Washington showed King Leopold and his agents of state to be liars of the most shameful sort.

> Against the deceit, fraud, robberies, arson, murder, slave-raiding, and general policy of cruelty of your Majesty's Government to the natives, stands their record of unexampled patience, long-suffering and forgiving spirit, which put the boasted civilisation and professed religion of your Majesty's Government to the blush.

He concluded with a direct charge and a clear demand to the world:

All the crimes perpetrated in the Congo have been done in your name, and you must answer at the bar of Public Sentiment for the misgovernment of a people, whose lives and fortunes were entrusted to you by the august Conference of Berlin, 1884–1885. I now appeal to the Powers which committed this infant State to your Majesty's charge, and to the great States which gave it international being; and whose majestic law you have scorned and trampled upon, to call and create an International Commission to investigate the charges herein preferred in the name of Humanity, Commerce, Constitutional Government and Christian Civilisation.

Williams would, in his criticism of the Congo Free State, coin a term which is now quite familiar, "crimes against humanity," though we too rarely think of the place and person from whom the term originated. Williams was one of the earliest vociferous critics of the Congo Free State, and his message was suppressed, but others joined the chorus, many of them missionaries. The leader to whom protest against the Congo Free State tends to be attributed, however, is Englishman Edmund Dene Morel. Morel worked for a shipping company that shipped rubber out of the Congo. On the docks in Antwerp, Morel observed that the ships coming in from the Congo were heavy with ivory and rubber. Those that departed were filled with firearms, ammunition, and soldiers.

Just as Williams's term "crimes against humanity" came out of the Congo Free State, the model of international human rights came out of the organizing that Morel led. And eventually there was enough pressure, and a few international incidents, that led to King Leopold giving over control of the Congo Free State to Belgium, making it a colony rather than a slave state. Even Mark Twain, a famously inscrutable figure when it came to race, wrote against Leopold's reign. And then there was English photographer Alice Seeley Harris, whose

turn-of-the-century images of Congolese people—men, women, and children—with amputated hands and feet made the fact of unabashed violence undeniable. I am grateful for their documentation and outrage. We all should be. But as I tried to understand what lay underneath that blue flag with the gold star, I was still yearning to "hear" from the Congolese themselves.

Their fragmented voices come from British colonial Blue Books. Blue Books are filled with all sorts of details about the empire and are a historian's treasure trove. In the late nineteenth century, they included letters detailing abuses witnessed in the Congo Free State by Brits who lived there. When Roger Casement, a British consul in Congo, was charged with writing a report responding to charges of abuse in the Congo Free State, he included information from Blue Books as well as his own investigation in order to produce the Casement Report. Testimonies from the Congolese appear in its pages:

> One of the men HH . . . said that two weeks ago the white man . . . had ordered him to serve as one of the porters of his hammock on a journey he proposed taking inland. HH was then just completing the building of a new house, and excused himself on this ground, but offered to fetch a friend as a substitute. The Director of the Company had, in answer to this excuse, burnt down his house, alleging that he was insolent. He had had a box of cloth and some ducks in the house—in fact, all his goods, and they were destroyed in the fire. The white man then caused him to be tied up, and took him with him inland, and loosed him when he had to carry the hammock.

> It used to take ten days to get the twenty baskets of rubber—we were always in the forest and then when we were late we were killed. We had to go further and further into the forest to find

the rubber vines, to go without food, and our women had to give up cultivating the fields and gardens . . . we begged the white man to leave us alone, saying we could get no more rubber, but the white men and their soldiers said: 'Go! You are only beasts yourselves, you are nyama (meat).' We tried, always going further into the forest, and when we failed and our rubber was short, the soldiers came to our towns and killed us. Many were shot, some had their ears cut off; others were tied up with ropes around their necks and bodies and taken away.

They had taken the usual tax of eight baskets of rubber, and he was sent for . . . and the white man . . . said the baskets were too few, and that they must bring other three; meanwhile, they put the chain round his neck, the soldiers beat him with sticks, he had to cut firewood, to carry heavy junks, and to haul logs in common with others. Three mornings he was compelled to carry the receptacle from the white man's latrine and empty it in the river. On the third day (sickening to relate) he was made to drink therefrom by a soldier named Lisasi.

When it was not enough rubber the white man would put some of us in lines, one behind the other, and would shoot through all our bodies. Sometimes he would shoot us like that with his own hand; sometimes his soldiers would do it.

I am moved by the word "we," as in "we were killed," "we were starved." The wounds were collective, not just particular. The "we" wasn't all Black people, of course. The Force Publique had Africans in it. But there was what sociologists call "linked fate," a common mourning, a shared lot among the people in their suffering, one that echoed across waters and national boundaries.

Parts of the accounts reminded me of the convict labor leasing system of the post-emancipation US South when countless people were convicted on trumped-up charges and hired out by states to private landowners. They too were subject to verbal and physical brutality; they too were patrolled at times by Black men who were enlisted as "trusties," agents of an order under which they themselves were also abused. But the scale in the US was so much smaller: pockets of a US region rather than a whole nation. And yet the blues music phrase "murderous home" was apt. In the years of the Congo Free State, the population declined from twenty million to eight million. That's more than racism; that is genocide.

We now know that "free state" doesn't mean free people and that "free trade" doesn't mean free from control and exploitation. We know that being at the center of global trade—as African people and resources have been through so many waves of history—doesn't keep them—us—from being "in the book nothing," like James Wait in *The Nigger of the Narcissus*.

So it won't surprise you that the aftermath of the Congo Free State was not repair.

It rarely is. I have a 1943 stamp of the Belgian Congo, the authority that took over Leopold's Congo Free State. Though less brutal, the colonial Belgian Congo maintained the trinity of sovereignty, Christianity, and private interest at the core of its authority. Yet for me, as a Black American, the stamp is a surprise. It is enchanting, a drawing of an African woman in profile. She is framed in blue. Beautiful, with high cheekbones and her natural hair drawn back in a puff, her ear adorned with a round jewel, her shoulder lean. The price is fifty francs. I shouldn't be so easily seduced by an image. It isn't the face of a citizen. And it doesn't say her name.

THE BLUES

◇◇◇◇◇◇◇◇

Who's that young girl dressed in blue?
Wade in the water
Must be the children that's coming through
God's gonna trouble the water . . .
—"WADE IN THE WATER," AFRICAN AMERICAN SPIRITUAL

IN 1934, WHEN folklorist Alan Lomax visited the Smithers planta-
tion in Huntsville, Texas, he asked if anyone could sing the ballad of
Stagolee. One of the extended rhyming folk tales that birthed hip hop,
Stagolee's story was improvised upon endlessly. The character of the
ballad was based on a late nineteenth-century St. Louis pimp, but the
folktales exceeded the details of the real man's life. In each iteration,
Stagolee was bold and brazen. Alan Lomax described in his memoir
how a man named Blue was offered up as the storyteller by the group
of Black workers gathered that evening:

> Blue, Blue, sen' him Blue. Blue kin sing 'bout Stagolee. Blue
> knows mo' 'bout Stagolee dan ole Stag do hissef. Gwan up
> dere, Blue, white man ain' gwine hurt you. What you scai'd
> of? Dat horn too little fuh yuh to fall in it, too little fuh yuh to
> sing at wid yo' big mouf.

Lomax described the response:

So ran the murmurs of the crowd as they pushed forward out of the darkness in the rear of the room the Negro Blue. He deserved his nickname, for he was blue-black.

The man named Blue agreed, with conditions. He wanted to sing his own song first. He did. He told about the pitiful circumstances of the life of a cropper like him:

> *Po' farmer, po' farmer, po' farmer, Dey git all de farmer make.*
> *His clothes is full of patches,*
> *His hat is full of holes,*
> *Stoopin' down pickin' cotton F'om off de bottom boll.*
> *Po' farmer, po' farmer, po' farmer, Dey git all de farmer make.*
> *At de commissary,*
> *His money in deir bags,*
> *His po' li'l wife an' chillun*
> *Sit at home in rags.*
> *Po' farmer, po' farmer, po' farmer, Dey git all de farmer make.*

Blue, standing before a White man, testified to their condition. If Stagolee, with his brazenness, delighted Black folks, Blue courageously advocated for them. He had no interest in entertaining without first speaking his mind.

A woman named Bat volunteered to sing next. She was golden-skinned with plaits sticking out straight in front of her face and a straw hat resting at the back of her head. She had an idiosyncratic style, but the way she sang "Motherless Child," a classic spiritual, was serious. She called upon the Lord for guidance, making the song more appeal than lament. After that, Bat brought forward three other women, whom she referred to as "her quartet." Lomax was impressed: "This

woman's quartet , which she herself had organized and led, was by far superior to any other group we had heard. None of them, in all likelihood, could read, and certainly none of them had had the slightest training in music; but their harmonic and rhythmic scope and pattern, their improvisations, were unusual and beautiful." The women sang and swayed with snuff tucked in their bottom lips:

> *Befo' dis time another year, I may be gone,*
> *An' in some lonesome graveyard, Oh, Lawd, how long?*
> *Jes' so de tree fall, jes' so it lie, Jes' so de sinner lib, jes' so he die.*
> *My mother's broke de ice an' gone, Oh, Lawd, how long?*
> *An' soon she'll sing dat heavenly song, Oh, Lawd, how long?*

Tobacco-chewing women and blue-black men sang work songs to keep time in the rural Jim Crow South. As with spirituals, there was a call and response. Whether in the context of labor or faith, the single voice, plaintive and sonorous, was answered by an echo: from one to many. In life, genre distinctions are a matter of the rhythm of days rather than formal academic assessment. I mean there is a time and place for each type of singing.

The spiritual "Swing Low, Sweet Chariot" is a story about a heavenly carriage riding across a cerulean sky. According to its lines, divinity would emerge out of the blue with a band of angels. On board, riders' view would extend to places the earthbound could only imagine, like the river Jordan. Songs allowed spirits and imaginations to stretch even further than their muscles strained and voices carried. The basics of the forms could be traced to an African origin, but as was the case all over the world, and since time immemorial, music was shaped by their immediate circumstances.

In the United States, after spirituals and work songs came the blues.

Why is that the name? And why that sound? It seems organic.

I can't give you a neat answer. The association of the color blue with sadness is of English origin. The sound is African-rooted. The color is global. When people took to the road, leaving behind plantations, seeking fortune, they brought their guitars, harmonicas, and memories of song with them. They might make a few coins playing tunes for parties and could find fellowship through music regardless. Prisons were filled with bluesmen. Southern industry depended on trumped-up crimes. Since slavery was over, punishment was the only way to force someone to work, and convict camps that felt like slavery—only more deadly—swallowed up time and life. Singing and playing was testimony in the convict camp, as well as in the church, of both forsakenness and God's grace. And the juke joint, like the camp, was the place for some gutbucket stories too, about lust and love, grown folks' business.

Before the music was called the blues, slow-grind dancing was called the blues. Those blues were letting loose, bodies twisted together, getting a little pleasure in the cracks of the hard scrabble. But the name got firmly stuck to the music that accompanied the dance. Movement and music, however, can't easily be disentangled when it comes to Black living.

Unlike "jazz," a name some musicians have always taken issue with—preferring a term like "Black American classical music" to one baldly used by clubs and record producers for marketing and promotion when it crossed over to mainstream audiences—I've never heard an objection to the designation "the blues." The music came by its name honestly. But it did proliferate through marketing schemes, which explains how and why it would be ascribed a clear genre and a form in the early twentieth century. William C. Handy's 1912 sheet music "Memphis Blues" was definitive. It was a three-line blues verse with a potent response, a trinity of repetition before a yielded insight—the blues would do it in the juke, and pastors would too in the pulpit. Though sacred and secular music would be divided, sometimes with

great conviction and judgment, they had a common set of patterns and aesthetic arc. The blues, however, crossed over into the mainstream culture of the United States much earlier than Black preaching did. Isolated from its context, White musicologists were both taken by the blues and puzzled. It broke the rules of harmony as they knew them. It was made of sheets of sound, layered and unstable, that could make you feel much more than words. That was the blues.

It wasn't all sad. But it was certainly feeling. Albert Murray, one of the greatest critics of jazz and blues, made the important distinction between having the blues and playing the blues. The latter could be cathartic or playful. The latter could cure the former. It was as if the music asked profound, challenging, and rhetorical questions: Who said that life has to be lived on big terms? Who said that the minor key was not enough? The things that Black people found out by playing the blues are now recognized by the very society that once said they were subhuman. Psychologists finally understand that live music, laughter, prayer, friendship, ritual, community, sweet love, are the best parts of life. Back then, the people in the jukes were told by strivers and statesmen both that they were squandering their years with joy. I'm glad my folks knew and did better. What could be wrong with deciding to live fully despite the obstacles? What better legacy to move through hard years?

What I mean when I say that my people gave a sound to the world's favorite color is this: In the blue above, flight is possible. In the blue over the edge of the ship, one plummets to death. Hell was the bottom of the ocean floor until it became salvation. You had to swing mighty low to bring them up to the blue sky, weightless to memory and suffering. A voice could do it; a chorus could ensure it. In the main and in the meantime of history, Blackness insisted upon standing inside of life with a song. The series of catastrophic encounters on the coast of West Africa, the degradation that took on myriad forms in the Americas, and then the broken promise of freedom and citizen-

ship, well, that was all awful. But conditions being what they were, people kept living with what was at their disposal like blackberries on the bramblebush.

It may be that James Baldwin said it best in his essay "The Uses of the Blues." He wrote:

"The Uses of the Blues" does not refer to music; I don't know anything about music. It does refer to the experience of life, or the state of being, out of which the blues come. Now, I am claiming a great deal for the blues; I'm using them as a metaphor—I might have titled this, for example, "The Uses of Anguish" or "The Uses of Pain." But I want to talk about the blues not only because they speak of this particular experience of life and this state of being, but because they contain the toughness that manages to make this experience articulate. I am engaged, then, in a discussion of craft or, to use a very dangerous word, art. And I want to suggest that the acceptance of this anguish one finds in the blues, and the expression of it, creates also, however odd this may sound, a kind of joy.

Mind you, that doesn't mean that the blues is a world apart. It cannot offer transcendence. The point is clear when one man named Burn Down responds to Alan Lomax's request that they sing with anger. "I knows what you wants. You wants to make records of my singin' an' play 'em over de radio en so nobody will ever wanter hear me play again 'cause den ev'body'll know de songs dat I knows an' den where am I at?" Burn Down saw the deal. The music he made could become just another commodity, traded without his hand or thought in it at all. He might have been "wrong" about Lomax himself, or the particulars of how the extraction would work. But he was right about something: the blues were marketed, copyrighted, and taken out of their home grounds, and heard without being listened to, as though

there were neither anguish nor art, just entertainment. Some may hear it without getting it. No wonder then that blues songs grew full of mojo bags and roots to be worked. Knowing that pleasure is joy's infant cousin, they—the singers and the songs—had to be saved from becoming mere playthings for entertainment when their lives were the substance.

All of that said, blues singers and critics alike disagree about the soul of the blues. Albert Murray said you play the blues cathartically, but August Wilson wrote, through the fictionalized voice of Ma Rainey, that you don't play the blues to do anything in particular to your feelings, but that the blues are just life as it is, told. Both make sense. The blues are a private terrain shared. A crossroads of joy, pain, hurt, just living, and genius. As the story goes, Robert Johnson became the best blues guitarist in the world because he sold his soul to the devil, but when Lightnin' Hopkins played, it looked like he caught the Holy Ghost, brought to his knees by his own hands. "Otherworldly" captures both.

The original version of the song "What Did I Do to Be So Black and Blue" was performed by Edith Wilson for a musical revue—reportedly backed by the mob—called *Hot Chocolates*. Written by Andy Razaf and composed by Fats Waller, it ran for 219 performances in 1929 at the Hudson Theater in New York. Wilson, dressed all in white, moaned about being considered less beautiful because she was dark: "Browns and yellers, all have fellers. Gentlemen prefer them light. Wish I could fate, can't make the grade Nothin' but dark days in sight." She sang for a show, but testified to a deeper truth. People rank themselves even among the disdained. And the sorting hurts especially bad on the underside. Even in the gutbucket, where you think there's a camaraderie of disregard, there's a parade of preferences, and that's why her song had to be sung. It was a necessary testimony.

Louis Armstrong recorded "Black and Blue" too and made it famous. He repurposed it into a general statement about race, not color, not sexism, not women's beauty. And when you listen, you can hear that the question "What did I do to be so black and blue?" is rhetorical. Because "Why are we at the bottom?" does not really merit a serious reply. The reality of racism is morally appalling and unjustifiable. Humans, being essentially interchangeable, cannot ethically be placed in a genealogical hierarchy. Outrage and searching disorientation are appropriate responses to how Western history has treated Blackness; providing two of the only real ways of asking and answering the question "Why?" Other answers are sadness and blueness over being marked the very worst among "the least of these." The gravel in Louis Armstrong's voice announces that we have already lost when making appeals to power by trumpeting our worth. Corrupted judges cannot be trusted to come to a fair verdict. The only true freedom is for us to *be*. Armstrong rhetorically asked "What did I do to be so black and blue?" and sang the answer: blues-soaked grace. To earn one's place in a world that would dirty you so much is a trying thing. But it has been earned infinite times over by elegant survival. The blues taught us and everyone else that lesson if they would only listen. Really listen.

Ralph Ellison's protagonist in his novel *Invisible Man* describes wanting to hear five recordings of the Louis Armstrong version of "Black and Blue" played all at once in the darkness:

Invisibility, let me explain, gives one a slightly different sense of time, you're never quite on the beat. Sometimes you're ahead and sometimes behind. Instead of the swift and imperceptible flowing of time, you are aware of its nodes, those points where time stands still or from which it leaps ahead. And you slip into the breaks and move around.

If Ellison's words serve as a meditation on the existential challenges of a Black life, then Toni Morrison's famous quip of a response—"Invisible to whom?"—is a reminder that Black folks have had to see each other regardless of what the larger world will recognize. That too is the majesty of the blues, a beauty shared and witnessed by its people, no matter who is listening. It is not the sound of appeal; it is the act of living. Together.

EATING THE OTHER

> They walk in front of me, those eyes aglow with light
> Which a learned Angel has rendered magnetic;
> They walk, divine brothers who are my brothers too,
> Casting into my eyes diamond scintillations.
> They save me from all snares and from all grievous sin;
> They guide my steps along the pathway of Beauty;
> They are my servitors, I am their humble slave;
> My whole being obeys this living torch.
> —CHARLES BAUDELAIRE

WHEN ÉDOUARD MANET painted Jeanne Duval, her vision was failing. It was near the end of her life, and she needed assistance walking. Syphilis was killing her. Manet captured her in a bed overwhelmed by a dress so fluffy and white she seemed to be swallowed by it. The 1862 title of the painting followed suit: *Baudelaire's Mistress*. (Now it is called *Woman with a Fan*.) She was described as only an appendage to the Frenchman. Duval had been described in the writer's work frequently. She and Baudelaire were long-term lovers, though she remained an exotic to his pen and mind. He referred to her home, Haiti, as a "hot blue land." And in one of his poetic dedications to her he wrote "Blue-black hair, pavilion hung with shadows / You give

back to me the blue of the vast round sky; / In the downy edges of your curling tresses / I ardently get drunk with the mingled odors / Of oil of coconut, of musk and tar." The implied blue-blackness under her skin—the Haiti, the Africa, within a woman who, based on Manet's painting, we know was light-skinned enough to be blue-veined—was titillation for Baudelaire and his readers. In the painting, the shadows of her dress and fan are blue; her hair and eyes, black.

IT IS A strange but persistent thing: to be possessed, desired, revolting. This triad of relations to power has been a long burden of Blackness, and its people.

When Charles Baudelaire was just a teenager, Charles Lewis Tiffany founded Tiffany & Co. with a $500 loan from his father, a cotton mill owner in New England, and another $500 from his partner, John Young. The family had been cotton traders and, like Brooks Brothers, had dressed enslaved liverymen. The business flourished, of course, when it entered the modern diamond market. First, diamonds were mostly mined in Brazil with enslaved labor, but by 1900, it was overwhelmingly done by South African Black laborers controlled by the De Beers Consolidated Mines company. The little blue box with a sparkling jewel inside it that would become so iconic had at its root Black people, Black labor, and African land, exploited and expended. Do you see the pattern? There is no easy way to describe what it is to be racially, bodily, devalued and at the same time to provide—in land, flesh, and labor—precisely what is highly valued. The conundrum has had to be lived with and through for centuries. In an 1890 guidebook on West Africa, a vexing description of mixed-race beauty appears,

"With her Andalousian complexion, her delicately blue-stained lips, her jet-black hair that frames two melodious curls

of gold filament, her hairstyle, which she calls Dioumbeul, standing several centimeters in the air. Made of flamboyant madras scarves, simple Senegalese scarves with small blue and white squares, or white satin embroidered with fiery red roses, these strange head-dresses shaped like sugar-loaves are wrapped around the head by a narrow black or colored band. This monumental 'dioumbeul' offers the allure of a triple-crowned papal tiara, as a garland embroidered with gold fringe spirals it three times."

The reader is supposed to imagine her beauty. It seems that great pleasure was taken in putting together these words of description and gazing upon her body. And yet such pleasure did not disrupt the colonial project. It did not ensure respect or dignity, for her or the others. In fact, it could fuel an eagerness to conquer and oppress. Admiration was no protection, and of course neither was its opposite: insult. Caricatured Blackness in the figure of someone like "Long Tail Blue"—a dandy in blackface beautifully dressed but considered absurd for the effort—was mocked yet desired. The delight taken in his movement and elegance was also a form of humiliation.

In the appeal and revulsion, mixed together and projected onto Blackness, something emerged that is even more important and much more challenging than recognizing the deep contradiction. The push and pull have become the basis for a fundamental distrust that still lies deep. A White smile, a White compliment, a White invitation— could they be trusted any more than the snarl? The questions can't be dismissed as paranoia. I wonder if anyone will talk about this every time we cycle through performances of racial healing. It is a miserable and disorienting thing to wonder. But it could not and cannot be avoided. An eerie matrix of wanting was cultivated in the close quarters of bodies and feelings that live inside both the slave state and the colonial enterprise. And it was so intense that even

objects became imbued with the contradictions of race. We are become things. Things become us.

Boucle fabric, made of looped yarn of wool or mohair into a cloud-like surface, suggested Blackness. An 1886 fabric advertisement announced, "Nigger head boucle at 57 cents per yard." In response to a query about an advertised fabric to a magazine titled *Textile World* in 1895, the editor replied that it "is an astrachan cloth on stockinet back, although it somewhat resembles what is called nigger head boucle. We find the sample almost completely matched at Jordan Marsh & Co.'s in Boston . . ." The wearer of a boucle coat, cloche, or purse would be—at least symbolically—adorning themselves with the hair of a Black person, I suppose like a skinned calf or rabbit. They became a little bit Black, it seems, with adornment. Coats advertised as "nigger head blue" were midnight in color and softly coiled in texture, enclosing the wearer somewhere between blackness and the darkest night.

It wasn't unusual for the slur to be used in advertising in everything from candy to coal, and even plant life. Anything with a fuzzy crown, from echinacea to cacti, could refer pejoratively to Black people and their distinctive heads of hair. And it was wanted. The same is true of color. In the 1920s and '30s, "nigger brown" was advertised as a color for coats, mostly referring to dark brown. But in millinery advertisements of the same period, it was also common to see "nigger blue" as a selection. "Nigger blue" didn't have a completely consistent meaning, however. In some places it was identified as a milky greenish blue, and in others a very dark blue. I suppose the latter is a version of blue-black. Maybe the lighter one was the color of their worn denim clothes, like what was once called "negro cotton."

Blue-blackness wasn't only donned; it was consumed. A 1937 recipe for the alcoholic beverage "Blue Nigger" is 25 percent Jamaica rum, 50 percent grapefruit juice, 25 percent French vermouth, and a dash of gomme syrup. Shake and strain. The drink is a golden color.

The blue can't possibly then have referred to the color of the drink. Instead, it must have referred to feeling. What a thought: the idea that a White person could get drunk enough to become a Black person with the blues.

In the early twentieth-century period of Egyptmania, paint catalogs featured references to the browns and blues of Egypt, like Luxor and Nile, colors we would call russet or mahogany, turquoise and teal. These were also colors of Black people's bodies and adornment. The same color could be a slur and a praise. Brown could be both luxurious and grotesque, and blue adornment could be garish or gorgeous. I suppose that is part of what racism consists of, painstaking yet wild sorting of things into good and bad where they don't exist naturally. We must be trained to *see* colors in particular and sometimes contradictory ways for racism to function.

Charles Baudelaire, Jeanne Duval's famous lover, is known for several things. One is the concept of the flaneur, who exists "amid the ebb and flow of movement, in the midst of the fugitive and the infinite." Another is the concept of modernism. Duval moved too, traversing the globe like Baudelaire did. She traveled from Haiti to France, and then, as she was ailing, she moved all about France on crutches. But her movement was not what we would consider exactly free. She was a burdened flaneur. Each step was fraught and constrained by the way she was moved about, literally and figuratively, in the poet's imagination. Duval was a modern subject, and she was objectified. Cosmopolitan and global yet flattened by lust and disgust. Pleasure and denigration: these are central features of how racism would be performed in the twentieth century and into our twenty-first. The dance between the two extremes would employ generations of Black entertainers—who were and are asked to be ugly caricatures and intoxicating exotics both. It would be a different form of exploitation than sharecropping, mining, and factory working, one that had

to be negotiated delicately. Art was treacherous when you wanted to eat, to work, to create. Black artists learned to smile while singing the blues and to rage on the electric guitar.

Ambivalence about Black people is a key to why we have been depicted as dangerous. We titillate as much as we threaten, in the imaginations of those who have dominated and the throngs who believe the domination is right and good. Black people aren't the only ones to be cast in contradiction in imperial imaginations. It is a long-repeated strategy. But here I'm sitting with what it did and does to the inside of Black life. The spiraling reduction of who we are to a vice, a fad, a yearning, and then a pestilence is exhausting. The moral panics around each branch of Black art, integration, political leadership, books, music, dance, style, anything that captivates a mixed audience, leads to this (usually implied) question in one form or another: "Will we be destroyed if we fall prey to Black wiles?" The olive branch of art, "Enjoy this beauty," is read as "We will corrupt your children and maybe even you." And this adds another layer of distrust that is already so well-earned. How can we believe what you say—the claim that you don't have any racist bones—when we've seen what you've done and said about us, to paraphrase Baldwin, even and especially when kindness comes belatedly after much contemplation and consternation? Black watching, worry, caution, are wise because what if the ones holding out their hands don't, in fact, shake yours warmly, but instead snatch you into snares? And you lose your balance, gone in an instant, like a fly in Venus flytrap?

JANIE'S BLUES

<><><><><><>

Who been here since I been gone? A pretty
little gal with a blue dress on.
—African American folk song

ZORA NEALE HURSTON wrote *Their Eyes Were Watching God*
over the course of six weeks in Haiti. The novel begins with an oft-
cited passage that makes me think Hurston was moved by Melville's
description of Corlears Hook: "Ships at a distance have every man's
wish on board. For some they come in with the tide. For others they
sail forever on the horizon, never out of sight, never landing until the
Watcher turns his eyes away in resignation, his dreams mocked to
death by Time. That is the life of men."

That first part is what most people remember and repeat from
Zora, the dreaming part. But the killing part follows: "Now, women
forget all those things they don't want to remember, and remember
everything they don't want to forget. The dream is the truth. Then
they act and do things accordingly." The cutting matter-of-factness
of a woman's life, and specifically a Black woman's life, is how Hur-
ston began her lauded novel. Critics have described *Eyes* as semi-
autobiographical. Like her heroine, Janie, Hurston had a passionate

love affair with a younger man. But unlike Janie, Hurston was sensitive. Underneath her well-documented boldness and bravado, she had gallons of hurt feeling. Her aspirations—to earn a doctorate, to have her research supported, to bring the Black South to full recognition—were often thwarted. She was told what to do by the patrons who paid for her to live, told she didn't do enough by scholars who held degrees out of her reach, and shortchanged often. What Hurston created in Janie was something hard but important: a dreamer who can be defeated without devastation.

The novel begins with Janie returning to Eatonville. She is the subject of gossip. Folks ask "What she doin' coming back here in dem overhalls? Can't she find no dress to put on?—Where's dat blue satin dress she left here in? . . ." Janie is unconcerned and unselfconscious. We learn Janie's story through her testimony. She's been through three men and a storm. All of the men had predetermined blueprints for their lives into which she was expected to fit. Logan Killicks, chosen by her grandmother for his stability, was an older farmer who saw in Janie a suitable wife and found her ungrateful. Her second husband, Jody, was a striver who took fictional Janie to the actual town that Hurston called home, Eatonville. Jody led the community to self-determination, and wanted Janie to sit like a queen above the townspeople. But Janie yearned to be in the waves of laughter and banter, to be with the people. When Jody died, she had money and her chance. And that situation is what allows her to fall in love with Tea Cake. This is finally true love. Tea Cake wants her to wear blue because it is pretty on her. He plays guitar. They work side by side in the Everglades, where she dons overalls and gets strong. She's free to hunt alligator and play checkers. But her life turns stormy because Tea Cake bristles at her independence. And then, following a hurricane, he is held captive in the convict leasing system—a legal means to return Black people to a condition akin to slavery through incarceration. Finally, Tea Cake loses his mind, and Janie must violently defend herself against him.

It is a story of love, disaster, and also simply making do. When life breaks you or your heart, the size of your response can and should vary. You may collapse or shiver. Or fill your mouth heavy with something savory and light with something sweet. Relish a word. Hold a note or a waist. Clean each crevice twice, digging the rag in angrily. Your doings must be improvisational, and offer something other than numbness. Faltering numbness undoes the delicate stitches of making do. This is something we have learned well and taught a few. Sometimes a dam of rage breaks free into a gorgeous hurricane. This Blackness is a storm story. And one of surviving the storm.

Katherine Dunham, one of the most significant modern dancers and ethnographers in American history, was in Haiti the same year as Zora. Both of them inspire me, with the breadth of their artistic imaginations that were matched by deep intellectual commitments. If Hurston was a natural storyteller, Dunham was, in a sense, destined to be a dancer. Her first performance at age fifteen was at a cabaret she created called the Blue Moon. Like Hurston, Dunham studied anthropology, and she appreciated the field for giving academic structure to her impulse to record Black life. And like Hurston, she never sustained a strict scholarly distance from the subject matter. As she would describe it, "The struggle between science and art was fermenting . . . and the nearest I ever came to a solution to this conflict was perhaps this period when I divided my interests as I chose between the two and saw no real incompatibility." Both women studied Vodou as initiates— spending days at the crossroads of spirit possession and mounted by loas who could occupy their intellects as well as their bodies.

They might not have been seekers of blue, but they found it where they looked. When Dunham sifted through the meanings of her time in Haiti years later from her home in Senegal, she often referred to blue in landscape and symbolism. Of Erzulie, the Haitian loa of love, she wrote, "Erzulie likes perfume and orgeat, a syrupy almond drink, and elegant clothes of filmy pale blue and silver and

white." And when Dunham went through a series of ceremonies to become an initiate into the Vodou religion as a spiritual child of the loa Damballah, she described how blue was an essential part of her wardrobe. She wore "the necklace of blue and white trade beads with snake vertebrae interspersed" as she performed rituals with "the cocks, Florida water . . . barley water, strawberry soda and sugar cookies . . ."

Hurston and Dunham, two Black American women, both found Haiti to be a place of spiritual grounding and intellectual inspiration. They traveled with a kind of freedom that was rare for any Black women of their era, with the exception of blues singers. But instead of making their way along chitlin circuits wearing spangles and sparkles, singing about love, sorrow, pleasure, and freedom, they ventured into places where their bodies were familiar but their language was not. These two scholars, Hurston and Dunham, moved through zones that were wildly varied—universities as well as bateys, urban centers, the Blue Mountains of Jamaica and the deep forests in Haiti. In each place, they tried to apprehend something not yet fully articulated on paper about Blackness.

But they differed too. Hurston was as Southern and country as could be. Dunham was a Chicagoan who was born in the midst of the first Great Migration of African Americans out of the South.

In Haiti, Dunham was courted by dignitaries, and classified as mixed race. She bristled at the fact that her light-brownness led Haitian elites to frequently warn her to stay away from the blackest people and practices—she was supposed to see herself as superior to them and act accordingly. Though colorism existed in the United States, it had a more fluid stratification than in many parts of the Caribbean, especially Haiti. Hurston, as far as we know, was dark enough to be in the blackest of Haitian spaces. But she seemed somewhat less critical of the class stratification of Haiti, perhaps because she wasn't in the same places as Dunham and so didn't hear what was being said about

Haitians of her own color. Dunham had limitations in her analyses of Haitian politics likely due to an American frame of reference, as did Hurston, who was meticulous in describing Florida Black life but fast and loose with Haitian culture. Even as Blackness had some clear global meanings by the twentieth century, Black people could not be expected to fully understand one another. I comment on the limitations of these women I deeply admire, in order to keep track of this truth for all of us, including myself. Fellow feeling doesn't always mean deep mutual understanding or intelligibility. But what I find most interesting about the two, beyond their shared time, place, and passion, is that they both wanted to leave behind a record of their connection to Black life beyond the borders of the United States. The efforts themselves— even when flawed—are revelatory of who they took themselves to be.

As a young dancer, I performed zepaule, a Haitian folk dance that Dunham recorded. Here is the most memorable part for me: you must be connected to the earth to dance it correctly. Your left foot rises with both arms, then is quickly planted down. Your right, the same. Your center of gravity is low. This is rooted movement. Unlike ballet, which reaches up into the ether, even as your body descends, in dancing zepaule, you must maintain contact with the ground upon which you stand.

Dunham filmed dozens of dances. Hurston wrote down hundreds of folk tales and filmed some dances too. Dunham's acclaim as a dancer and choreographer grew over her long life. Her "Dunham technique" continues to be part of dance curricula around the world. Hurston ended her life as a domestic laborer. Publishing opportunities had dried up for her. Although she had once been sponsored and supported, her days became lonely, and for decades her legacy was largely neglected until Alice Walker began to tend to it in the 1970s. Hurston's life was a matter-of-fact blues. When there was nothing else, you could clean houses: do the laundry for some White folks, make the whites whiter with some laundry bluing. Return, like Janie, to where you began, with the clothes on your back and some stories to tell.

BENTONIA

◇◇◇◇◇◇◇

ONCE, LOCAL RULES prohibited the sale of Coca-Cola to Black folks in Bentonia, Mississippi. They drank Nehi, Pepsi, and moonshine instead. White folks drank whatever they wanted to. Today there are two Coca-Cola signs (and two Budweiser ones too) on the front of the Blue Front Café. The population of the town is 318. But Blue Front remains a draw for blues aficionados eager to experience the real thing. The face of the joint is pool blue and white, as it has been for decades. It's made of cinder block and has hosted some of the greatest blues artists in the world since 1948, when Carey and Mary Holmes opened their doors to patrons and players. Once upon a time, musicians passed through regularly and played a song or two or ten in that bitty juke on Highway 49 in Yazoo County, Mississippi, north of Jackson. Now the gigs are relatively infrequent.

In Bentonia, at the Blue Front, you could hear the strings reverberate and echo like ghosts were haunting the guitar. In a video of Bentonia man Jimmy "Duck" Holmes, a great mid-twentieth-century Mississippi bluesman, his fast-moving fingers show a hand working acrobatically like a lindy hopper even when the cadence is easy. Skip James's Bentonia classic "The Devil Got My Woman" squeals like an amp from how he works the strings. He sings, "I laid down last night,

tried to take my rest / My mind got to ramblin', like a wild geese / From the west, from the west." It is country and architectonic. In sound and substance, the Bentonia blues will remind you that bluegrass and rock traveled the same roads.

ONCE UPON A time, in reaping season, when the days were long and sweat-chilled itinerants gathered in the small town, they could go all night, drinking, eating, stretching, having a little bit of leisure in cotton country. Leisure let you catch your breath, which was a much bigger deal than a contemporary reader might think. When Richard Wright was a little Mississippi child at the beginning of the twentieth century, he had a cinder block battle with White boys. One raised the stakes and caught Richard's head with a glass bottle. The Black boy bled profusely. His mother smacked him afterwards. He was never to fight with White boys again. It could cost him his life. That wouldn't be the last time a White boy broke a bottle on him. But he lived. Grown and in Jackson, he wrote about working as a bellboy at a brothel. One of his colleagues was caught in bed with a White woman sex worker. Wright testified, "He was castrated, and run out of town. Immediately after this all the bell-boys and hall-boys were called together and warned. We were given to understand that the boy who had been castrated was a 'mighty, mighty lucky bastard' because he lived." Imagine that. Leisure was never frivolous with such minefields. It was evidence of life.

Next time I go to Jackson, I want to get to the Blue Front Café, to touch its concrete form. I'm worried I won't make it before it's gone. So much of what we create dies. If we are fortunate and good, when the things we make decay, they return to the earth rather than kill the earth on their way to obsolescence. That is a truth of humans as well as art. On the other hand, preservation is a vexing thing. What is preserved over long periods of time is largely a product of wealth and

power. Someone's resources protect certain things; others' poverty leaves much of what they make and value without protection. As a result, those of us who come from people whose past has been deemed unworthy have often found ourselves fighting for preservation in order to be counted. Our preservation commitments insist upon fuller and often more accurate stories than what empires tell about themselves. But we are nevertheless left with a difficult question: How do we decide what to keep? Most things must die, including every one of us, and yet we are cagey or passive about accepting how much has to be let go over the course of our journey to death. We usually leave that work to our survivors. But what if we are deliberate about what we pass on, guided by ethics and the needs of our descendants? What then?

One strange feature of Blackness is how often it is treated as static. Like Black just is as it will ever be. But displaced and misnamed people are ever evolving out of necessity. The truth is the condition is like waterways, blood vessels, circuits. As Gwendolyn Brooks said, "We jazz june, we die soon." So we double back, merge, emerge. We try out different grammars and habits, routines and histories to live by and explain ourselves with. We the people who are darker than blue remain under construction. So, all of that to say, I'm not sure how long these precious places—Bentonia, population 318, and the Blue Front Café—will survive. Because so much of what is held dear will necessarily be forgotten or left behind. And our past is only available to us through the artifacts and imaginations of those who came before and only as long as somebody lives to tell us what was told and why. I think—and I'm not sure this is true, but it seems right to me—that the most important preservation is not perhaps a particular place or thing, but the sensibility that lies in blues, that of living as a protest. It can remain even when recordings degrade and buildings crumble. Spiritual sustainability is a natural condition for those on the underside of empire. Richard Wright told us something about this when he talked about the blues:

The most astonishing aspect of the blues is that, though replete with a sense of defeat and down-heartedness, they are not intrinsically pessimistic: their burden of woe and melancholy is dialectically redeemed through sheer force of sensuality, into an almost exultant affirmation of life, of love, of sex, of movement, of hope. No matter how repressive was the American environment, the Negro never lost faith in or doubted his deeply endemic capacity to live. All blues are a lusty, lyrical realism charged with taut sensibility.

We are thereby taught to sustain ourselves by strings, flesh, and technique.

If Ralph Ellison's speculative challenge to a White public—"Who knows but that, on the lower frequencies, I speak for you?"—asks a question that answers itself in the affirmative "I do" because I'm human, then perhaps on the higher frequencies of tradition we speak just for ourselves. Pool-blue cinder block and a cold drink on a devil-hot road was one precious iteration, but there are many more to come.

BLUEPRINTS

◇◇◇◇◇◇◇◇

RALPH ELLISON, BEST known for *Invisible Man*, one of the great novels of the twentieth century, applied to Tuskegee twice. He was admitted the second time as a trumpet player in 1933. Ellison rode the rails like a hobo to get there and felt acutely aware of his humble origins upon arriving. Despite the popular perception of Tuskegee as a bunch of rural farmers, there were a lot of middle-class strivers there. Ellison was ambitious in his own way. Though aspiring to be a composer, and often sneaking off campus to play in Knoxville, he fell in love with literature at Tuskegee. But Ellison was embittered by the institution too, and his protagonist in *Invisible Man* was forged out of a thinly veiled version of his experience at the school. In the novel, the invisible man is forced out for exposing the underside of Black life in the town to White donors. Afterwards, he makes his way to New York and through several political ideologies before escaping into the sewer to live. Of all the people he meets in the story, there is one blue encounter of particular note.

In the ninth chapter, the invisible man comes upon a man pushing a cart piled high with blueprints and singing an odd old blues song that compares the body parts of his loved one to animals. When the narrator comes alongside him, the blues man asks him a strange question: "Is you got the dog?" Our protagonist can't quite catch on

to the vernacular. The question makes no sense to him, literally speaking. Figuratively speaking, however, for speakers of the language of the urban North, "the dog" is the burden carried along with Blackness. The bluesman pivots and says maybe the dog has the invisible man. He himself has got "the bear" clawing at his behind. Harlem is, he says, a bear's den. And the bluesman is at risk of not being able to manage the condition of living while Black.

The invisible man refocuses on what is literal, asking what the man is doing with the cart filled with blue paper. They're real blueprints, the bluesman answers, but nothing can be done with them because people change their plans all the time. As he departs, the bluesman begins singing again. The whole encounter is absurd and profound at once. It is what we might call a jazz moment. When the bear is clawing, when the dog is on your back, you must be prepared to improvise in order to survive, blueprints be damned.

Architectural blueprints were invented in 1842. Before the photocopier, they provided the simplest means of reproduction. The blueprint was a map of intention. Linguistically speaking, its use as a metaphor in American English became so pervasive over the twentieth century that it became virtually literal. A blueprint is a plan, explicitly rendered. But plans are always being thwarted. Improvisation is itself a form of discipline, especially when blueprints have often become useless. This is it. Improvisation is a necessary part of the grammar of living while Black that stretches beyond a particular place, people, or language. Of course Blackness is not a monolith. It cannot be defined by some common fixed foundation. Nor is it some essential spiritual sameness. But a resourcefulness when it comes remixing the stuff of history, culture, and tradition in order to navigate within the constraints of empire, exploitation, colonialism, and plain old racism? That is indeed Blackness. And we remix in tandem on every corner of the earth.

In a letter to Albert Murray, Ralph Ellison once wrote about his

time visiting Tuskegee: "There's a sculpture of Booker sitting on the floor, and other relics, and as the day turned to dusk in the late spring the outside light turned a deep indigo blue. The same old nest, the same old briar patch. I only wish that I had known consciously that I was preparing myself to become something called a writer, rather than the aborted composer that I am . . ." Perhaps he was wishing he had spent more time learning what it was that Tuskegee had to offer. But no matter, Ellison worked what he took from there like a mojo hand. And he kept looking back. In the process, he revealed the chaos underneath the blueprint. His was an incisive criticism: perfectly striving people threatened to destroy what little freedom they had. Aspiration could be meaningful, but the best forward vision, well, that was a more elusive thing in a society and world organized against one's very existence.

Musicians expose this conundrum. Ellison was not just an aborted composer; he was a musician in writer's form because he understood. I tried to describe myself the same way once in an interview. The interviewer asked me which writer most influenced me, and I answered the composer Thelonious Monk. She looked at me strangely, and asked me for a literary example. But Monk *was* a writer as a composer and a social commentator. For example, as the story goes, Thelonious Monk's 1947 song "In Walked Bud" was inspired by a real event. It is musically based on the Irving Berlin pop song "Blue Skies," a love ditty ornamented with an image of bluebirds singing on a clear day. But Monk's song's origin was a night he was performing at the Savoy Ballroom in Harlem. The police raided the place and began to rough up Monk. In walked pianist and composer Bud Powell. A true-blue friend on a dark night, he protected Monk from their blows. Monk recorded his ode repeatedly over the years. Flourishes, vamps, new configurations. He dismantled every blueprint. He showed how it felt to be rescued. The exercise is clear in retrospect: act and build with love—when faced with the prospect of death. That's how we live.

CITIZENS

⟨⟨⟨⟨⟨⟩⟩⟩⟩⟩

INEVITABLY, WHEN I'M speaking somewhere about how much race still matters, an older White man will stand up and say how terrible things were when he was a child. And he will say something like "We treated you so badly," mixing past and present with an anxious cadence. And he will say, with a dancing preface, that I must admit things are better. Sometimes there is one more sentence. One word: "Right?"

The man who raised me, whom I call my father (also a White man, who would be older if not dead) taught me to invoke Malcolm X in these moments. He taught me to ask with biting irony: If you stab a man in the back and then pull the knife out halfway, do you ask if things are better? I have always used that example privately in order to understand the nonstop bleeding of Black folks. But I don't say it out loud.

In fact, I rarely say the same thing twice about where we are in relation to the past in those moments. It's freedom we're seeking, after all; it's not a war or a board game in which we easily declare victory or defeat. Sometimes I'm drunk on the valor of the ancestors and focus on them in my response. Other days, I'll do a matter-of-fact analysis of the wrecking ball of power. "It is efficient," I'll say sadly. The world we

face today is a consequence of what happened. What *is* is certainly less vile than what *was* in 1750 or 1840, for example. But to concede that as somehow "good" cedes the floor to a bad question.

I do not ask whether things are better. Though they are, they should be even better than this. And the real question I ask is, how is it that we have kept our hearts and souls reaching? Because that is what is worth saving. Black Americans are a people, but a very young one. We are older than the United States, but born in the colonial period. Older than Nigerians (as national citizens), but younger than the Yoruba or Ibo people of that nation. We are old among the young and very young among the old. For that reason, it makes sense that our connections to others—other Black people and other Americans—remain resilient regardless of the borders of nation-state or status. We are wise beyond our years, having learned via enslavement from the very worst of human habits and also having learned the heights of human possibility through elegant expression. Having survived slavery with some sense of being, we know that it is not especially useful to call ourselves exceptional. However, we do need some explanation of the resplendent figure we cut across global culture despite so much stereotype and diminishment. Maybe it is because from the underbelly of the brash young bully—America—we emerged as a people who connect arterially to the globe.

Post–World War II, the connections across the Black world came with asterisks—as if to say, we are different iterations of the same people until further notice. Now some of us—and here I mean Black people the world over—are full citizens, and some are second-class citizens, and some are noncitizens. And citizenship itself isn't created equal on a global stage. Passports have varying degrees of power.

Thinking about all of this is how I got to Andrée Blouin. Her book, *My Country, Africa: Autobiography of the Black Pasionaria*, captured my attention at first because her name means "blue." Second, the word "pasionaria" was intriguing, a reference to Isidora Dolores

Ibárruri Gómez, whom I knew of as a fiery leader in the Spanish Civil War. Yet I hadn't heard of Blouin before. And that was the last piece: I couldn't in all my years recall ever hearing about her until I found this old green vintage book written by a woman named Blue.

Andrée Blouin was born Andrée Madeleine Gerbillat. She was the daughter of a fourteen-year-old Congolese child named Josephine and a forty-year-old Frenchman named Pierre Gerbillat who was in the Congo on business. Though he wed Josephine in a traditional Congo ceremony, he later legally married a White Belgian woman which was a source of rage and sorrow for Josephine for many years to come.

As a child, Andrée was placed in the care of Catholic nuns along with other "metisse" children. The French authorities believed their existence was a sign of sin and shame and that therefore they must be both hidden and controlled. In her memoir, hunger is one of her most consistent childhood feelings. Barely educated, meanly treated, and kept away from family, she endured a miserable existence. As the girls came of age, they were systematically partnered off to mixed-race boys. It was an effort to contain the problem the children posed to the rules of race. Not wanting to be forced into a union, Andrée and several of her friends escaped over a wall topped in broken glass. Bloodied and fearful, her defiance began.

Andrée romantically partnered with a series of European men. The first was a Belgian aristocrat named Roger Serruys, who at first seemed eager to love her but ultimately hid her in the kitchen when respectable White company came to his home. The second time, she married a French businessman, Charles Greutz. Their legal bond made her initially believe that this relationship would be different. But, Andrée wrote quite succinctly, he was a racist. Charles refused her mother entry into their home. He called the Black man working for them a "big chimpanzee." The saving grace was Charles's affection for their children: both the daughter she had by Serruys and their son, René.

René became ill with malaria when they were living in Bangui, the capital of the French colony of Ubangi-Shari. He needed to be treated with quinine, but the colonial law said the medicine was only for Europeans. René was one-quarter African and therefore not eligible. Andrée appealed to her husband, who pilfered small quantities from his military post, but not enough to cure the child. She appealed to the mayor, begging for an exception to be made when it came to the racial rules of medicine in order to save her son's life. He refused. Andrée went to the mayor's office and screamed in desperate protest, calling him a child murderer, and was dragged out. The outburst enraged her husband when he learned about it. She had violated colonial protocol. That it was for their son didn't matter.

Without quinine, as anticipated, little René died. Andrée would write, "The death of my son politicized me as nothing else could." She left Charles and was on the path to becoming a revolutionary.

Andrée's third husband and she shared a name. He was André, and she took his surname, Blouin. It's the name with which she became distinguished. He was French, but as she described it, he didn't suffer from the colonial mentality regarding race. Moreover, he didn't prevent her political activism, and during their marriage she became increasingly African in a political sense. In Guinea and the Congo, she was active in anti-colonial organizing, in particular for women, and in that work she would also become an interlocutor and advisor to some of the important leaders of independence movements in West Africa: Sékou Touré and Patrice Lumumba. In her memoir, Blouin is so casual about the manner in which she rose to prominence that it is hard to apprehend how exactly it happened. And perhaps she herself didn't fully understand how she became one of the few women to enter into the inner circles of anti-colonialism. It had something to do with her conviction and intelligence. And she may have experienced favoritism from the male politicians because she was mixed race. Though the mechanics of it all are unclear, her matter-of-factness is deeply moving.

She felt outraged about the condition of African women under the thumb of both African patriarchy and the French empire, and about the way colonialism had made her mother so averse to her own Blackness, and most of all, she remained devastated by the death of her child because of his traces of African ancestry.

Blouin had a remarkable life that sat right at the axis of a shifting world. World War II simultaneously made both the scourge of bigotry apparent in the horror of the Holocaust and the hypocrisy of those who fought against fascism but protected and sustained racism crystal clear. Colonized people started dismantling what modernity had wrought for them—with revolt, revolution, argument, politics, and protest. The Black citizen was a new concept in the modern world. Although there had been citizens who were Black, it was only in the mid-twentieth century that Black citizenship was concretized in the global order. A Black person presumed to be a member of a nation, with rights, who could appeal to a sovereign force or an international community to protect them, was new. The category was stunted for generations by greed and armies, but here it came. We should not over or understate this. Citizenship was an imaginative abundance for Black people, some of whom were focused on the particulars and others on a linked fate across oceans. They had varying political ambitions, dreams, and, of course, beliefs. Too much of the hope of that season would be dashed. Empires didn't give up so easily. Ideals shattered. Yet creative connections and common purpose kept coming. And, of course, there were some old and some new stratifications. That seems to be the standard choreography of our history.

These pages are a rendering of what happened in one of the most consequential periods of human history. Fast and impressionistic moves sifted from hundreds of facts and dozens of mid-century stories I've learned by heart. Exponentially more exist beyond my knowing. Here are a few paintings of a period in sound and color.

MONTGOMERY, NEWPORT,
CAPE VERDE, ACCRA

◇◇◇◇◇◇◇

IN 1953, ARGUING before the United States Supreme Court in the case of *Brown v. Board of Education*, Thurgood Marshall had something to say about blue eyes and the truth of the law of segregation:

> Nobody will stand in the Court and urge that, and in order to arrive at the decision that they want us to arrive at, there would have to be some recognition of a reason why of all of the multitudinous groups of people in this country you have to single out Negroes and give them this separate treatment.
>
> It can't be because of slavery in the past, because there are very few groups in this country that haven't had slavery some place back in history of their groups. It can't be color because there are Negroes as white as the drifted snow, with blue eyes, and they are just as segregated as the colored man.
>
> The only thing it can be, is an inherent determination that the people who were formerly in slavery, regardless of anything else, shall be kept as near that stage as is possible, and

now is the time, we submit, that this Court should make it clear that that is not what our Constitution stands for.

Not the fact of color, but the belief that something resided in the bloodline, some corrupting thing in African ancestry, had shaped American constitutional law. And in 1954, with the *Brown v. Board of Education* decision, there was a hairline crack in the armor of Jim Crow. People were ready to stomp on the crack and break things open.

The Montgomery bus boycott began on December 5 of 1955, a year and seven months after *Brown v. Board of Education* was decided, and on the Monday after Rosa Parks was arrested. The strategy was deliberate: The city buses depended upon Black people, especially Black women, who rode them to work. Confronted with an organized community that was deeply interdependent and mutually trusting, buses passed through the streets without riders.

Summer in Alabama is hot. And it starts early. By June 5 of 1956 a federal district court in Alabama had declared bus segregation unconstitutional. But Black people stayed off the buses and in the heat. They refused to enter them until desegregation was actually implemented, not just in law but in deed.

In Newport, Rhode Island, the weather is milder in the summer. For generations, Southern elites, as well as New Yorkers and people from various other parts of the Northeast, gathered there to *summer* as a verb. Montgomery and Newport are worlds apart. But maybe not in the way you think. Every affluent New England resort town is a bundle of contradictions and distinctions, not unlike the South. If you don't see them, you don't understand the place. But it was a big deal for the jazz festival to come to Newport—a venture that initially was received with deep skepticism for the very Black popular music. But 1956 was its third year. And on July 7, the third day of the third

year of the Newport Jazz Festival, Duke Ellington's orchestra took to the stage and had one of the most storied performances in jazz history.

Just as Black women in Montgomery carpooled or walked to work, drenched in sweat before they even began scrubbing floors in White folks' houses, residents of posh Newport, Rhode Island, with its stately homes still gleaming with Gilded Age prestige, prepared for the arrival of Black musicians. Black people had not only been in Alabama since it was settled; they had also been a significant part of Newport's origin. Over nine hundred slave ships had departed from Rhode Island between 1725 and 1808. Communities of free Black sailors in the eighteenth century who worked whaling ships and riverboats settled in Newport, and in the nineteenth century, many more Black whalers arrived, the bulk of them from the Cape Verde Islands.

A Cape Verdean son of New England, Paul Gonsalves was one of the Newport Jazz arrivals in 1956. He performed with Duke Ellington's orchestra on that third night. A host of remarkable musicians had already played before them: Louis Armstrong, Miles Davis, Art Blakey, and Sarah Vaughan. The bar was high.

Ellington's orchestra closed with two songs blended together "Diminuendo in Blue" and "Crescendo in Blue." Ellington had been reworking these two compositions he'd written with frequent collaborator Billy Strayhorn. He'd tried joining them before, once in a song called "Transblucency." This time, he was working with Paul Gonsalves live. He gave the saxophonist a solo.

Gonsalves hadn't begun his musical career in jazz. As a young man, he played Cape Verdean folk guitar. But in adulthood, he developed a passion for the horn and the music born in the Southeast of the United States. His talent was undeniable. Gonsalves had accompanied greats like Count Basie and Dizzy Gillespie, as well as Ellington, many times. But this time, he took center stage. Playing "Diminuendo and Crescendo in Blue" in New England, by the water, he put his hands in the middle of those rising and falling blues.

In that town, where the slave ships had anchored, loaded and unloaded, he played a chorus. A White woman named Elaine Anderson jumped up and danced to the horn. She wore a black dress and her hair had been set in rollers. The curls fell.

Elaine flushed with excitement. Her husband was angry. Duke slapped his hands to the rhythm.

Everyone on the lawn got to moving and Gonsalves kept going in. Newport was only around sixty-five degrees that evening. But it didn't feel cool. The night was hot with music. Cops grew antsy, nervous that a riot was coming the way the beat was driving, the way the tranquil town was turning into a great big percussion.

The boys in blue took to the stage, and Duke, sensing danger, slowed the tempo. Twenty-seven triumphant choruses in, he had to be cool in the crescendo of blue. Gonsalves, a golden man descended from the coast of West Africa, had sent the crowd—unaccustomed to movement, to Black music—into paroxysms of joy.

The next morning—just as Rosa Parks's hip-grazing hair got coiled up for another day of refusal, and other sisters shrank into an afro before they got to work (it was eighty degrees and humid that day in Alabama), and White ladies mumbled words of frustration about their "girls" being late—Newport awakened to something new. It was a moment and metaphor. History at mid-century was jazz. Every blueprint previously thwarted, Black people played the combinations and borrowed from one another, looking for a way to freedom. Each season new riffs, new wounds.

In December of 1956, the buses were finally desegregated. Montgomery was Martin Luther King's first big test as a civil rights leader, and with the walking women as the backbone, he met the challenge. The people of Montgomery had chosen him as their spokesperson, and with the boycott he was catapulted into international recognition. In March of 1957, Martin Luther King Jr. and his wife, Coretta Scott King, traveled to Ghana at the invitation of the new nation's first prime minister,

Kwame Nkrumah. Witnessing the dawn of Ghana's independence from Great Britain bolstered the Kings' courage and that of African Americans back home, who read every detail of the occasion in their newspapers. Nkrumah drove through the crowd to his inauguration in an ocean-blue 1957 Cadillac Series 62. Perhaps the color was an homage to his fraternity, the African American organization Phi Beta Sigma, which is branded in blue and white. Onlookers noted that he took an American car—unlike many of his colleagues, who rode in European models. It made sense: Nkrumah had been educated in the United States and lived there for ten years. America was his metropole, not England. The connection had been evident a year prior, when Louis Armstrong visited Accra on a tour of Africa at the behest of the US State Department, which sent jazz musicians out into the world as an act of Cold War cultural diplomacy. Nkrumah was then prime minister of what was still called by the colonial name Gold Coast, though independence was approaching. He had accompanied the musician around the city. Armstrong was feted by large crowds who cheered him enthusiastically. And he played "Black and Blue" in honor of Nkrumah. That year marked a turning point for both men. Armstrong refused to go on any more tours for the US State Department, given the persistence of segregation. Nkrumah would transition from being prime minister of a decolonizing country to the president of an independent Ghana.

Martin Luther King Jr. was deeply moved that Nkrumah and his ministers wore their prison caps during the inauguration. They had been forced to wear them when locked up by colonial authorities for fighting for Ghana's independence. Now they wore them as testimony. King wept. He returned to the US renewed. He'd be jailed too, fighting for his people's freedom. Ghanaian independence resonated all over the Black world. Belief grew a little bit more.

On September 4 of that year, nine Black children arrived at Central High School in Little Rock, Arkansas, to desegregate it. One of them, Elizabeth Eckford, and her family had no phone. And so she

missed the message that the children were supposed to meet and walk together through the back entrance of the school. She walked to the front instead that morning, and stood before a mob of four hundred people. Over the years, far smaller mobs had killed Black people who breached the color line. She trembled and cried.

For two weeks, the nine Black children stayed home from school. They, their families, and the civil rights organizers they worked with had to strategize as best they could to remain safe in a profoundly unsafe state. When they returned, they entered school through a side door. The children wore starched cotton and walked with dignity. They were excellent students. The mob, now one thousand strong, had gathered at the front. Upon realizing the Little Rock Nine had made it inside the school, they boomed with outrage. Throngs rushed into the building, bloodthirsty. The Black children quaked, hidden in the principal's office.

And yet they returned again. Their return was made possible because President Eisenhower federalized the National Guard. They were charged with protecting the Black children inside the school and certainly saved them from death. Nevertheless, Elizabeth was thrown down a flight of stairs. Black and blue.

AFRO BLUE

✧✧✧✧✧✧

IN DECEMBER OF 1957, Nina Simone recorded her first album, *Little Girl Blue.* Though she'd become a popular live jazz performer, Simone was still smarting from her rejection years earlier from the Curtis Institute in Philadelphia. A prodigy classical pianist, Simone knew she was immensely talented and believed Curtis had Jim Crowed her.

The title track of *Little Girl Blue* is simpler fare than what she was capable of, but it anticipated the way she would become known for reimagining torch songs and show tunes, turning them into experimental forms. The song is sweet but also melancholy and inventive. Back then, though she had success in jazz, Simone still wanted to be a concert pianist. Once the album was finished, she reimmersed herself in Beethoven for three days straight, almost like a cleansing. Despite her performance as protest, popular music would bring her into the public, and this first album was the path. On the cover she wears a red-and-black coat, leaning on a park bench. There's annoyance on her face. Blue is only hinted at, a shading in the concrete, a hint in the water of the Central Park Pond, the mood if not the hue.

Melancholy is part of social movement, as is restraint. They are companions. The work of organizing for freedom requires a manage-

ment of rage that can break your heart. There is no good reason one should have to endure spittle and bombs, insult, dogs, and jail in order to achieve simple legal recognition. In the color photographs of the civil rights era, blues are everywhere in both sense and color: at lunch counters, on Jackie Robinson as he broke the color barrier. It was at weddings too: Coretta Scott King wore blue as a bride, as did Maria Cole at her nuptials to Black recording artist Nat King Cole, who had crossed over into the mainstream like no one had before. Black women and girls especially seemed to cleave to blue. Carlotta LaNier, one of the Little Rock Nine, wore it on her first day at Central High School, and Fannie Lou Hamer wore it to testify before the Democratic National Convention in 1964. There's a blue dress home sewn by Rosa Parks in the National Museum of African American History. It was the color of steely grace, elegance without excess, and composure of the kind that was most likely to keep you alive when you were fighting back.

The blues remained local and arterial. Cuban musician Mongo Santamaría was performing in the civil-rights-era United States as revolution was waged in his homeland. That revolution ended with the socialists victorious on January 1, 1959. Santamaría recorded the song "Afro Blue" in April of 1959. He was still in North America and frustrated. He had grown up poor and Black—dark-skinned—in Havana. And in the United States, he existed in a Latin music world that—albeit not White—was not deep brown and Black like the people who made the music in Havana. In the United States, he lived in a society that was more rigidly, if not more fundamentally, racially unequal than the Cuba he had left.

Santamaría quit Tito Puente's band, which he had played with from 1951 to 1957, reportedly because Puente didn't speak up against the racism directed at Santamaría during gigs in Miami. Mongo struck out on his own with William Correa, known professionally as Willie Bobo, at his side.

Afro–Puerto Rican percussionist Willie Bobo called his friend and collaborator Santamaría by a nickname: "Mongomery," with round Spanish O's, a clever extension of his traditional Cuban nickname "Mongo" to the American context. And like the people of Montgomery had a few years before, Mongo chose a defiant new choreography.

The song he wrote, "Afro Blue," is both sonically and socially an affirmation of Blackness. Composed with an African 3:2 time, "Afro Blue" is inflected with jazz and R&B, sounds that in the US were also unequivocally Black. Mongo's "Afro Blue" was an undeniable call to celebrate Blackness. The next year, jazz musicians Abbey Lincoln and Oscar Brown Jr. recorded a version of the song, in response. Brown gave the song lyrics, and Abbey Lincoln—the vocalist who had taken on a tongue-in-cheek self-naming after the man they said "freed the slaves"—put it on her album called *Abbey Is Blue*. Historians have taught us over the decades that Abraham Lincoln's reputation is a misapprehension. The enslaved freed themselves. But once was not enough, and maybe that's why Abbey took up the mantle with her name. New forms of captivity and exclusion were made and had to be resisted. It didn't happen in one place; it was all over the world. Black people, no matter how different, were bound together, by the history of the slave trade and the tragic creativity of empire, but even more so by freedom dreams.

In the same year as "Afro Blue," the Miles Davis album *Kind of Blue* was released. Jazz critics describe it as one of the greatest albums of all time. This was six years after Davis's album *Blue Period*, which was aesthetically cool. On *Blue Period*, the track "Bluing" had the name of the laundry item used to keep whites bright and clean, and the conjure ingredient for good root work. Davis was clever as well as brilliant. With an animated swing that sounds like the bustle of living, he paid appropriate homage to the tradition. But he also reached wide.

The name *Blue Period* referenced Picasso, an artist who found inspiration in Africa, as if Davis chose to take back his root. The elliptical nature of Black art, departure and return, local and global, connected through empires though not reducible to them, was on full display. On the *Blue Period* album cover, the photograph of Miles is blue-toned, as though awash in the color.

The cover and content of *Kind of Blue* six years later is different. Davis's face and body are not blue-toned. But he is a man dressed in blue, as though he wants listeners to understand that he has deliberately dressed himself in his musical tradition to make this album.

Listen to it. The standard scales are gone. Instead, there are long unchanging harmonies all throughout. Miles Davis of 1959 doesn't just give us jazz to listen to. He brings us inside the experimentation like a tour guide. Miles breathes audibly—the smokiness, the smoothness, the sustained respiration through change after change is magnificent. He—bourgeois dentist's son, erudite, educated, posture so unflinching—performed a patterned dance of breath, breaking the rules of formal musical training.

Movement is a divine word. To call organizing for freedom "the movement" was a strike of genius. The moves in our culture of art and performance—be they dancing, playing jazz, blues, or hambone, singing or hoofing—are all the art of living. And forgive us, Lord, for the Western sacrilege of sometimes being mere spectators to that divinity. It beckons participation. Miles told us with his breath, Mongo with his independence, Gonsalves with his permutations, the women of Montgomery with their walking, and Nina Simone with her refusal to be boxed into a genre. It was as though, at every turn, the people shouted "MOVE!" and responded to themselves with action.

THE BOYS IN BLUE

◇◇◇◇◇◇◇◇

TEN DAYS AFTER the dramatic release of *Kind of Blue*—people had lined up for blocks to purchase it from record stores—Miles Davis was beaten to a pulp by a cop in New York City. Witnesses claimed that the drunk police officer was angry over seeing Davis with a White woman. In the aftermath, photos showed Davis covered in blood with his head wrapped in bandages. The "boys in blue" stand in notorious tension with Black America. The blue uniform is a metonym for the enforcement arm of the state. Black Americans began, as a group, as people outside the law. And in the new age of mid-twentieth-century social revolution, the law was often on the side opposite freedom fighters. The choreography is hard to follow, but there are some consistent pieces. For every liberation action, there was a cruel reaction before the state relented, if ever. And for every corner imagining life differently, there was an echo miles away.

That same summer, the documentary *The Hate That Hate Produced* was released. A sensationalistic portrait of the Nation of Islam, it issued a moral panic about the organization's theology of Black divinity and White depravity. The crisis was a couple of years old by then. In 1957, a member of the Nation named Hinton Johnson had

been beaten nearly to death by cops in New York City. He'd been try-
ing to defend another Black man who was being beaten, and the cops
turned on him. Johnson was taken to jail. Malcolm X and over one
hundred other members of the Nation appeared at the precinct and
demanded that Johnson be taken to the hospital. The Nation followed
Johnson's ambulance and stood outside of Harlem Hospital, a warn-
ing that he better be cared for. Once they were assured Johnson was
getting proper medical attention from a Black surgeon, Malcolm X
had the crowd disperse with a small hand gesture. Malcolm X was
clearly powerful and therefore frightened the powers that be.

Perhaps what made White Americans most nervous was Mal-
colm X referring to them as "blue-eyed devils." Conventional images
of cherubim with golden curls and azure eyes were nothing more than
wolves of Whiteness in Malcolm's tongue. He mocked belief that blue
eyes were the height of beauty. Red-headed, golden-skinned Malcolm
was hot, and neither cool nor cautious. And that might have been the
very thing that so electrified him for Black folks.

But he wasn't alone, and the confrontations accumulated. The
social transformations were hydra-headed. At a convening in Raleigh,
North Carolina, in April of 1960, the Student Nonviolent Coordinat-
ing Committee was formed at the prompting of mentor Ella Baker.
Young people of the Southern freedom movement decided to create
their own liberation strategies and organization, and they gathered
inspiration near—from elders in their midst—but also very far, from
anti-colonial movements they witnessed on the African continent. On
September 23 of that year, seventeen new states were admitted to the
UN; sixteen were African, and the General Assembly adopted the
Declaration on the Granting of Independence to Colonial Countries
and People. It was a hopeful time, but also a dangerous one. Just a
few weeks before the UN meeting, on September 5, the new prime
minister of the independent Congo, Patrice Lumumba, had been

overthrown in a coup that was endorsed by both the CIA and their former colonizer, Belgium. Why? A general answer would be Cold War interests in controlling Africa. A specific and potent one was the uranium-rich Shinkolobwe mine in the Congo. It was the source for the Manhattan Project—and therefore the atomic bomb. Lumumba wouldn't have let Western powers maintain control of the country's resources. His usurpers did.

Though deposed, Lumumba evaded capture for a few months. And the Black and decolonizing world for whom he was a beacon breathlessly hoped he would remain free. But on January 17, 1961, Lumumba was murdered by a firing squad, and his body was desecrated: hacked apart and thrown in acid. Some present took pieces of his body as souvenirs the way onlookers once had after lynchings in the US South. In the United States, it took nearly a month for newspapers to report that Lumumba had been killed. Lumumba, the one who rejected ethnocentrism and tribalism in favor of Black self-determination; Lumumba, the trade unionist turned Pan-Africanist who refused to be a pawn of the Cold War; Lumumba, whose steely straight-spine intelligence made Black people proud, was no more.

The response was immediate. Protests were mounted in major cities around the world. In New York, the Cultural Association of Women of African Heritage, which included Abbey Lincoln, Maya Angelou, and Caribbean American writer Rosa Guy, protested at the United Nations on February 15. Amiri Baraka and jazz musician Max Roach were there as well. But the group was largely comprised of everyday Black people, native-born and immigrant, who were outraged. They carried signs that read, "Congo Yes, Yankee no!" They shouted "Murderers!" and "Assassins!" Police responded to them aggressively by dragging protesters out. The protesters fought back. A riot ensued. Ralph Bunche—one of the most well-known African American leaders and the then undersecretary of the UN—referred

to the protesters as "misguided misfits," and then, astonishingly, as if he were some sort of spokesperson for Black Americans, apologized to the country on their behalf. He bore a political resemblance to the Congolese officials who had supported the coup.

James Baldwin contextualized the event this way in an essay for the *New York Times*: "My immediate reaction to the news of Lumumba's death was curiosity about the impact of this political assassination on Negroes in Harlem, for he had—has—captured the popular imagination there." Baldwin went on to describe how Bunche and others diminished the protesters by saying they had been put up to it by either Soviet-backed communists or Muslims, and how the civil rights movement in the South was similarly blamed on "outside agitators." No, he said, this protest was a reflection of Black people's convictions in that moment, writing:

> The time is forever behind us when Negroes could be expected to "wait." What is demanded now is not that Negroes continue to adjust themselves to the cruel racial pressures of life in the United States, but that the United States readjust itself to the facts of life in the present world . . . The Negroes who rioted in the United States are but a very small echo of the black discontent now abroad in the world.

Playwright Lorraine Hansberry was outraged as well, and published a letter in the *New York Times* shortly after Baldwin's essay. "Mr. Baldwin's gift for putting down the truth in his celebrated ringing essay style prompts me to remark that I too was profoundly offended by the effort to link the Lumumba demonstrations at the United Nations with Mecca or Moscow inspiration," she wrote. "We may assume that Mr. Lumumba was not murdered by the black and white servants of Belgium because he was 'pro-Soviet' but because he

was . . . truly independent which, as we seem to forget in the United States, was at the first and remains at the last an intolerable aspect in colonials in the eyes of imperialists."

In the Congo, Mrs. Lumumba was grief-stricken. She marched bare-breasted through the streets of Léopoldville to protest her husband's murder. The Western dress and jewelry she was known to wear were gone. Small blue marks on her cheeks, traditional scarification, caught the angry tears she shed. She was not given any of her husband's remains, but there was no doubt he was dead.

In her memoir, Andrée Blouin wrote that it had been Lumumba seeing his wife snatched by General Joseph Mobutu's forces—just as he was making his way by ferry to the safety of Stanleyville, where he still had a stronghold—that left him vulnerable to being captured. "From his side of the river Patrice saw his wife brutally seized by . . . soldiers. It was then he made an unforgivable mistake. Unable to bear the screams of his wife, begging him to save her, Lumumba betrayed the Congolese people. He ordered the ferryman to take him back across the river . . . There he was taken." He had to save her. He was killed soon thereafter. Perhaps Blouin was correct that he was made vulnerable by love. But it is hard to imagine that Lumumba, who sought to persuade rather than control, who was more collaborative than suspicious, could have outrun the Cold War.

As would be the case with many leaders of the age of decolonization and civil rights, Lumumba would later be honored by those who played a direct role in his death. When Joseph Mobutu, once a member of the Force Publique of the Belgian Congo, took control of the Congolese government in 1965, he claimed to be the inheritor of Lumumba's legacy, despite the fact that he had a direct hand in the coup. "The stupefying lie succeeded," according to Blouin. Mobutu gave new African names to many places in the country that still went by the French titles, and sealed the fiction by bringing Mrs. Lumumba back from Cairo, where she was living in exile. Blouin was

incensed, saying, "And Pauline Lumumba agreed to this travesty against her husband's name, and the Congolese people, opening a ball on Mobutu's arm . . ." Mobutu was soon known to be a slaughterer. Three million Congolese were killed during his regime.

Andrée Blouin's husband André Blouin left her in 1973. She then settled in Paris, where her home became a salon for young African intellectuals and organizers. Despite her deep conviction, her faith in a free and flourishing Africa waned in the 1980s. She would bemoan the seductions of imperialism and the fomenting of interethnic strife that undermined a united Africa, a continent that she talked about as a singular entity. The full scope of what it means to be Black can be hard to catch hold of and hold steady. And even harder to protect once you do.

Blouin grew despondent at how few of the revolutionary hopes had been actualized. Her book made matters worse. It was the product of pieced-together interviews, and when Blouin read it as a whole, she believed the editor had turned her story of political struggle into a psychosocial narrative, and depicted her as far less revolutionary than she was. Blouin sued to keep the book from going to press and lost. Her story was published in 1983. Three years later, she died of lymphoma. We are left not knowing if her words were really hers. It seems like the changing same.

OVERALL MOVEMENT

◇◇◇◇◇◇◇◇

Detá quitinho bô dixam bai

Bô dixam bai spiá nha terra

Bô dixam bai salvá nha Mâe

Oh Mar . . .

—Cesária Évora, "Mar Azul"

ON THE FIRST album, he was just listed as Bobby Bland. It was a song, "Little Boy Blue," that made the color stick to his name. On that song, in the beginning, he sounds like he might be a straightforward crooner sad about a lost love until that squall starts gurgling in his voice midway. A hint at greatness. Bobby Blue Bland was born in Tennessee and dropped out of school in the third grade. He worked in the fields. He signed his name with an *X*. His voice often went to the higher register.

I have read that he got that squall from the Reverend C. L. Franklin's popular and widely distributed sermon "The Eagle Stirreth." The sermon took some inspiration from Deuteronomy and some from Paul Laurence Dunbar's poem "Sympathy" of 1899. It's the one that speaks to the anguish of the caged bird. In the Reverend's story, emancipation is divine. First, the eaglet just looks too big to be in the nest with the other birds. Then, once he is recognized as an eagle,

he gets a cage of his own, which he keeps outgrowing. You can't get more symbolic than that. Eventually, the eagle had to fly. His eagleness required it.

Blue had a hard-luck life and also a wildly fortuitous one. Talented with plenty of ruin, his voice was sweet like syrup. He smiled on stage, liquor in hand. His vulnerable sound would be rendered with precision. A sound that wouldn't let go of the dirt underfoot. By the end of the decade, his sound was described in mainstream popular culture as nostalgic—past his heyday. His end came faster than his beginning. But his was the sound of country folks, feet on solid ground, eyes and voice skyward. That was the very sensibility in which the student organizers found their inspiration.

The young people who arrived in the Delta wore overalls, made of what in the antebellum period was called "negro cloth." Sturdy denim. Dressed like sharecroppers. Chude Allen, a White woman who belonged to SNCC, reflected on their attire:

> I mean, this was serious stuff . . . It was that question—Are you going to step off the track? Whether you were Southern or Northern, whether you were Black or white, if you took that step with SNCC, you were agreeing to go off the track . . . And I'm sure there are some people that went back to more lucrative lives than others. But for anybody who—whether they literally put on those overalls or whether they figuratively did in terms of who they were—you never were the same again. And yes, at one level, it was making that commitment to the poor, but that sounds romantic, and it is easy to get into romanticism with that. What it also meant was a rejection of all those values that are [so much] worse today . . .

THE OVERALL-WEARING YOUNG people were mocked by some of their peers. They worried their parents. They risked their private

futures for the public good by becoming apprentices to those who lived close to the land. Students wore worker clothes and worked. They cleaved to the folk rather than running away from the fate of the blackest among us. Diane Nash, a Chicagoan with her blow hair and blue-green eyes, and Stokely Carmichael, Trinidadian with his smoker's blue bottom lip and mahogany skin; Anne Moody, from the land where the blues began, the deepest Mississippi, who grew up with a growling belly; Bob Moses, quiet New Yorker with a gift for math and strategy—these kinds of young people put their hands to the freedom plow, figuring how freedom could be everyday virtue. They stepped into the terrifying unknown. As Diane Nash said it, "We presented Southern white racists with a new option: kill us or desegregate." Bobby Blue Bland's voice sounded like the places and people they apprenticed to, linked arms with, to imagine freedom. It was dangerous work. Everyday terrorism was the response to the exercise of Black citizenship. Generations before, Black people had fled plantations to free themselves in Union blue. Now, they returned to the plantation South to free themselves in slave-cotton blue.

IN 1963, AMIRI Baraka published *Blues People*. It is a work of social theory and commentary. Baraka historicizes blues and jazz, and details the cosmopolitanism of Black music—in particular the ability of the jazz musician to integrate any form encountered. *Blues People* is an encomium to Black aesthetics from a fierce social critic. There had been people who came before who talked about the blues like his former professor Sterling Brown, the man who said Harlem Renaissance literary impresario Alain Locke was wrong about the impending death of folk cultural forms like the rural blues. There was James Weldon Johnson, who had treated the blues more academically. W. E. B. Du Bois, who had said that spirituals were the first American music, died the year Baraka's book was published, in exile in Ghana, on the eve of the

March on Washington. He'd given up on the American project. Albert Murray would claim jazz and blues as forms of Americana that were deeply hybrid, in contrast to Amiri Baraka's Black nationalist reading of the blues. For Murray, these were the idiomatic expressions of a people bound to this country whether they wanted to be or not; they were enduring, though modified African forms of art. Brilliant thinkers had nearly directly opposing interpretations of a form they all held in the highest regard.

One of the ways you can tell how important the blues and its offspring—jazz, rhythm and blues, soul, and hip hop—are to Black people is in how often Black critics, myself included, ask the music to stand in as an example of all of their most important thoughts. But even if we could evade that impulse, the truth is that the music has to be there, through everything. The movement rang with song, just as work had, just as Sundays had, just as leisure had. It is and was definitional.

In 1963, Tanganyika gained independence; a year later, joined with Zanzibar, it became Tanzania, under a flag of green, black, slivers of gold, and blue. Julius Nyerere, the new leader of Tanganyika, had captured the political imaginations of organizers in the United States, especially students who thought deeply about economic exploitation and domination in the rural South that seemed awfully close to colonial arrangements. On May 26, he delivered a speech at the Addis Ababa summit of heads of African nations, in which he said the following words: "We came here to find our common denominator in our approach to African unity . . . I do not propose to bother you by stating why Africa should be free and why Africa should be united . . . It has been . . . stated by the suffering of our people; by the blood which our people have shed and are still shedding at the hands of our oppressors; it has been better stated by the millions of our people who died in the slave raids all over Africa by those powers whose prestige was built upon the humiliation of Africa." Three weeks later, Medgar Evers, field secretary for the NAACP in Mississippi, a man who

insisted that the constitutional right to vote be protected for Black people, was murdered in retaliation. The Southland and Motherland were bound not only by history but by struggles. Each place struggled on its own terms, though. In July, Nyerere came to Washington, DC, and met with JFK. JFK said in his welcome, "I think it is most appropriate that this ceremony should be held between the White House on the one side and, on the other, between the Washington Monument and the Memorial to Thomas Jefferson, because in a very real sense, our guest of honor too . . . has played a role comparable to those distinguished Americans in the founding of his country." Among Nyerere's words of response were these ones offered after his statement of gratitude: "I have been coming to the United States now I don't remember how many times. I always associate the United States with freedom." It was diplomacy. A month later, in August, the March on Washington heralded the advance of civil rights. But on September 15, the killings at 16th Street Baptist Church in Birmingham made clear that retaliation for each step toward freedom would continue.

AT THE MONTEREY Jazz Festival five days later, Black musicians had the South and the world on their minds. While there, Dizzy Gillespie—a world-renowned trumpeter, composer, and bandleader—launched his tongue-in-cheek presidential campaign with the promise that he would change the White House to the Blues House. Running as a write-in candidate, he proposed musicians to be in his cabinet such as Duke Ellington for secretary of state, Miles Davis as director of the CIA, Max Roach as secretary of defense, and the fiery leader Malcolm X as attorney general. Though the campaign didn't go far in terms of votes, Dizzy raised money for civil rights organizations. He did not want his efforts to be considered a joke but rather a sincere effort to raise awareness about hunger and injustice.

Dizzy Gillespie had come of age in Cheraw, South Carolina, dirt-poor rural cotton country. And though far removed, he was acutely aware of the significance of the struggle in the Deep South. And its dangers. The world would continue to be exposed to the violence with which its racial order would be defended.

IN JUNE OF 1964, Goodman, Schwerner, and Chaney, three civil rights workers, were murdered on a Mississippi road. In the search for their bodies through swamps, hollers, and lakes, numerous other victims of Jim Crow's violence were dredged up before their remains were found. But Mississippi Freedom Summer continued, through anguish and fear.

A new strategy emerged in response to the national election. It was called a Freedom Vote. Black Mississippians were denied their constitutional right, so they took a vote of their own—and made their way to the Democratic National Convention. Fannie Lou Hamer testified, dressed in blue:

> I was carried out of that cell into another cell where they had two Negro prisoners. The State Highway Patrolmen ordered the first Negro to take the blackjack. The first Negro prisoner ordered me, by orders from the State Highway Patrolman for me, to lay down on a bunk bed on my face, and I laid on my face. The first Negro began to beat, and I was beat by the first Negro until he was exhausted, and I was holding my hands behind me at that time on my left side because I suffered from polio when I was six years old. After the first Negro had beat until he was exhausted the State Highway Patrolman ordered the second Negro to take the blackjack.
>
> The second Negro began to beat and I began to work my feet, and the State Highway Patrolman ordered the first Negro

who had beat to set on my feet to keep me from working my feet. I began to scream and one white man got up and began to beat me in my head and told me to hush. One white man—my dress had worked up high, he walked over and pulled my dress down—and he pulled my dress back, back up.

I was in jail when Medgar Evers was murdered.

All of this is on account we want to register, to become first-class citizens, and if the freedom Democratic Party is not seated now, I question America, is this America, the land of the free and the home of the brave where we have to sleep with our telephones off of the hooks because our lives be threatened daily because we want to live as decent human beings, in America?

The national Democratic Party offered the Mississippi Freedom Democratic Party two at-large seats, which would allow them to watch but not participate in the proceedings. They refused such second-class citizenship.

After the convention and with the financial support of Jamaican American entertainer and organizer Harry Belafonte, SNCC delegates traveled to Guinea. There they met with, and learned from, the president of the newly independent nation, Sékou Touré, and Malcolm X, who was part of their delegation. With a deepening internationalist perspective, some among them became more overtly Pan-Africanist and politically radical. Others turned attention more intensely to electoral politics as a necessary course for Black freedom. If you are American, you're probably more familiar with the part of the story that details growing ambivalence toward the practice of nonviolent resistance. But that detail is far too modest to explain all of what was being grappled with. The question didn't pivot around nonviolence of self-defense. It was really about *how* to ensure Black freedom and self-determination, figuring out how to pursue it, wondering what it

would take to get it, and where and under what governmental authority it could exist. They tried different paths—nationalist, integrationist, socialist, communist, capitalist-democratic, autocratic—and were thwarted in too many ways by world powers and puppets.

In 1965, Malcolm X was assassinated as he was building the Organization of Afro-American Unity—a body that exemplified his own changed political philosophy, one that was internationalist, anticolonialist, and collaborative. It was yet another global heartbreak.

These are all just brief sketches of how, over the course of a decade-and-a-half history, tragedy and triumph happened in the tightest timeline. That is how it was: deep learning, extraordinary hope, and devastating death. Again: the height of blue sky, the depth of ocean floor, a blues song of living on a loop. The vise grip of racism was not going to be released, even with the promise of Black citizenship. Freedom wasn't free. It cost thousands of lives and millions of dreams.

IN 1966, SENEGALESE filmmaker Ousmane Sembène released his classic film *Black Girl*. M'Bissine Thérèse Diop—who plays Diouana, the Black girl—is striking in the black-and-white narrative film. She is Wolof, a people desired for service by the French during colonialism because of the beauty of their blue-black skins and the elegance of their long limbs. Diouana has a silhouette that reminds one at once of Marie-Guillemine Benoist's 1800 *Portrait d'une femme noir*, of a bare-breasted African woman, hanging in the Louvre, and Johannes Vermeer's *Girl with a Pearl Earring*—except Diop's earring is in the shape of a sunflower instead of a pearl. Diop as Diouana is shot with the three-quarter gaze of the Vermeer, yet she wears a gele like the subject of the Benoist. Perhaps Sembène was being deliberate, placing this Wolof woman's body inside an iconography of Western beauty, and then telling her story of being in the West honestly.

The film is about a young woman who travels from Senegal to Antibes, France, to work as a nanny in 1960, just as Senegal has become independent from France. She expects cosmopolitanism. She encounters endless domestic work. Diouana is held captive inside the home. Hers is a lonely Blackness. Elegant and hardworking, Diouana is insulted by the mistress of the house for her efforts to be chic. No heels and an apron tied about her waist become requirements of her job.

Throughout the film, Patrice Lumumba's presence haunts. Before she leaves for France, Diouana visits her boyfriend, and Lumumba's face adorns his bedroom curtain as he worries about her departure. One day, as she is in service, her employers explain to their European friends that Senegal is fine to visit, far preferable to the Congo, which had been much more assertive in throwing off European control. This detail did not appear in the short story that Sembène wrote preceding the film. This is probably because the short story was set before independence, the film after. But in both, Diouana is warned about what will happen to her in Europe. In his story, her cousin attempts to dissuade her, knowing what France could do. "He had left, rich with youth, full of ambition, and come home a wreck." Indeed, hers too will be a shipwrecked life.

The story is also more explicit in describing her condition as a form of slavery. She has—upon seeking the mother country—suffered the fate of the enslaved ancestors. Sembène tells us she would have been better off staying in her homeland, writing in verse:

> Image of our Mother Africa,
> We lament over your sold body,
> You are our
> Mother,
> Diouana.

His lyrical Pan-Africanism reflected the times. In this new historical moment, Black people were finding each other around the

question of who they, we, would be and shaping each other's identities as well. Maybe that's why Sembène was okay with having Diouana voiced by a woman who was not Senegalese. The speaking voice in the film did not belong to the actress who acted in the film. Instead, it was dubbed by Toto Bissainthe, a Haitian singer and actor who was then living in exile in France. Bissainthe could not return to Haiti due to her opposition to the brutal leadership of dictator Jean Paul Duvalier, known as Papa Doc, one of more than a few Black dictators in the mid-twentieth century who appealed to Blackness but answered to empires. That history is its own form of blues.

Right before the Black girl dies in the movie, she removes all of her aspirational wear. No wig, no heels, no clothes. Her employer goes to her mother and tries to compensate her. The mother refuses.

Sembène based the film on a true story he read in a French newspaper of a woman laborer who died by suicide. Look to the colors of Pan-Africanism, and they are red, black, and green—following the scheme of Marcus Garvey's early twentieth-century flag—not blue. But in retrospect, it all seems blues-soaked. For every possibility, there was dashed hope and disaster. And then they'd dream again. You can't call it foolish, but maybe not wise either. "Beautiful" is probably as apt an adjective as possible. Try again.

In March of 1968, Stokely Carmichael and Miriam Makeba married. Theirs was a Black revolutionary love story. Makeba was a popular South African singer who had gained international acclaim. In 1963, she had testified at the UN about South African Apartheid—colonial Jim Crow—after which her South African citizenship was revoked by the White ruling government. She moved to the United States and became enormously successful. She won a Grammy Award for an album with Harry Belafonte in 1966. Though she was already politically outspoken when she married Carmichael—who had proclaimed Black Power and railed against all forms of colonialism—she was effectively blacklisted, and her US visa was revoked. The

month after they married, the man who had both cared for and debated Carmichael, Martin Luther King Jr., was assassinated, and American cities burned in outrage. King too had fallen from grace in the United States for his opposition to the Vietnam War and his organizing against poverty and ghettoization. Nina Simone said it plainly: "The King of Love Is Dead."

Makeba and Carmichael traveled to the Bahamas, and when they returned, Makeba was denied reentrance to the United States. They decided to settle in Guinea instead, at the invitation of leader Sékou Touré. There, Stokely took the name Kwame Ture, and Makeba recorded the song "Lumumba" to honor the slain leader. By then, Kwame Nkrumah had been forced out of Ghana, and he was in Guinea as well, in exile. Freedom dreamers were fugitive.

Back in the United States, Roberta Flack, a young Howard University–educated musician, was a teacher by day and a performer by night at a speakeasy called Mr. Henry's in Washington, DC. In the thick of the anguish and unrest of the summer of 1968, she played. She had been a prodigy, enrolling at Howard when she was only fifteen years old, and, like Nina Simone, was both a classical pianist and a jazz musician and singer. Lines formed around the block for her performances. In February of 1969, she recorded her first album. Bucky Pizzarelli was on guitar, Ron Carter was on bass, and Ray Lucas on drums. And though it didn't make it on that first album, she recorded "Afro Blue" with them. Listeners wouldn't get to experience that recording for many years. And that is unfortunate because it is a beautiful rendering. It is elliptical, like the Santamaría original. It creeps down to the lower registers, and is near silent at moments, like the pen of Ralph Ellison. And then, around minute seven, she musically quotes the opening of Miriam Makeba's classic song of 1960 "Jikele Maweni" (on the album cover for that song, Makeba was wearing a heavy blue satin dress before a golden-brown backdrop, with a short afro and glowing brown skin, a mix of Western attire and African

blooming). The song depicts the arduous life in the South African mines. South Africa's mines—diamond, gold, coal, uranium—were sources of extreme wealth for the White elites and terrible danger and ailments for the Black workers. Makeba's song was subversive; the voice was defiant even as it detailed subjugation. It called for resistance. And in that moment in "Afro Blue," Roberta Flack gave a response, a recognition to Makeba, before returning to Mongo's mystic pan African—Afro-Blue.

I met Miriam Makeba once, at the home of my high school mentor, Mrs. Neblett. Mrs. Neblett had been a mistress of culture for the Boston Black Panther Party and socialized us, the members of our African American History and Culture Club, to see ourselves as part of a fabric of culture that stretched beyond borders and far back into history. For Mrs. Makeba, we held a tea. Lace graced the ebony table. We drank from cups of fine bone china and learned about the unfinished business of revolution.

HOLY REPETITION

✦✦✦✦✦✦✦✦

AT FIRST, I didn't remember what the photos of the old indigo pits at Kano, Nigeria reminded me of. It was an Instagram post by the Bahamian artist April Bey that jogged my memory. The pits looked like blue holes. The aerial view of a blue hole is also a richly colored blue polka dot, though lighter on the perimeter and sapphire in the center. When I was a child, Jacques Cousteau's television documentaries of underwater exploration would rerun on television on the weekends. In 1971, Cousteau did an episode called "The Secrets of the Sunken Caves" about the largest blue hole in Belize, an underwater cavern that reaches hundreds of feet deep. The episode was mostly about how the divers couldn't reach the depths they wanted. Fifty-odd years later, we know that the farther you go, the wider the cave and the more diverse the life swimming in and out of the coral and stalagmite towers. Below sea level, there is more than you can imagine. There are hundreds of blue holes throughout the Caribbean, especially on Andros. In the region, the people—the ones who descend from the enslaved, the Beninese, the Haitians, the Bajans, the Hondurans of the Mosquito Coast, the Seminoles, the South Carolinians, the Floridians—say that luscas, mythological sea creatures that are combination shark and octopus, live deep inside down in the warm water and

snatch the humans who dive in. It is undeniable that the blue holes are dangerous. We use different languages for explaining why. For some, it is the sea creature; for others, it is nitrogen narcosis, an indescribable euphoria that seduces divers to their deaths, something that we imagine science will eventually describe. It is agreed that there is life down there. Regardless of who and what it is, they are wise to protect their blue depths.

BLACK SAINT

◇◇◇◇◇◇◇◇

BRAZIL CELEBRATED THE eightieth anniversary of the abolition of slavery in 1968. Soon thereafter, new stories of a folk saint named Escrava Anastácia (Anastasia the slave) began to spread organically. A drawing done in 1839 by Jacques Étienne Victor Arago during his travels to Brazil called "Slave with an Iron Muzzle" showed up alongside her story.

Arago wrote about his time in Brazil:

I have mentioned the negro slaves to you, but I have not told you that the slave-trade is still permitted in Basil [*sic*]. Rio contains one hundred and twenty thousand souls, five sixths of whom are purchased slaves. Fifty vessels are engaged in the slave trade . . . the idea of these unfortunate wretches crowded together, devoured by vermin, exposed to all sorts of diseases and privations, wrings my heart, and fires it with the indignation against a government, which thus traffics with the lives of so many thousands of individuals, because their color differs from that of its own subjects . . .

I have seen two Negroes whose faces were covered with tin masks, in which holes were made for the eyes. They were

thus punished because their misery had induced them to eat earth for the purpose of putting an end to their existence . . .

Olaudah Equiano described a horrible contraption akin to the one Arago saw in his own narrative:

I had seen a black woman slave as I came through the house, who was cooking the dinner, and the poor creature was cruelly loaded with various kinds of iron machines; she had one particularly on her head, which locked her mouth so fast that she could scarcely speak, and could not eat or drink. I [was] much astonished and shocked at this contrivance, which I afterwards learned was called the iron muzzle.

Imagine the heat of being covered in metal underneath the Southern US, or Brazilian, or Caribbean sun, dizzy, burned, nauseated, and humiliated.

Though the figure Arago drew is thought to have been of a man—historically speaking—it was repurposed—spiritually speaking—and taken to be Escrava Anastácia. Anastácia had been venerated by Black Brazilians as far back as the nineteenth century. But under the influence of the global Black freedom struggle, and in light of the eightieth anniversary of emancipation, her popularity grew. Some described her as a woman who was born in Africa, others in Brazil. Some described the vicious contraption covering her mouth as punishment for her beauty, others for insurrection. Her eyes are always a brilliant blue. Her skin is brown, and her hair coiled. In the world of symbols, history matters, but facts are movable. The people needed to see her this way, an embodied inheritance.

Escrava Anastácia's image is imprinted on prayer cards. She is worn on medallions. She is depicted on candles and statues. Devotees today make intercessions to her. She doesn't fit tidily into any of the

religious traditions of Brazil: Catholicism or Candomblé or Umbanda. But her followers have appealed to the Catholic church for her sainthood. That alone is a kind of insurrection. Catholic sainthood has formal rules, a doctrinal mode of recognition according to documentation that Anastácia's insurgent heroism doesn't abide. But her eyes are the color of Mother Mary's attire, as though her vision refuses any attempt to disrobe her of her status. Eyes of Marian blue with black skin. If we can admit that Christianity was used as a weapon of empire, and that it continues too often to be cruelly stratifying even as the world's disenfranchised have prayed it into something that could resonate with Jesus's love for the poor and suffering, then perhaps there is good reason for Mary's honest eyes to be painted in a Black slave woman's face. Spiritual witnesses, followers of Anastácia, correct the cruelty, soothe the humiliation, honor the woman degraded.

Anastácia's feet must have ached and been hard-soled and wide from labor. Tough flesh is real. Some insist she must be fiction, and others see her as worthy of veneration. We do know that if they stilled her mouth—and many mouths were stilled—her eyes still looked up to the sky, and out to the water, and blue was everywhere, reflecting back into them. And when she took in the bodies of her people in bondage, she saw how their midnight flesh glistened with exertion and broke open with blows. I wonder what the saint turned slave thought of Brazil. Was it . . . hell?

Even if I don't know which details are fact, I do know why Escrava Anastácia had to be conjured up. We have no choice but to contend with our past inside our present. We're haunted many generations over.

OLD BLUE EYES,
NEW BLACKS

◇◇◇◇◇◇◇◇

I got a mother in Beulah Land, outshine the sun
Way beyond the sky . . .
—MISSISSIPPI JOHN HURT

IN 1970, TONI Morrison published her first novel, *The Bluest Eye*, and Curtis Mayfield released "We the People Who Are Darker Than Blue." The latter clearly signified on the American body politic. Mayfield's "We the People" is to the Constitution's preamble what "just us" is to justice. The album and song on which it appeared are sermonic. Mayfield encouraged Black people to maintain a deep self-regard irrespective of poverty and injustice. It was a liturgy for the street.

Morrison's work was more unusual and not celebratory. First, because the entire plot of the novel was written on the cover of the book. And secondly, because it did not neatly fit into the Black Arts movement's unabashed affirmation of the beauty of Blackness. Instead, it was a proposition and provocation: What about if and when Black isn't considered beautiful? How would we contend with that? Her concern was apt, and history proves it.

In the novel, Pecola Breedlove is raped and impregnated by her father, Cholly. Theirs is a family in which disaster echoes. The baby dies. Pecola dissociates. Cholly has repeated a violence done to him, but made it worse. As an abandoned child, he'd been abused by White men who found him in an early sexual encounter, and forced him to continue while taunting him. Cholly tried to disclose the hurt to a man named Blue, the one person who seemed to care for him, but didn't or couldn't. Instead, he turned the wound inside and then out—on the girls and women of his life.

Morrison, like her contemporary, playwright August Wilson, composed history with her art, and art with existing materials of daily Black life. In Wilson's play *Fences*, when the protagonist, Troy—an older Black baseball player who never got a chance at the major leagues and lives with the resentment—tells his wife about a recalcitrant dog he had in childhood named Blue, he begins to sing an old folk song, "Old Dog Blue." Troy tells Rose that his daddy made up that song. But Troy is wrong about that. The song is so old there's no telling who exactly wrote it, and it has been a blues song and a bluegrass one, and other forms in between. But it doesn't matter. What matters is that "Old Dog Blue" is a blues piece set in Wilson's theatrical collage. And the ornery old dog, which Troy chases away for not following orders, well, that's a metaphor for Troy's habit of taking his frustration with the world out on the people he loves at home. Both Wilson and Morrison questioned the idea, in multiple works, that American dreams—integration, patriarchy, and wealth—could repair us. Or that the past could be set aright. That belief was as foolhardy as dreaming for blue eyes.

At the end of *The Bluest Eye*, Pecola believes she has gained blue eyes, gifted to her by a strange elder, a pedophile who seeks to be redeemed by God, though he doesn't have nearly enough shame. It isn't clear, really, whether Pecola does indeed have new blue eyes, or if she

just is suffering from a psychiatric break in which she now sees her life through blue eyes. That would be the far worse outcome.

Morrison's worry about the seductions that came along with Black Power–style romanticism are repeated across her novels. Blue-black-skinned people in her books are beautiful but no less prone to moral failings. Those who are economically successful are also often the cruelest. Her fingers were on a racing pulse. In those days, you'd open Black magazines, filled with gorgeous images of mayors and players and models and leaders. The ladies wore blue and teal eye shadows. Elegance and power were bedfellows. Between the stories, advertisements for menthol cigarettes—turquoise-hued Newports; brilliant blue Kools, the kind that Nat King Cole smoked—abounded. (Even Marlboro had a "brother in the blue dashiki" advertisement, which didn't last long because Marlboro had cultivated a cowboy-masculinity image.) Later we'd learn that the menthol in the cool blue-packaged cigarettes marketed to Black folk allowed more nicotine to poison the lungs. Underneath the cool, anguish remained. That's what all the stimulants and drink and highs and lows showed you. The glamorous imagery of that era—whether in cigarette ads or blaxploitation films—came from the style of urban hustling, conveying a street-level aspiration to power. And the quintessential figure was Frank Lucas, a North Carolinian who made his fortune as a drug dealer in New York. His heroin came directly from Southeast Asia. Lucas claimed he got it to the States via the coffins of dead Vietnam War servicemen. Associates have said that was just myth. Even so, it was a cold-blooded idea. His strain of smack was nicknamed "blue magic." It was strong. Blue magic softened open wounds. It was a terribly potent killer.

Here is a lesson that every Black revolutionary and regular person has to learn sooner rather than later. Some Black people will break your heart. Why? Because we/they are human. Nothing more, nothing less. Lucas claimed he turned to drug dealing because he witnessed a

lynching in his youth. According to that line of thought, trauma legitimizes its repetition no matter who it hurts. Lucas joined an antisocial league of actors who would take advantage of the cruelty of the system of law and order to which Black folks could hardly appeal for protection or care. And he got rich doing so, until he got caught. The cages are awful. The ravages are real. None of that makes it okay.

Here's how: In 1970, Muhammad Ali had not fought in three years. He'd been stripped of his heavyweight title. And because he refused to fight in Vietnam—what he and many others across the globe considered to be an unjust war—Ali couldn't get a boxing license any place he applied. That is, until Georgia. Atlanta was known as the Southern city too busy to hate when there was money to be made. Welcoming Ali there—below the Mason-Dixon—made the point sharply. He was set to fight Jerry Quarry, the latest boxer to be given the colloquialism "Great White Hope." The message was clear: Atlanta was so progressive that even the brash Kentuckian who belonged to the Nation of Islam could be tolerated. Jim Crow looked dead. Especially with that crowd on October 26. All the King's men—as the allies of the slain civil rights hero were sometimes called—showed up, including Andrew Young, Julian Bond, and Jesse Jackson. Even King's widow, Coretta, was ringside, along with many famous musicians and athletes.

Another Atlanta constituency was there too. Pimps and hustlers arrived, dripping in jewels and wearing minks too hot for Georgia. Frank Lucas, a Southerner too, but from the far less ostentatious culture of North Carolina, was there that night, and he was bothered. These Atlantans were small-time hustlers compared to him, but they looked so much richer. That evening was not a good time for the underworld in general. Ali won the lackluster fight on a TKO, and then a bunch of hustlers got robbed at a lavish post-fight party. Lucas escaped their misfortune but was still put out by the evening. Next time would be different.

In March of 1971, Ali and Joe Frazier fought. Ali liked to mock Joe Frazier, calling him slow and dumb, seeing himself, a product of the urban Upper South, as the polished sophisticate ready to pummel the country boy from Beaufort, South Carolina. But that night, the sharecropper's son prevailed in a unanimous decision. Lucas thought he did too. He wore a $100,000 floor-length chinchilla coat with a matching hat over an icy blue suit. It was a cold outfit on a chilly night. And it drew attention, as did the fact that Lucas's seat gave him a better view of the fight than Vice President Spiro Agnew's. The police learned who Frank Lucas was that evening, and it was the beginning of the end of his empire.

As you already know, a simmering disaffection had existed between Black folks and police in the United States for generations already. But in the 1970s, mainstream journalists began to cover what was termed a "blue code of silence" and the "blue curtain" to describe a conspiracy of protection among police officers against accountability for lies, brutality, and participation in criminal activity. Black newspapers had covered police misconduct for decades. But now the problem crossed over into mainstream attention. At the same time, deindustrialization and White flight gutted tax bases, and the freedom movement was deliberately dismantled by COINTELPRO, the FBI counterintelligence movement. The buoyant hope that was sustained through dogs, hoses, assassinations, and White calls to "go slow" had worn down. It was hard to know what to do next, even if freedom dreams hadn't yet been snuffed.

Albert Cleage, that blue-eyed Black pastor from Detroit, had an idea. He took his inspiration from Father Divine. Like the charismatic Great Depression minister, he wanted to feed his flock literally and spiritually. A Black nationalist, Cleage believed that creating food and shelter of one's own was a key element to Black self-determination. He was, as Nyerere would say, "a true revolutionary who analyses any

given situation with scientific objectivity and acts accordingly." What was happening in independent African nations, Cleage and his people believed, could have a version here. Cleage renamed himself Jaramogi Abebe Agyeman—his surname the Akan word for "liberator"—and set about making Beulah Land: a self-sustaining community through farming and faith. Beulah Land was never vast, and perhaps that's why it wasn't destroyed. It was a blueprint for how to live in the world as Black people. Such efforts existed in local forms in various corners of the United States, and in more extensive forms in the Caribbean and Africa. Free nations were proving to be more challenging to execute than they were to imagine. Global politics, world powers, and individual greediness encroached on the visions of independent Black countries.

Meanwhile, the backlash against the Black Power movement was fierce in the United States. Organizers dispersed to various places like Cuba, Algeria, and prison. By the time Nina Simone got to Liberia in 1974, she had lost many of her closest friends and heroes and had suffered mental health crises and a disastrous marriage. She and her daughter took up residence on Congo Beach. Simone claimed to feel at home there, yet she lived the life of an elite expatriate, defying local social expectations: appearing scantily clad and frequently disrobed, with a butler, a driver, a gardener, and a cook. Stokely Carmichael and Miriam Makeba were her frequent visitors. She talked about freedom—fast and frenetic—but something was slipping away.

Paul Gonsalves died in May of the same year after many years of a heroin and alcohol addiction. Duke Ellington passed ten days later of lung cancer, unaware of his bandmate and friend's passing.

In 1975, Frank Lucas's New Jersey home was raided. Can't you just hear the R&B crooners with the same name as the heroin that made Lucas his fortune? Philly soulsters Blue Magic sang their hit "Sideshow": "Let the sideshow begin, hurry hurry, step right on in. Can't afford to pass it by, guaranteed to make you cry." The police

claimed they found over half a million dollars in cash on his property, but Lucas claimed they pocketed much more. Lucas was sentenced to seventy years in prison, but after testifying to the crimes of others, he only had to serve five. He found himself back in prison again in the 1980s, and yet again in 2012. He kept on hustling backwards until the end.

Nina Simone traveled to the Montreux Jazz Festival from Liberia in 1976. She had had a long hiatus from performing. Simone sat at her piano, with a faraway, almost frightened look in her eyes, and declared that she would start at the beginning with a song about a little girl whose name was Blue. This time, she sang "Little Girl Blue" differently. It was a reinterpretation of the material first given. In this version, she was not just describing the little girl blue; she was advising her: "All you can count on is yourself, liberated little girl blue . . . no longer little girl blue. Aint no use to try to tell them. They won't understand if you try to tell them."

At the conclusion, she adds a Swahili word, "umoja," which means "unity." It sounds like she's grabbing at it, fearful that something is escaping her. The song, from her first album, strangely fit in with 1976. This was a turning point too. Folks were looking back instead of forward, increasingly. An anxiety buzzed—what was being lost as things had changed but not enough? It's no happenstance that a blues song became a hit in 1976, Dorothy Moore's "Misty Blue," which was both melancholy and old-fashioned. A few years earlier, Bobby Blue Bland had also briefly made his way back into mainstream popularity with the song "This Time I'm Gone for Good," from an album called *His California Album*

Ralph Ellison was looking back too, in his 1978 essay "The Little Man at Chehaw Station." By then Ralph Ellison was hopelessly out of step. The elder statesman of African American literature had grown ornery and conservative—holding fast to the deep Americanness of Black people in the United States and a militant integrationism, while

keeping Africa as well as radical politics at a distance. He reflected on his own youth frequently, and in this piece as well, offering nostalgia and something of a cautionary tale. Chehaw Station, outside of Tuskegee, Alabama, was the site of a parable created by his music professor Hazel Harrison. Harrison had been an accomplished pianist who had played with the Berlin Philharmonic and the Minneapolis Symphony. But she had never been offered a position with an orchestra because of her race. Ellison wasn't focused on those details of her life, however. In the essay, he focused on her evisceration of him after his delivery of a subpar performance. Harrison had told him that there was a little man even in the podunk train station near Tuskegee with a learned ear for music who merited excellence. For Ellison, her point was that in America, there could be expertise in a vernacular listener, and that that was a marvelously American thing. And when those at the bottom—Black people—have made your nation's only classical music, such aesthetic democracy was made possible. To Ellison, all that Black nationalism stuff full of proclamations about being African was sophomoric. He wrote:

> . . . while this latest farcical phase in the drama of American social hierarchy unfolds, the irrepressible movement of American culture toward the integration of its diverse elements continues, confounding the circumlocutions of its staunchest opponents.

And then he told a story as an example of his point:

> In this regard I am reminded of a light-skinned blue-eyed African American featured individual who could have been taken for anything from a sun-tinged white Anglo-Saxon, an Egyptian, or a mixed-breed American Indian to a strayed member of certain tribes of Jews.

He saw the young man on Riverside Drive in Harlem, driving a new blue Volkswagen Bug. He struck an impressive figure: "Clad in handsome black riding boots and fawn-colored riding breeches of English tailoring, he took the curb wielding—with a pukka-sahib haughtiness—a leather riding crop. A dashy Dashiki (as bright and as many-colored as the coat that initiated poor Joseph's troubles in biblical times) flowed from his broad shoulders down to the arrogant, military flare of his breeches-tops, while six feet above his heels, a black Homburg hat, tilted at a jaunty angle, floated majestically on the crest of his huge Afro-coiffed head." The man proceeded to fashion self-portraits with his Japanese camera (quite a feat before the age of selfies), capturing the majesty of Manhattan as his backdrop.

Such spectacular cosmopolitanism was classic in the 1970s. I remember, a small child at that time, that traveling exhibition of the treasures of King Tutankhamen and the words "Egypt is in Africa" blazoned across the entry wall. It was a challenge that had everything to do with how Blackness was being expressed. For generations, Western scholars had assiduously separated Egypt from the rest of Africa, even dismissing its close connection to the neighboring Nubia, because Egypt was an impressive civilization and Africa had been cast as the "Dark Continent." Modern Egyptians, descended from Arab conquerors who'd participated in their own African slave trade, echoed this distinction. Debates over the color of ancient Egyptians, like debates over the color of people in the Bible, were ideological jousts about the wages of White supremacy, and were rarely really about the fact of color. No matter, they mattered. Egypt is in Africa. Jesus had hair like lambswool. People once called "Negroes" were newly self-proclaimed Africans and Black with glorious submerged histories, and they intended to look like it all.

In that Tutankhamen exhibition, blue was everywhere. The god Amen-Ra had blue skin; the holy herons had blue feathers; blue geometries covered sarcophagi, walls, and jewels—the color

of the heavens and the floodwaters, it was a divine color. And Black American people—blue-eyed and blue-black—looked to Egypt and, of course, to West and South and even North Africa (*The Battle of Algiers* was a popular film among activists) for inspiration. This blue-eyed young man who Ellison saw, and mocked, was, according to the old man, a somewhat vain performer instead of an authentic "African." He wrote: "The man was hidden somewhere within, his complex identity concealed by the aesthetic gesturing. And his essence lay, not in the somewhat comic clashing of styles, but in the mixture, the improvised form, the willful juxtaposition of modes. Perhaps to the jaundiced eyes of an adversary of the melting-pot concept, the man would have appeared to be a militant nationalist bent upon drama-tizing his feelings of alienation—and he might have been. But most surely he was not an African or an Englishman." It was the man's gait that gave him away: according to Ellison, a "pimp walk." He was a cultural hybrid with the improvisational style so characteristic of Black Americans. Ellison was right and he was also wrong. Standing in life, carrying a moving tabernacle, relying upon what is at hand, making something new of it, was at the center of the Black American tradition. Ellison was right about that. But he was wrong that all these refreshed elements, including nationalism and African identity, were alien to that. Living is a doing.

The blue-eyed, dashiki-wearing Black man was to Ellison's mind a symbol of something fundamentally American. Perhaps. But he was also a symbol of something fundamentally Black. Africa as a concept and continent was born of a series of indelible encounters. The continent is a geography, an idea, and an inheritance. All have changed over time. We Black people have all been made cosmopolitan by history, though we are woefully and wrongfully rendered as nar-row and fixed, sometimes by our own selves. That is to say, while there are myriad expressions of Blackness, all the ways were created in the shadow of modernity and at the crossroads of the world. And

they, we, keep getting remixed. What Ellison recognized in the blue-eyed dashiki wearer was specific. But that remix had its own versions in Brixton, Bahia, and Accra. Bob Marley—the Jamaican musician who made the whole world rock to a Rastafarian vision of justice with rebellious peace—had both teal blue and baby blue Land Rover trucks, and a blue BMW Bavaria; even he who eschewed material things seemed to take pleasure in elegance and blues. Perhaps the why is found in his 1974 song with the Wailers, "Talkin' Blues," when he speaks of having "feet too big for your shoes." Blue was the aesthetic of dreamers. He'd traveled the world with it.

Crossing waters, when Black people have reencountered each other after this long history of encounter, we have mutually admired and reinterpreted the remixes. There is no single Black essence. There is no fundamental inborn way of being Black. But we do watch each other closely, and try on each other's grammars. Elegance in survival is contagious.

Saint Lucian poet and critic Derek Walcott would make a similar criticism to Ellison's. He said of the Black nationalist era that people of the diaspora in the Caribbean and the United States performed Africanness in the 1960s and '70s but did not truly inhabit it. To him, it was merely a form of mimicry. He describes this when recounting the staging of a play called *The Road* by Wole Soyinka, the Nobel Prize–winning Nigerian writer, saying: ". . . Ogun was an exotic for us, not a force. We could pretend to enter his power, but he would never possess us, for our invocations were not prayer but devices . . ." Perhaps that was true of that particular collection of actors. But what Walcott seemed to forget is that there were children of the orisha-deity Ogun in the Americas who had practiced syncretic Yoruba-based faiths for generations. Ogun wasn't a stranger to everyone in the Americas. But let's allow Walcott's point to unfold. He opined: "Once the New World black had tried to prove that he was just as good as his master, when he should have proven not his

equality but his difference. It was this distance that could command attention without pleading for respect. My generation had looked at life with black skins and blue eyes, but only our own painful, strenuous looking, the learning of looking, could find meaning in the life around us, only our own strenuous hearing, the hearing of our hearing, could make sense of the sounds we made. And without comparisons." He too was right, and he too was wrong. Walcott's "blue eyes" referred to a White gaze, a European judge, of oneself and one's people. Indeed, it is a terrible thing to turn one's self-assessment over to a tradition that has called you inferior. But the risk of such self-alienation had never been limited to one corner of the Black world. Everyone had to do painful strenuous looking to find meaning in their lives in order to avoid the risk of self-immolation to each Black soul. A romance of Africa, a romance of America, a fetish of nationalism, myths of superior origins, or rankings of authenticity or admixture—each type of posturing, myth, and hierarchy is a danger because they lead us to either believe the funhouse distortion of the blue-eyed mirror or run away from the ugliness of history. That's why we needed Pecola's story. She was one of *us*.

HEAVEN'S THERE
FOR THOSE . . .

<><><><><><>

RUTH HILL WORE a deeper blue than her husband, and her voice was quiet, like a gentle rumble. She never seemed to get tired of him flirting with her. I first met them the year Roberta Flack's *Blue Lights in the Basement* album came out, and they looked like Flack's duet with Donny Hathaway "The Closer I Get to You" come to life: "Sweeter and sweeter love grows / And heaven's there for those / Who fool the tricks of time / With the hearts of love they find true love / In a special way . . ." I remember how he would turn his head, reach out his hand, and ask her a teasing question. Her gap-toothed smile was pure mirth.

She came from a small but sturdy Black Massachusetts family. Born in Pittsfield, Ruth was the great-granddaughter of Samuel Harrison, the man who served as chaplain for the all-Black Massachusetts 54th regiment in the Civil War. She had the kind of matter-of-fact distinction that is so common among Black Massachusetts—a degree in bacteriology from the University of Massachusetts at Amherst in 1946, a master's of library science at Simmons College in 1948. Simmons was a genteel place, and I imagine Ruth navigated it elegantly,

just as she did Harvard and Radcliffe, where she held a succession of positions. She married Hugh Hill, a Harvard man, in 1950.

When I first met Ruth Hill, she had recently founded the Black Women Oral History Project at Schlesinger Library. I was five years old, though, and had no idea that she was making a world for me to remember. What I did know was that she reminded me in a remote way of the women who nurtured me. You could look at her and see she was responsible, restrained, and also sweet. But her speech had a Northeastern clip, and she carried her knitting with her. That was different.

I looked at her and saw comfort, but I watched her husband and felt joy. All of us children did. Outside of the library where my mother was studying—we'd moved to Massachusetts for her to pursue her doctorate at Harvard's Graduate School of Education—he stood on a hill. Hugh Hill stood on a hill to tell the people stories: it could have been the beginning of an epic, and he certainly deserved such distinction. It occurs to me now that he probably chose that place because of its proximity to Ruth's office. He dressed in such a way to draw us in; like a wandering minstrel, he wore a soft blue denim shirt and pants, a blue tam on his head, with streamers of all colors hanging off his clothes. Butterflies were pinned to his clothes, some blue and some rainbow. He'd open his palms, and butterflies were drawn on them. He took off his shoes to be connected to the earth, with his long keen caramel feet. He'd look at Ruth when she accompanied him, and say, "This here is sacred ground."

We called him Brother Blue. He was a reliable presence, always ready to tell us stories. There was the jazz version of *King Lear,* and the blues-inflected version of *Romeo and Juliet.* But the story we wanted most often—and he complied—was the one about the butterfly who didn't know what he was until he came out of his chrysalis. The butterfly had to turn inwards in order to become. It was a sermon.

And maybe it was also a form of autobiography. When I was an

adult, Farah Griffin told me that I should look for Brother Blue in the Harvard College yearbook. I must have looked surprised. She said, "You won't believe it." I found his image in the dusty stacks at Widener Library, baby-faced and clean-cut. He looked just like one of those "race men" we all knew—African American strivers who served as a model of excellence and an advocate who believed every point of individual achievement and access served "the race." To me, then, he looked nothing like himself. The Brother Blue I knew was half bluesman and half hippy, an iconoclastic bard who kept on living in the 1960s all the way through to the new millennium. But now I understand you can't know a person when you only start with the third or fourth movement of his life.

Hugh Hill was born into a working-class Black Cleveland family. Indeed, that Black Midwest cadence never left his voice. Neither did the watchfulness in his eyes. Hugh was one of four children. His father was a mason with aspirations for the children. He moved the family into a predominantly White neighborhood so his children would have access to better schools. This also meant that they routinely had to defend themselves against the punches and slurs of White kids on the walk to school and back. Hugh Hill grew up tough.

Hugh had another challenge. He was a stutterer. His father learned a piece of information that he shared with his son: the famous Greek orator Demosthenes had filled his mouth with pebbles to perfect his speaking voice. Inspired, Hugh did the same, quelling his stutters with a weighted tongue. That exercise led him into student theater for the first time. I imagine his parents beamed as their child took the stage. And he would move from stage to stage with distinction, bearing the strong shoulders of someone used to adversity.

I only learned the hardest part of his story years after the death of Brother Blue. And it was yet another clue to how and why he became who he was. During the Great Depression, Brother Blue's father couldn't find any masonry work. And therefore couldn't feed

his family. In desperation, he purchased a life insurance policy and shot himself in the head. That was the only way he could imagine their survival. He lived, thank God. And so did his family. I imagine they felt at once gratitude, anger, and an uncanny mix of betrayal and deepest fidelity from their father. Maybe the conventional responsibility of a man is too much to bear when the world conspires against you.

The youngest boy in the family, Tommy, was severely disabled. Brother Blue said that Tommy could only ask one question—"Do you love me?"—and couldn't pronounce "Hugh" so called him "Blue." That was the origin of his name. However, it seemed to Brother Blue that Tommy understood more than he said. Tommy delighted in the sermons and music that they heard at the AME church they attended. Tommy's joy was at least as significant an influence in Brother Blue's later years as his father's heartbreak.

Brother Blue, then still a young man called Hugh, went off to fight fascism in World War II, like many other Black men. It must have been a combination of strength of character, intelligence, charisma, and work ethic that led him to rise to the rank of first lieutenant. And perhaps those are the same qualities he displayed in the letter he wrote to Harvard College from Europe requesting admission. He received a welcome letter from the oldest and most elite university in the United States. And just like that, his fortunes changed.

Hugh Hill was a distinguished young man. But he was looking for himself. He matriculated at Yale School of Drama after graduating from Harvard College and was by all accounts exceptional. Robert Penn Warren described him as "certainly one of the most intelligent and gifted people [there]" and, over thirty years later, as "one of the few people of that place that I vividly recall." And yet Hugh knew he wasn't destined for a conventional theater career. He enrolled at Harvard Divinity School in 1967, and while he'd carry the lessons from that place with him as well, he wasn't set to be a pastor or a theologian. As attorney Michael Anderson would say, "The liberal

Northern Harvard elites would have loved to make Blue a respectable Sidney Poitier figure, an engineer, or a doctor. But sometimes people like Blue just got away."

He wanted to tell stories. And so he did. Adopting the name Brother Blue, he took off his dress shoes and ties and put on what he called his "rags" like a Shakespearean fool—meaning wiser than society's dictates. The stories, he decided, had to be the kind Tommy would be able to grasp, and had to move people like the sermons of the AME pastors of his youth. In that he succeeded as well.

Hugh Hill went back to school after becoming a storyteller. But he pursued this education according to the details of his calling. He showed up at Antioch College in Ohio with the goal of being admitted into an experimental PhD program called Union Graduate School. He brought two artifacts with him: the shackles his grandfather wore as a slave and the trowel his father used as a mason. Always Socratic in his method, as a student and a teacher, he used this as an example. Ask the right questions, and you'll move toward virtue and truth—that was his ethos. His question before the dean of admissions was, what does the labor of my ancestors demand of me? And the answer—which he offered himself—was to continue the work of freedom dreaming. This commitment was infectious. Over the many years I knew him, everyone called him brother.

In African American culture, we use the expression to "put a handle" on someone's name, meaning a title of respect. Hugh Hill did not choose "Doctor" or "Mister"; he chose "Brother," that word that was embraced in church and in the streets of the Black Power movement. Not a word of hierarchy but of a respected and universal and very Black kinship.

Brother Blue's PhD defense took place at Deer Island Prison off the coast of Boston in 1973. Deer Island was infamous for terrible food, brutality, and unlivable conditions. Brother Blue brought a twenty-five-piece orchestra to play for the inmates as accompaniment

to his storytelling. Of it, he would say, "My Ph.D. project is a total effort to fuse the arts of theatre into new forms of worship, to body forth reality in us which is beyond verbalization, music, all sound. In the language of motion, I long and pray to reveal something of the invisible, the inaudible in man, woman, child. I believe that physical gesture can and does express the God within us." The performance was cut short because of an inmate revolt. I do not know whether they were specifically inspired by Blue, or if his visit was just part of the storm of protest. But the outcome was that Brother Blue earned his doctorate.

Over the years, he became internationally famous as a story-teller, but most of all he was a mainstay in Cambridge until his death in 2009. I loved the harmonica that he used to accompany his raspy-voiced storytelling. Every sentence and breath was music. In 1977, when I first encountered him, I was a small child; I knew he was different from anyone I'd ever seen, and yet his rhythm was a Blackness I knew deeply. But his impact extended far beyond those who experienced him as familiar. Intellectual luminaries from every discipline would fondly recall his presence and power, from Nobel laureate Seamus Heaney to evolutionary biologist Stephen Jay Gould. Long after the social-upheaval years of the 1960s and early '70s receded, Brother Blue stayed in that moment of possibil-ity, a one-man Greek chorus, a griot in the West African tradition, a hoodoo wordsmith in the African American one. He held fast to his belief in the transformative possibilities of struggle. He often said that we needed "the Blues, y'all. 'Cause we been through some-thing . . ." For him, it was a technique for living. One of his stories would go: "You stand around that old piano. It's broke. You ain't got no money to fix it. You transpose around it. You work around it."

That work-around is the grace of survival. It isn't politics nec-essarily, or striving for attainment. It is a strategy for living. Brother Blue traveled so far beyond the streets of Cleveland: to the battlefields

of Europe, the stages of Russia, the neighborhoods of the Bahamas, and the corners of Cambridge. But he remained that little boy from Cleveland and fed that child's need to make sense of his suffering and to survive it, and in turn, he fed our need as well. As I came of age, I learned from him, making my way through the same institutions of higher education as he had. He taught me that all stories are ours—meaning Black folks'—even when they come from the very people who mean to keep us down and out. What matters is the telling, meaning the integrity of our voices. We do not have to fashion ourselves in the image of our yearbook photos and diplomas. We can be pious to our callings, no matter how iconoclastic they are. With the boldest spiritual persuasion, he cautioned everyone who was milling around Massachusetts being smart and collecting degrees and A grades in order to validate our existences that "God is shaking his head at what people have done in the name of the scriptures. Waging all these wars with words. We've fallen under a spell. It's called the idolatry of the written word."

THIS IS THE same man, mind you, who also told us to read and study everything. But there was no contradiction between the two statements. The lesson was that the study and the writing only matter insofar as they are pursued in the service of what is good and humane. Otherwise, it can all easily sour and rot. Your chrysalis must be built with care so that you can emerge with your natural human holiness intact. I listened to him on Cambridge streets, but his classroom was one of the most important of my life.

I learned from Ruth that the collector of stories is the partner of the storyteller. Like the Biblical Ruth, she created the oral history collections in the Schlesinger Library of Radcliffe to attest to the divinity of regular folks doing the daily work of tending to the earth and its people. I learned from her that the quiet part is as potent as

the sonorous one. They work together. I can still see the duo in my mind's eye. I often walked behind them, slowly, so as not to overtake the couple, witnessing their whispering and giggling, bright blue and muted deep blue, a caramel neck and a mahogany one, a tam and a headscarf, a swinging arm and a steady one.

She lived for fourteen years after he died. Their record remains.

FROM INDIGO CHILD TO
WHITNEY'S BLUES

◇◇◇◇◇◇◇◇

INDIGO WAS ME. People look for themselves in books and there I found myself. Ntozake Shange's character Indigo from her novel *Sassafras, Cypress and Indigo,* was a precocious girl-child, still playing with handmade dolls when she got her period (she gave them a menstruation tea party), a girl who befriended old women and rough boys, a girl who fashioned her own hoodoo recipes for making the world in the image of her people. Her mother's diagnosis, "It was the South in her."

Through the 1970s and '80s, there was a breathtaking renaissance of writing by Black women. They carried their mothers and grandmothers with them into a society that was confounding. Social movements had opened doors. But the backlash against them was causing new suffering—Black liberation and feminism both bloomed, yet both movements seemed to expect Black women to sit in back seats. I sometimes think the magic of the page for them, like it is for me, was that it was where you could make the world as you hoped it would be. That's what Indigo did: "She made herself, her world, from all that she came from . . . There wasn't enough for Indigo in the world she'd been born to, so she made up what she needed." She was who I needed to see.

In those days, the blues were reborn. They were in hip hop, which borrowed its double entendre, apocryphal tales, and masculine bombast. They were in house music, which had its share of gospel too. You could hear it in queer Black clubs in Chicago if you rode the Blue Line into the Loop late at night. The high hat would take you into a trance as powerful as the Hammond B3 at church. And the young people from projects that stacked them on top of each other danced hard until the sweat cascaded off their bodies. Things were hard, but they were also magic. And it was due to the art of Blackness. I recently heard a young person ask fine art documentarian photographer Dawoud Bey what art was, and he answered cogently: art is the thing that we bring into our lives to transform it. That transformation was everywhere in the 1980s, even though progress stalled and the people had a hard way to go.

I remember seeing Whitney Houston in *Seventeen* magazine at some point in the early 1980s. I was just nine years younger than her and felt even closer. She was a beautiful rail-thin Black girl in a magazine that seemed to be unapologetically for White girls only. It was a strange thrill, a reflection of myself, which was a sign of an anemic kind of progress. Within a decade, she would become one of America's sweethearts, with a series of pop hits sung masterfully in that pristine New Jersey–style gospel voice. Houston was accused by more than a few Black critics of abandoning Black people, Black radio, and Black style for mainstream success. She bore the brunt of our ambivalence. We weren't sure if we were supposed to like the mainstream, even as we clamored to get in it. She, a young woman with a heavenly gift, became an avatar for a big ball of fearful uncertainty. Between the integration and access of a few and the urban crises of the many, we Black Americans worried that we were losing our common ground and linked fates. I was a teen, though, and really didn't understand how things were changing. I just liked that she was brown and skinny, like me, adorned in candy colors that were usually only displayed on White girls with blond hair, and she was luminous. My adoration in the '70s of her older

cousin Natalie Cole, a soft-voiced, hazel-eyed, brown-skinned delicate type who wore blue eyeshadow and a diaphanous blue dress to win her first Grammy, shifted over to Whitney—she wasn't quite me, not like Indigo, but closer than anyone else I could see on MTV.

Natalie Cole and Whitney Houston both suffered underneath their pristine surfaces. We now know about their addictions, their loneliness, Whitney's verboten love with her dear friend Robyn, and more. And when it came to Whitney, it was as though the difference between the surface and the substance wasn't just about her; it was about all of us, and how often we struggled with the gap between who we were and who were "supposed to be."

In 1991, Whitney Houston sang "The Star-Spangled Banner" at the Super Bowl, backed by the Florida Orchestra. Over 750 million people watched her performance on television. Stunningly beautiful, Houston looked patriotic in a red, white, and blue jogging suit. The United States had just entered the Persian Gulf War. It was the largest overseas deployment of US forces since World War II. The flag rippled behind the Black and platinum-voiced star. She gave us chills. An American dream achieved, I suppose. No, it wasn't the March on Washington of the past, nor was it the election of the first Black president of the future, but it had a kind of symbolism that could be inspiring and discomfiting at once.

Over 150 years earlier, an American flag was sewn for Fort McHenry in Baltimore. And a Black girl named Grace was among the seamstresses. She'd been indentured as an apprentice to Mary Pickersgill, flag maker, when she was around ten years old. Mary was required to provide food, shelter, and clothing, and also to train Grace in housework and sewing for six years. Education was not part of the arrangement, however. Grace was likely illiterate.

Mary was contracted to make the flag and did so with the assistance of her daughter, two nieces, and Grace. Wool was used for the stripes and blue background, which was dyed with indigo. The

stars were undyed white cotton. The flag was complete by August of 1813.

It was made to be flown to support the American cause in war. The War of 1812 pitted British forces and Indigenous nations against Americans who wanted to expand west. Empires make strange bedfellows. This flag, once hung, was visible in the Battle of Baltimore. It may have inspired the soldiers to prevail. It was a key victory for Americans. Francis Scott Key noticed it. And when he retired to the Indian Queen Hotel, inspired, he wrote a poem that was printed as a broadside immediately under the title "Defense of Fort M'Henry," to be set to the tune of "Anacreon in Heaven." He'd previously applied the tune to his 1805 song about American valor against Tripolitanian forces in North Africa during the First Barbary War. But this was the version that would be remembered. The song would become known as "The Star-Spangled Banner."

Francis Scott Key was a slaveholder and a nationalist. In the third verse, he expressed his disdain for the Black men like Billy Blue who joined the British in exchange for freedom. And though the British might not have been motivated in the least by concern for Indigenous people or the enslaved, their strategic alignments made the older empire arguably on the better side of history at that particular moment. Though Key's poem included the line "the land of the free and the home of the brave," his belief in freedom was limited to White people. He favored the idea of returning Black people to Africa and, as a result, joined the American Colonization Society. Slave or gone were the options for Black Americans in his mind.

Grace's hands worked the flag that inspired Key alongside Mary's family. She was inconsequential to many, if not most, in the nation, irrespective of her labor. "The Star-Spangled Banner" made it clear.

If we could have sent Grace in a time machine from 1813 to 1991, her mouth might have dropped open like mine did at the vision of slender, striking Whitney Houston singing before hundreds of thou-

sands with the flag rippling behind her. Houston's name was known around the world and was called the voice of the nation. But I think we've learned in the thirty-odd intervening years that the truth underneath these striking moments of incorporation into the red, white, and blue is a hard one. And that maybe these moments are much less meaningful than our twisted genealogy in indigo, hoodoo blue, the blues, the forget-me-nots, blue jays, and morning glories.

Whitney's life ended tragically in a bathtub in Hollywood. Substances had eaten up her magical voice; the pressures of perfection had swallowed up her life. I don't know Grace's life, but I do know that she and Whitney were both enlisted in a tidy form of storytelling that suppressed their fullness. The blue notes left in their wake are a testimony. When Whitney's daughter died in the same manner she had, I don't believe I was the only one who could see Whitney weeping at the side of the tub—beside her baby's body. Surely I wasn't the only one who doubled over in tears at the specter. Surely this was all supposed to be different by now.

In the fall of 1991, when Houston was still at the height of her career, Haitians embarked on boats for the United States in droves to escape the military coup. Most were diverted to Guantanamo Bay, a US military base and prison at the southeastern end of Cuba. I wonder if Grace, in 1813, knew about the independent Black republic of Haiti. Perhaps she daydreamed about going there, a place where the flag flew for Black people like her. I know that in 1991, I looked at the boats of Black people and felt deep in my gut that despite the fact that they didn't have the citizenship papers to enter my country, their fate had something to do with me, just like Whitney's singing the national anthem perfectly did as well. At nineteen, I was beginning to understand that Black citizenship in the modern world was still and maybe always would be a hard thing.

An admission: I am very much an American, and that is an uneasy title for me. I have a culture and an identity tied to this land; I am

without apology who and what I am. The unease is about the relation-ship between my citizenship and the rest of the world. My Blackness is a conduit, but my Americanness is so often a betrayal of that con-nection with others. I know the classic response is coming from some: "People want to come here from all over the world. The American dream is universal!" I think that dream is of a castle of security that exists inside the palace gates. I come from inside the territory but out-side the gates, so I know better. But I have one take; there are many others. We are no monolith. This is my blues.

I listen for those with whom I am in concert. In 2023, my friends Ashon Crawley and Vanessa German were two of six artists selected to put installations on the National Mall as part of Monument Lab's *Beyond Granite* exhibition. Vanessa made a spiritual icon of Marian Anderson, the famous contralto who sang in front of the Lincoln Memorial in 1939 after the Daughters of the American Revolution had her barred from Constitution Hall because she was Black. Van-essa is always working in blue. And in this piece, she had Anderson adorned in a skirt and crown of cobalt bottles of the sort that rest on South Carolina trees, with her hands raised in supplication. On one day of the exhibition, Vanessa did a performance piece. It was one of her frequent "blue walks." In this one, she traversed the grounds of the National Mall with a long blue chiffon train covered in a script of prayers she invited us to offer. Like Shange's girl-child Indigo, Vanessa makes what she needs and recommends we do the same. Whether it is power figures that are contemporary mojo hands, or remixed historic events, or a tribute to the "blue mother"—where she made an installation that combined her late mother's quilts and her own incantatory assemblages—Vanessa's work is a practical conjuration of Black in Blues. She is one of the artists who has taught me to not only think with blue but to create with it as well.

I'd been writing about and talking to Vanessa online for years, but it was Ashon's installation that brought me and Vanessa together

for the first time. His work, *Homegoing*, was an open-air shrine and sound installation made in three shades of blue. In the shadow of the Washington Monument, two mazes in the shape of the Arabic word "Amin" meaning "Amen" led up to an arch under which one could hear him read 350 names of Black church musicians who died of AIDS in the 1980s and '90s, often alone and shamed. The sound of the Hammond B3 organ played behind his recitation.

In the evening after I visited *Homegoing*, Ashon had a companion performance at a church. Vanessa and I sat in pews with Ashon's friends and family, as well as local people who were moved to attend. The choir sang his original pieces, which were interspersed with the names. The liturgy left us weeping, remembering all our dead. Ashon, like Whitney, was raised in the bosom of the Black-migration church culture of New Jersey. And I thought of her too. As with everything, from the Great Depression to COVID, Black people have been most ravaged by AIDS in this country, and also most deprived of care. But this moment was caretaking in the tradition of dressing graves on antebellum midnights. Through my tears, I felt a heartbroken glimmer of hope. Something hardy was planted. We stood and raised our hands in thanksgiving for the art, the artist, and the ancestors. I returned to my hotel to write some more about blue.

I think it is true that art is that thing we bring into our life in order to transform it. Art has an immediate force—it feels so good to dance, to sing, to play—but it also has environmental power. We can retell and rearrange who we are to one another and where we tend in living artfully. The imperative to do so is as constant as the blueness of the sky.

I am fifty-one now, but I was only ten years old, a reader of everything, when I found myself in Shange's *Indigo* and loved her fiercely. She made a world. She grew up to make music and deliver babies. I had babies and make books. She kept her dolls and the South in her. Me too, Indigo, me too.

SEEING THE SEVENTH SON

◇◇◇◇◇◇◇

The Negro is a sort of seventh son, born with a veil and
gifted with second sight in this American world . . .
—W. E. B. Du Bois

Those funded experiences, colored in a dark shade of blue
. . . enable us to invade the future with a bit more than luck.
—Eddie S. Glaude Jr, *In A Shade of Blue*

I WAS STANDING in textile artist Sonya Clark's home studio as
she helped me time-travel. I wasn't surprised. There are people with
whom you keep experiencing kismet, and Sonya is one of those
people for me. It seems as though whatever she is making at any given
time has a direct relation to what I am making. On this day, she was
explaining her project in progress, inspired by Toni Morrison's *The
Bluest Eye*. And I was trying to hold my tongue about what I was
writing about *The Bluest Eye*, telling myself that my writing obses-
sions ought not to overrun every conversation. But then I looked
up to think on something she said, and as I lowered my chin back
down to my neck, I caught a wall of blue. "You know I'm writing
about blue?" I blurted out. "Oh!" she said. "I have some blue for
you!"

ARTISTS, OF COURSE, have inspired every step of this book. I remember when writing *South to America* I first saw Bill Traylor's paintings that featured a blue man in a top hat, and my first impulse was the urge to grab it. Traylor's blue was so clean and charged. Traylor, born into slavery in Lowndes County, Alabama, was a sharecropper who spent his elder years making pictures on a street corner in Montgomery, Alabama. And as I moved through his and other folk artists' work, I realized how often blue was the steadiest color and my steadfast color. In recent years, blue has clearly become an anchor in Black fine art too, from West Africa and the Caribbean, and from African Americans. Often the bodies are blue-toned, or vast swaths of blue take over canvases. It is as though from all these disparate places a common spell is being cast. I'm under it.

I walked to the basement with Sonya. She is a teacher with a broad smile and a lilting voice. Her hands, the tools of her trade, alongside an active intellect and deep imagination, move frequently. There, she gifted me with a catalog of her *Finding Freedom* exhibition, a blue marvel. Ever educating, she described the process: Sprinkle tomato and sweet basil seeds onto muslin. Leave it in the sun. The exposure of the sunlight darkens the cloth to tan, except where the seeds are placed. Then the fabric is dipped into cyan dye. She repeated this process with students in various places, from high schools to prisons. She told some of her students to place their seeds like constellations, specifically the Big Dipper and the North Star that once led fugitive slaves from the Deep South to freedom in the North.

"You know," one of the prisoners in Massachusetts, a horticultural student, told her, "that if you shine a black light behind the cloth, the stars will be brighter." She tried it. He was right: it glowed.

Sonya sewed the cloths together, making a 1,500-square-foot quilted canopy. That became the night sky, and as people walked through the exhibition hall, they looked for the North Star to freedom.

And that is how she helped me time-travel to the beginning of

this project and through every enchanted blue moment I'd felt. I'd looked up to the blue of my grandmother's ceiling, and into the blue of myriad canvases, but it has never been just a passive admiration. We—the people who encounter the beauty of an artist's work—are also experiencing labor, process, and memory; we are part of their transformation and transposing of our relationship to the past. Frequently, Black people speak of being haunted by the past: slavery, conquest, Jim Crow, colonialism. But the artists teach us people of today to haunt the past, to whisper to the ancestors and rearrange the materiality of their lives with our care, to show them they are respected and loved. A haunt is a place we frequent. To haunt is to trouble or frequent somewhere. We haunt the past to refuse to let it lie comfortably as it was. We give back to them in return for the inheritances they have bestowed upon us.

That's what I see in Adebunmi Gbadebo's artwork. She returned to the South Carolina plantation on Pawleys Island where her ancestors were once enslaved. It is a place called True Blue, where indigo and rice were grown. She visited, then depicted the place in historic scenes. On rice paper she silk-screened the plantation with indigo ink. Black people matter in these images. They are more than labor or chattel; they are vital. And of course there are holes—they grow organically on rice paper—just like the gaps in recordkeeping of antebellum Black life, and the gaping wounds caused by physical and emotional punishment. There's no romanticism—the cost was mighty—but there's also no denial of their human legacy. I have read that with the proceeds from her work, Gbadebo plans to purchase part of the land of True Blue, now a golf course, and use it for the descendants of the slaves who once worked it. It will be a living altar.

You see? Blue is a portal. Our ancestors have worked so hard from the other side to keep us going; this is how we tend to them in return.

In 2019, fine artist Lorna Simpson took up the weight of blue on a massive scale in her show "Darkening." The paintings stretched

across walls. Some were massive blue-toned arctic landscapes. In others, she screen-printed vintage photographs of Black people atop the paint. And then she painted again on top of that with inky deep blues. This layering of the blues reminded me of Toni Morrison's *Beloved*, again, as so much I see does, a book in which escape from slavery was not the end of suffering but the beginning of more, a book that teaches that the dead remain unsettled; in other words, it is fiction that is a true story.

Sethe, Morrison's fugitive protagonist in *Beloved*, did the unthinkable: she killed her child, and attempted to kill her others, in order to prevent them from being taken back to slavery under the Fugitive Slave Act. When her dead baby returns in the body of a woman, she tries to explain herself repeatedly. The trauma behind her deed emerges in bits, phrases. But the past eats her up as soon as the sorrowful stories hit air. How the plantation schoolteacher had told the boys to write about her in two columns, human and animal, and they could because her life was theirs, and they could rape her too for the same reason. And she, Sethe, unlettered, owned by someone other than her own self; Sethe had been the one to make the very ink that they used to write down her degradation.

Oak gall ink, the nineteenth-century kind, is transparent blue before turning blue-black. Over time it turns the rusty brown that historians are so familiar with. But at first it was blue. Sethe had inherited the inky color she made. Her absent mother had worked in indigo, hands in the vats, flies buzzing, stinking, dizzying work. And Sethe, crazed by unfreedom, gave her own children her blues. Morrison inherited a past—one shared with Lorna Simpson, Sonya Clark, Adebunmi Gbadebo, Brother Blue, me, and so many more—and reordered the telling and showing in order to make it livable for us and to put the ones who came before us to rest. Blue has hurt, but we can also use it to soften the scar tissue.

I thought I had come to a conclusion when it came to the stories

of blue art that this book would tell. But then Sarah Lewis and Lorna Simpson both alerted me to something I had missed: David Hammonds's 2002 installation piece *Concerto in Black and Blue*. Visitors to the installation were given blue flashlights to walk through a darkened room. "Bathed in Blue" was how Simpson described the experience. I regretted I had not been. Then I imagined it with the sound of Coltrane's "Alabama" in my head, because I was so taken by the word "Concerto." Of course it was a kind of music-making, an improvisation in blue light made by the guests. There was a life ethos Hammonds was invoking. The idea returned to me when I visited an exhibition of artist Firelei Báez's work at the Institute for Contemporary Art in Boston. I walked through her piece *A Drexcyen Chronocommons (To win the war you fought it sideways)*, which was another immersive installation. It was a grotto made of draped perforated blue tarp—the same kind of tarp used following natural disasters in Haiti and her native Dominican Republic. You may have also seen them in New Orleans. Baez's tarps were fashioned like a night sky, with bits of light streaming through. In the grotto, there were two breathtakingly lush paintings of blue-skinned women on opposite sides, who were surrounded with flora so that they looked like altars to the Yoruba Orisha Yemayá, whose color is blue. But they were specific historic figures: paintings of exiled Haitian Queen Marie-Louise Coidavid and her daughters. Yet the associations to the long arc of Black women's histories were abundant. They were themselves, but they were also many others. The installation itself was named after Drexica, a Detroit Techno duo who rewrite the Middle Passage in their songs. They imagine that pregnant women thrown overboard gave birth in the Atlantic to babies, "Drexicans," who could breathe seawater and made an underwater home.

I was enchanted. I continue to be, at each new beautiful blue story in the plethora of Black art pieces and forms. I rue the ones I

missed. I seek the new ones to come. But I had to stop to finish this book. And to remember that the point was not to document them all, but to attend to what these artists teach, in sound and color, about the human condition. I think I know: this tradition I've devoted myself to exploring and explaining is the place where imagination is excited into faith and deed. Conjurers survive conquerors.

We have so many designations: painter, writer, historian, musician, storyteller. These categorizations may be useful as a practical matter. But they often fail to capture the fact of common calling: to transform and transpose the world our ancestors faced, to reclaim the beauty of the sky, and the water, and the indigo, from the moving crypts without ever forgetting the disaster.

And that's why I so wanted the Titus Kaphar painting *Seeing Through Time* to be the cover to this book and wrote his friends until I could reach him. He describes it as "two paintings . . . overlaid to create a fictional, one-dimensional time warp whereby the removal of the European character from the painting creates a space for a young black page to encounter a contemporary black woman. They exchange a gaze." That's the calling, to see through time in order to see today. Each act of haunting and witnessing the past is also the work of living in the along. You know the plot device of time-travel stories, how if the contemporary figure goes into the past, her meddling can forever shape the future? In popular culture, that's considered a bad thing. But in our lives, it can be holy.

In *Beloved*, Sixo, a man with blue-black skin, is caught by slave catchers. Right before he is burned to death as punishment for his escape, he laughs and cries out "Seven-O." Sixo believes in the future even as he is killed. The woman he loves—he calls her the Thirty-Mile Woman because he regularly traveled that far to see her—has made it to freedom, pregnant. "Seven-O" is the child he won't live to see but who will live. Now, who knows if the Thirty-Mile Woman really did make

it. Morrison doesn't tell us. Plenty didn't. Who knows what happened to his Seven-O son—if he would grow to be a free man or a captive. All we know is Sixo held on to faith in imminent death. That he knew that some things must be shouted joyfully to drown out the nightmare. I think that is what we mean in church when we say, "Make a joyful noise." At least, I want it to.

Robert Farris Thompson, the White Texan art historian who traced the impact of Kongo culture on African American life, once wrote that hoodoo is an associative form of knowledge. I like that, as an associative writer of the hoodoo people. It is elliptical—perhaps because of the certainty of suffering—and voracious in figuring out the formulae for survival. How could anything be completely coherent with what we have endured? You'd have to be a fool to really believe a blueprint is all you need. But you'd be foolhardy if you didn't understand that the joyful noise is grace, and the blue note is living.

In 2022, I read a news report about an effort at colonial redemption. It said that Patrice Lumumba's tooth—one that had been ripped out of his mouth—was being returned to the Lumumba family. There was an official ceremony at Egmont Palace in Brussels in which a Belgian official handed over a small blue box containing Patrice Lumumba's gold-capped tooth. I am not Congolese, though I am a remote cousin whose ways are shaped by Kongo ancestors. I cannot speak for his people, family, or nation. But I can speak for me. It felt like no remedy; all it made me think of was the horrific pain he must have felt as he was being slowly killed. The gesture was less than anemic. It was perverse in its inadequacy. And I was convicted to write that sentence, which also is inadequate.

We scholars ask what are the uses of the past, but perhaps a more pressing question is what are the uses of the present. Should it just be recklessly spent because there is no reliable tomorrow and no clear path to doing right today? Yet I do marvel at how impossible it is to

avoid being bound to present violence, no matter how attentive we are to its past. I write as an actor inside this tragedy. Cobalt powers the very computer I'm using to write this book. Seventy-five percent of that mineral comes from the Democratic Republic of Congo. Again, abundance is the author of suffering. There, people dig it up with their bare hands. Many are children. They breathe the toxic particulates. Babies are born bearing copper-induced disabilities. People die young. Accidents happen; extremities are smashed. Life is eaten up. Six million deaths since 1996, over this and other natural resources as well as territory. I think, shame-faced, that Julien Raimond appears to have my face now, darker, American citizen, and a woman. Think about it for a moment. And if I am honest, the mirror must indict as well as inherit. I don't want to fail the future. Maybe, I think, even at this advanced age, I can learn to be more like Carver, Anastácia, Williams, or Toya. May incantation become action. May I/we haunt the past to change the present and claim the future. Amin.

GOD'S WILL UNDONE,
THE CREEK DID RISE

> They saw the God of Israel. Under his feet there
> seemed to be a surface of brilliant blue lapis lazuli,
> as clear as the sky itself. And though these nobles of
> Israel gazed upon God, he did not destroy them.
> —EXODUS 24:10–11

AS I WAS completing this little book with a big story, my cousin Cornelius Durrel Perry died following a heart and lung transplant surgery that was necessitated by a severe case of sarcoidosis. Two weeks before the memorial service, my aunt Thelma texted me these words: "Durrel's favorite color was blue, so we thought that it would be nice if we wore blue or a splash of blue." On that day, I made a heap of mistakes. I forgot to sign papers, I got confused, I sent bizarre emails, I made a mess. I bickered and snapped. Then, like a whirl-wind, I moaned. My cousin was gone. I did not know which blue he loved most either. I could hear myself wail. I didn't know that sound from me. The sound of I don't know what to do with all of this want-ing something to be different. For so much to be different. It grew to a howl.

In the days before his memorial service, I was walking back and forth along the water at the Hermitage Artist Retreat in Florida. My housemate is fine art printmaker Delita Martin. I ask her one early evening when the air smelled like salted honey why, in her portraits of Black women, her outlines were blue rather than black. She told me a story about her father's funeral. He had been an artist too. And all of his children had showed up to the service wearing indigo blue without a plan to do so. And although I had chastened my lost opportunity with my grandmother, by the time I was sitting with Delita, my age peer, I was wise enough to understand that this answer—a spiritual one—was more precise than standard American English logics could recognize. Her answer was not just saying that they wore blue. It was a sentence-long sermon about how blue is a conduit, something felt and known, even more than seen. Delita and I talked in deeply moving spurts through the week, about having sons, love, grief, and art-making. I remember her saying at one point that some artists who use printmaking techniques are hesitant to call themselves printmakers, as though it were a lesser art form than a painting because painting is more obviously one of a kind, and I think about Nikky Finney's quote "Repetition is holy." Another afternoon, I asked Delita if she'd ever heard of "blue gums," and she laughed and said yes. Of course she comes from people who knew hoodoo.

In a cocoon of grief and writing, I completely stopped answering email and phone calls. People were looking for me. I was trying to get this book down on paper. The seaweed was rust-colored, and in the evening the water turned reliably blue like the throat and irises of a double-crested cormorant. Those fish-eating birds were once called without a second thought "nigger geese." According to historic accounts, their babies are edible. But the adults have grown too tough. The bird opens its mouth wide, and a brilliant blue leaps out. That is what the water reminds me of in the evening. The part inside. I

think I have learned the exile's trick. It isn't escape. It is rhythm, a bass line, holding something constant, a steadiness to the chaos. Keep walking. I could see my way through that. The certainty of the tide did it for me.

In Atlanta for the service, Thelma gave us seeds of blue flowers to plant in his memory and blue heart pins to wear on our dresses and lapels. My uncle Cornelius spoke and talked about Durrel's blue blanket, the one that covered him as his body grew thinner and his soul worked its way free. On each hand that day, my uncle wore a single lapis ring. I was curious and asked him questions. Later he sent me articles about the symbolic meanings of lapis. I told him that I live according to one of his precepts, that as long as I can read, I can teach myself to do anything. Even survive a broken heart. It's true. A little more than a year later, we wept again for another one of us gone, my cousin Dwayne. I stood in front of the wreath of blue-dyed roses. I gazed upon my uncle's lapis ring again. It was, like Nathaniel Mackey wrote, "blue devotion's annuity looped and led back," and I tarry in the refrain of sorrow. And I have found something out along this way of grief—reading the sound and color and text. We Black people are not quite like other Americans. We do not live in the same fantasy that we might evade death by collecting things like dollars, houses, fences, and passports. But we are as human as humans come. The incomprehensible keeps happening. Death comes fast, frequent, and unfair. And we're still here. We know how to breathe underwater. Living after death.

IT IS A universe in blue.

ACKNOWLEDGMENTS

◇◇◇◇◇◇◇◇

The archive I turned to to write this book is so expansive that any thorough acknowledgment would be far longer than the manuscript pages. I hope, however, that each name and event on each page sends readers on a journey of discovery to learn each story with greater detail and nuance. This book is a quilt literally only made possible by thousands of scholars, thinkers, artists, and authors.

Thank you, as always, to my late grandmother Neida Garner Perry; she and all the people she raised in that yellow house and blue room were direct inspiration. Especially my mother, Theresa Perry, who in the '70s wore her navy blue suede Nehru jacket with her geles and jeans, elegant Black nationalist intellectual that she was, and who gave me my father by love, if not blood, Steven Whitman, whose blue eyes teared up at Malcolm's words and who dreamed of Black liberation for me and for humanity. What an inheritance.

My children, Issa Garner Rabb and Freeman Diallo Perry Rabb, now young adults for whom the world is insufficient but fortunate to have them as part of it. Their imagination and beauty is the best inspiration in the world. And I am also so grateful for the presence of our young cousins, who are also emerging beautifully into it: Jeremiah, Miah, Cameron, Jalen, Gianna my reading partner, Emerson, Avery, Nouri, and sweet Ian, who loves blue like me. Eshe Alexandre-Sanders and Isaac Agrippa Freeman Leslie, your auntie loves you.

Khari David Walker, a child I loved and held who departed too soon. Thank you for being.

Cindy Uh, a dream agent and great friend; Sara Birmingham, an editor who is not only extremely skilled at her job but deeply soulful and wise; TJ Calhoun, Mary Beth Constant, Helen Atsma, and the entire community at Ecco who have made this book possible; my brilliant writing partner, friend, and most consistent interlocutor on ideas and craft Eddie S. Glaude Jr.; my *Black in Blues* visual mystic inspirer, Yaba Blay; Tarana Burke, who is the world's best cheerleader; Mark Jefferson, for wisdom about the fundamental and beautiful human frailty of Black folks; my always-sending-blue-paintings friend, Paul Holdengraeber; my visual artist friends who let me use their incredible work in this book: Jason, Ashon, Vanessa, Sonya, Delita, and Titus; the artists who don't know me and let me use the images anyway; extraordinary artists whom I met through this book: Lorna Simpson and Adebunmi Gbadebo, every single supportive reader and reviewer of *South to America*, *Looking for Lorraine*, *May We Forever Stand*, *Vexy Thing*, and *Breathe*, who gave me the courage to be even more experimental and expansive in this book; the MacArthur Foundation, the Guggenheim Foundation, the Hermitage Foundation, the National Book Foundation, the Pew Foundation, PEN America, the American Studies Association, Phi Beta Kappa, and the Hurston Wright Foundation; my colleagues in Women, Gender, and Sexuality Studies, the Black Teacher Archive, African and African American Studies, and the Harvard Radcliffe Institute; all at Harvard; and my forever but former colleagues in African American Studies at Princeton, I am because WE were. I am especially fortunate to have a marvelous circle of artists, intellectuals, and curates who provide everyday inspiration: Theo Davis, who understands Pip and healing better than anyone I know; Ilyon Woo, for her magical eyes and gaze; Damaris Hill, Simone White, Michele Alexandre, Kiese Laymon, Robert Jones Jr. (zoom!), Dawoud Bey, Maori Holmes, Tracey K. Smith, Kathy Van Cleve, Airea D. Matthews, Sarah M. Broom, Henry Louis Gates Jr., Robin D. G. Kelley, Mary Haft, Leigh Haber, Cheryl Landrieu, my

Mt. Airy massive, the "Cornchips" and Cornel West, the free-women group chats, the Black and Brown Bookstagram and bookstore communities. W. E. B. Du Bois, the intellectual ancestor who modeled the courage I need.

And last but never least: the blue Alabama sky under which I was born. Langston Hughes wrote, "When I get to be a colored composer / I'm gonna write me some music about / Daybreak in Alabama." Me too, Mr. Hughes, me too.